ALL-IN-ONE CINE BOOK

WITHDRAWN
FROM
MIC-SPCT

All-in-One
CINE
BOOK

Paul Petzold

THE FOCAL PRESS
London and New York

First published 1969
Second impression 1970
Second edition 1972

in Swedish:
SMALFILMA BÄTTRE
P. A. Norstedt & Söner, Stockholm

in Italian:
IL LIBRO DEL CINEAMATORE
Fotografare, Rome

in Spanish:
TODA LA CINEMATOGRAFÍA EN UN SOLO LIBRO
Ediciones Omega, S.A. Barcelona

in Danish:
BEDRE SMALFILM
J. Fr. Clausens Forlag, Copenhagen

in Hebrew:
ספר ההסרטה
Sadan Publishing Company, Tel Aviv

Printed and bound in Great Britain
by Billing & Sons Limited, Guildford and London

CONTENTS

5

6

7

I am your cine camera. In a sense I am also a time machine. I can toss time about so that it goes any way you want. I can take whole chunks of the past and bring them into the present, or even into the future if you want me to. I can go over the events as many times as you please.

With me, you can rearrange things, give them a new look, a new meaning. I can turn time upside down and make it do crazy things. I can even make life jog merrily along backwards!

It is easy for me to make holidays and great occasions come back to you so that you can enjoy them time and time again. My memory is much more accurate than yours, and I'll bet yours isn't in colour.

I can record every detail and every moment, just at the speed that it actually happened, or if you want to be awkward, a lot faster or a lot slower. Your memory has only one speed at the best of times and even that's not too reliable. If you take me with you, the things you do will never be forgotten.

By now you will have realised that I am just about the most fabulous invention you've ever met! But this is only half my usefulness. Better still, I can tell a story—perhaps one that never happened. Even so, people will believe it. Seeing is believing, and film is the greatest of all story tellers. People really get involved and they cannot escape.

It is a wonderful world of fantasy that is now open to you. I can create more excitement, more surprise, more joy and reality than a whole book of ghost stories. Oh, by the way, that's another of my accomplishments, making ghosts. I can turn them out by the dozen.

Although I can do all these things, the trouble is, I must admit, I can't do them by myself: I have to depend on *you*. I make everything as easy as I can but I still need your help. This is why I hoped to meet you in this book and although I confess I boasted a bit, I simply had to introduce myself. When I have shown you how you can use me, I think we shall get along fine. Luckily I know all about how films are made, and together we can really get things moving. All you need to know is here to see. Come with me and I will show you.

SO YOU'VE GOT A CAMERA

Just to own a camera is a pleasure. But where some hobbies end, with owning things, cine begins. It's what you can do with the camera that matters.

Some people are terrified by a camera. They hold it gingerly, not at all sure what the dials and figures are for and secretly doubting that they'll ever know. Anyway, what has all that stuff got to do with taking pictures?

With many cameras nowadays you simply point and shoot. You can avoid the technical quagmire altogether. In fact, it is much easier to use an ordinary cine camera than to take snapshots. After taking dud snaps for years, many people have been surprised to pick up a cine camera and get results the very first time. They know their film isn't perfect but it's not bad for a first effort.

Cine is rewarding from the very beginning. The main thing is to decide what you want to do with your camera. Then you can find out all the things you really need to know to avoid mistakes. Knowing a lot about the theory of a practical subject doesn't make you good at it, but to know what matters can help enormously.

Some people are real scavengers for information and collect odd bits and pieces from all over the place. Does it help them? Not a scrap! You can find out all you need to know soon enough; there is no point in collecting information you will never use.

CINE IS NOT SNAPSHOOTING

Many cameras are such a joy to use that you are easily tempted away from your subject to shoot at things that you don't really want. Everybody does it—to begin with. The result is that when the film comes back from the processors you find it is filled with things that are not worth looking at.

You must be in charge of the camera; and not have *it* in charge of you. A camera is a very clever instrument and might do all the

difficult working-out for you, but one thing it will never do is tell you what to shoot. Nor will it tell you how to shoot it. Unlike snapshots, pictures on cine film are joined end to end, and this is important because unless you cut the film up later (in other words, edit it) and rearrange the scenes, they always appear in the order you shoot them. And every time you look at them they appear in that same order.

The joined up scenes follow so quickly after one another that it is a good idea if they are related, or at least have something in common, otherwise the film is such a jumble that after a few months have passed neither you nor anyone else can make head or tail of it.

THE WRONG WAY

Bad filming habits are all too easily formed. Imagine one day you go out with your camera. The first thing you see is your daughter teasing the kitten with a ball of wool. So you shoot. You go out of the gate and down the road. A horse in the field next door is looking over the fence and you take a shot of him, too. Later that day you shoot a train rushing over the crossing, a pleasant woodland scene and the old windmill. Back home, you take some more shots of your daughter, who by this time is doing a jigsaw puzzle. The kitten has disappeared. You finish with a shot of your wife (who doesn't really want to be photographed) cooking your dinner.

The result when projected doesn't make much sense. The film rushes through from one subject to another and you can't explain quickly enough what each one is. What went wrong? You used the cine camera like a snapshot camera.

Soon, you may have half a dozen reels of jumbled film. They will bore and confuse your friends. You will soon forget what it was, where it was, when, which, why, and feel only that you wasted your time and money on it.

From all this, we can learn our first lesson: there is no such thing as a snapshot with a cine camera. It simply can't be done like that. Cine and still photography are very different and you must tackle cine in quite another way.

THE RIGHT WAY

You have seen what happens when you shoot unrelated pieces of film. Yet a film *can* be made up from random material,

provided it is all related to the same subject. If, for example, you go on holiday to the seaside with your camera you might shoot: the children making sandcastles, the waves, a gull on a rock, some birds flying overhead, boys playing ball, your wife venturing into the sea, waving grass on the sand dunes, an ice-cream man, Punch and Judy show, deckchairs, donkey rides, a heap of buckets and spades outside a seaside shop, baby pouring sand over a sleeping uncle, and, finally, everybody piling into the car to go home.

You will not have a film in the true sense of the word, just a collection of memories—some interesting, some amusing, some beautiful. But later, when you see the separate scenes all together, the connection between them is obvious and they help to recall the occasion. The little reel stays in its tin and you may dig it out from time to time. It will remind you of a happy holiday.

This film although a little disjointed in places is not a jumble like the last one. There is nothing really wrong in making a film like that, but it does not get anything like the best out of your camera. Some improvements could be made. You might have begun with your arrival and taken the things in better order so that events followed one another more realistically. You could have added some connecting or linking shots to make the film less like jottings in a visual notebook.

FILM MAKING PROPER

Let us suppose that you had another holiday. This time you were at a village; you climbed mountains, sailed a boat on a lake, went for walks in the woods, visited a local zoo and a

A film for the family.

funfair. Here you have several unrelated subjects, so you cannot take random shots. Casually filmed sequences just won't do. Some forethought is needed. The scenes have to be filmed so that the final picture, however many reels long, hangs together well.

12

This organising of yourself and putting shots into some order is film-making in its simplest form.

Film can be a personal thing, a family thing, something for everybody, or any of these together. It enables other people to see things through your eyes and enjoy them as you did. It is when others really enjoy your films that you get the greatest pleasure from them. So do begin to think of a film in terms of something that you want others to see.

THINK OF YOUR AUDIENCE

How can you make a film that other people will enjoy?

Everyone likes to see a film—the first time. If you can do well enough, polite comments and stifled yawns will change to real interest. Soon, your friends will begin to ask if they can see anything new you have done.

A film for your friends.

What does an audience want to see? What do you want to show them? What do your family want to see? Who is your audience anyway? No one is so "spoiled" by television professionalism that he will not be interested in what you call your "humble" attempts.

Your audience will not be muttering away in the dark comparing your films with a television production. You can soon show that there is no rivalry between your movies and TV. Your films are a personal record and a personal effort that your friends may even admire. They do not invite comparison. You can do so many things with your camera that you don't see on TV.

Your audience will react according to how you treat them. If you use your camera in the right way they'll appreciate it. So will the family. The main thing is to present something interesting— to develop an idea.

HOW TO DEVELOP AN IDEA

One of the main attractions of cine is that if you get an idea you can try it. It may be a flop, but on the other hand the result could be truly spectacular!

Such ideas may occur to you on the spur of the moment. You see a boy in a tree. You ask him to jump down while you take some shots. By an act of jiggery-pokery with your camera you can make him jump straight back into the tree again from a standing start! Alternatively you can make him float gently down like a leaf and land in a dignified sprawl. That is one method of filming. The boy in the tree sparked off ideas which you tried out.

See what you can get.

Another time, you are walking in the country and you come to a fast-flowing brook with an old bridge. You hear a horn in the distance. It is the master of the hounds calling the hunt together and, sure enough, in a few moments you see little white bodies bobbing across the field. How pleasant it would be to get them going over the bridge with the brook in the foreground. You move down the bank and wait. Soon the horses and men in hunting pink appear and duly cross the bridge. Good! A bit of forethought paid off.

Arrange it on the spot.

You notice a dog snuffling around on the bank. A shot of him and the other horses and with a few more general shots you have a fine sequence of what most photographers would admit is a difficult subject.

14

When you see the film projected your best shot is the one of the horses going over the bridge. As it happens, you've got the brook tumbling along in one direction while the horses are going in the other. So much the better. There is plenty of movement and the whole film comes to life.

You also took some brief shots of water bubbling over pebbles, so fresh and clear you'd rather fancy a glassful. It was a good job you thought of that one.

The bridge shot is the best. But it's not enough on its own. Add the others and you've really got something.

You started out with one idea, but that gave you another and another. . . . That's a second kind of filming. You saw the subject and developed ideas on how to film it.

FROM IDEA TO PLANNED SHOOTING

Making a film is a bit like daydreaming. The two ideas just mentioned are not the kind that you work out. You may not even have time. You pursue them almost without thinking and they are spontaneous, immediate, and so much the better for it.

Now for a third kind of idea. You've got two reels of film. You're going on two weeks' holiday. Two reels seems a lot, but it's only about 8 minutes. Somehow you have got to squeeze two weeks' holiday into two tins of film. You can't stretch the film

Rough out a scheme.

so you'll have to compress the holiday. That doesn't mean cancelling the second week but it does imply that you'll have to be choosy about what you shoot. If you want to play safe you might buy another two films but that doesn't solve everything. You still have to be selective.

This is a time when you can plan your ideas in advance. Not what you are going to shoot—you can't do that for you haven't seen it yet—but a scheme that you can work to on the material available. This will help you achieve a balanced result.

15

The film will be the product of your ideas and you have to decide beforehand what kind of film it is going to be. In the case of a holiday film this obviously depends on the kind of holiday it is. A winter holiday would probably emphasise the people rather than the scenery. The same goes for a holiday by the sea, but a summer tour might be mostly scenery. You can form a clear idea of this before you set out and then elaborate on it once you get there.

But you can be sure of two things on any holiday—that it will have a beginning and an end. So must the film. Remember this when you venture forth.

GIVING IT SHAPE

A holiday is an event and an obvious subject for a film; other subjects are not so obvious. What about your garden? Where do you begin to make a film of a garden?

Nature is a shapeless sort of thing but it doesn't mean that you must make a shapeless film of it.

After wandering around with a camera apparently lost in your own garden, you will probably decide that the best thing to do is to plan the whole film out from the start. This is our fourth method of developing a film idea. You save yourself endless footage because you know just what you want, how much film you have got, and even how much it will have cost by the time you finish!

Plan it out in detail.

Suppose you begin by drawing up a plan, or script as it is called. You can start with some shot that really looks like the start of a film, such as a shot from outside the garden. Then the gate opens and you enter.

Or you could start with nature's own opening scene—sunrise. You might choose a shot from inside the house looking through the window or the opening shot could be the reflections in a pool or a close view of the leaves on a hedge.

The next part of the film will be of greater interest but you must also leave something for the climax—perhaps glorious waving blooms in close-up and the full-face portrait of a sunflower.

You might end the film with some dark-coloured flowers or a general view of the whole garden when all the flowers you have met in the film can be seen together.

You know your garden; you can think out this sort of thing and build the film around it. This will leave space for the odd shots taken as you see them while wandering around. They can be fitted in where they go best.

Working out most of your ideas beforehand in a kind of schedule of times and scenes may seem too much like hard work, but it is a surprisingly quick way of doing things and the results prove the value of this detailed method time and again.

EXPERIMENTAL SHOTS

You may want to try out a particular idea while you are making the film. Often the opportunity does not arise. It is no good foisting your idea on to the film, it will stick out like a sore thumb in the finished job.

Rather than spoil a film, you could experiment on an odd scrap of film material, perhaps at the end of a nearly completed reel so that you can easily chop it off afterwards.

FOUR WAYS OF FILMING IT

To summarise, we have examined four different ways of developing film ideas. First the boy in the tree—a spur-of-the-moment idea done for fun. Here you are really playing with the camera.

Then the situation where you see the subject and develop ideas on filming it as you go along, producing little self-contained sequences or scenes.

Next, where you plan in advance a rough scheme that helps you to keep control of the subject and produce a well-proportioned result.

And finally, the fully planned film where you work to a detailed list of times and scenes to which you add other random or experimental shots like pepper and salt. In this last case the advantage is a film that runs smoothly from beginning to end,

tells a story, saves time, money and missed opportunities, and really makes sense on the screen. If you are prepared to go to that trouble, your ambition need not stop there—the whole world of film making is open to you.

WHAT KIND OF FILM?

The purpose of the film you decide to make will influence the way you treat the subject once you start filming. When you have a firm idea of the type of film, the most suitable approach can then be found and, what is more important, that approach must be maintained.

One way to keep in mind the purpose of the film while you make it is to say to yourself, for example: "This is a travel film. Will this shot fit in? Do I need it? If so, is this the best way to shoot it?" That way, you can always keep to the subject and avoid "pet shots" that can never be used. Some films are long in the making and you can get hopelessly lost. But bearing the goal constantly in mind enables you to keep a hold on things and find a way out if something goes wrong.

The kind of film you make is not necessarily a gauge of how simple it is to do, though, of course, you would expect fewer complications with a film about the family than if you were doing a long story film. A beginner is better off with a simple subject because it makes filming simpler, too.

audiences may re......do you good as
their criticism is......to be sympathetic......and helpful than not
indulgent. They understand the problems you meet in making
a movie and......gratitude for the effort. In......the novice
needs a little help to......him over it......start.

YOU AND YOUR AUDIENCE

Audiences are not made to order. You may play safe by inviting only your friends to see the film. But this is cheating. After all, they like you and don't want to upset you if they are not impressed, although some are more likely to tease you than any stranger.

The number of people who like to see films just for the novelty gets less every day. Once someone has his own cine equipment he can watch his films whenever he pleases.

A person is more receptive to a film and more tolerant of its failings if he himself appears in it. But this happens only occasionally and even then he is probably more interested in his own performance than in the film.

HOW WILL THE AUDIENCE REACT?

Your sole means of regulating the kind of audience is by inviting only those who find the *subject* of the film interesting. You can invite relatives to see a family film, friends to see a film about a subject of mutual interest, and keep the general interest films for a more mixed audience. It is hardly fair to expect a general audience to sit appreciatively through mile upon mile of your personal reminiscences.

However, even a hand-picked audience cannot guarantee a thundering applause every evening. Audience reaction is often very difficult to account for. It seems to depend upon many things. An actor will tell you that on some nights he can button-hole his audience from the moment the curtain goes up, but on other nights they just sit there like cabbages, and it takes a truly big effort to get through to them. Perhaps their mood is really determined before the play or film even starts. Whatever the reason, some audiences respond more easily than others, and there is not much you can do about it. But the surest way to good audience reaction is to show a good film.

Most amateur film audiences are sympathetic. Cine club

audiences may be more critical, but that should do you good as their criticism is likely to be constructive and helpful. Don't get indignant. They understand the problems you are up against. Reserve your indignation for the clever character who never made a film in his life but knows all about it.

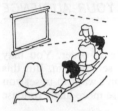

Think of your audience.

Why not take the bull by the horns and ask each audience to whom you show your film what they thought of it? Many will be only too glad to express an opinion. Assure them that you don't mind frank and outspoken comments. The conclusions drawn may give you some new ideas for better films, and even an offer to collaborate on a more ambitious project. Many professional films begin with a round table conflab; why shouldn't yours end with one?

As a rule, child audiences are easier to please than adults. At school they see travel films and inevitably some film about cocoa or oil—and they watch them willingly rather than do lessons. Outside school you have to give them something a little more entertaining. Funny films are one sure way to captivate a child audience. Animal films offer another solution, especially for young children. Films about planes, boats, cars and trains are obvious winners for boys, whereas dancing, pets, and wild life generally appeal to girls. Films in which children of their own age are seen doing various things like making a canoe, giving a puppet show, acting and dressing-up always go down well. Trick films are welcomed by everyone, so they are ideal for a mixed audience of children and adults.

Your audience problems are fewest when the audience knows more or less what it is going to see. Where you have been asked to make a film of a special occasion like a church bazaar or local sporting event, their response largely depends upon what sort of job you have made of the film.

Occasionally, societies ask you to make a film for them. Here audience interest is assured and there is little justification for pre-projection jitters on your part.

FILMING FOR YOURSELF

A favourable reaction to your film can be encouraged by appropriate treatment of the subject matter. You can produce different films of the same subject for different audiences.

Let us choose a subject and think of two different ways of handling it. First, we will treat it as if we were making the film for ourselves only; then we can have another go, this time sorting out the ideas to make an interesting film for others.

This example is an imaginery sequence of a scene as you might find it, *not a script*. The shots are your possible reaction to the situation. The idea is to show the sort of sequence you could shoot if all the time you were bearing in mind the objective; first of a film for yourself, and in the second version, a film for others. Also imagine it is a one-man job with just a little assistance from wife or friend.

Subject: The market place in an old English town.

Shots in sequence:

1 Signpost with name of town.
2 Town from a distance seen in valley: church steeple, rooftops, etc.
3 Your car arriving in town, either shot from kerbside or from inside (help needed in either case as you want the car moving). Second best is your car static in surroundings, with car fairly large in picture.
4 Car smaller in frame, shot from another angle (but the way things are today you will probably have to move on). The car park isn't exciting so forget that. Alternatively, walking in from bus stop.
5 Wife or self looking at town plan, pointing at place.
6 Shot of wife walking up street, peering at window and passing group of people, then walking into crowd in market-place (general view), where lost.
7 Picked up again at hat stall trying on hats. Hats in foreground.
8 Expressions, trying hats.
9 Reflection in mirror.
10 Shot of salesgirl.
11 Shot of coloured hats.
12 Other big hats.
13 Wife buying hat.
14 Wife wearing hat.
15 Hat moving among heads in crowd.
16 Wife's repulsed expression: what is she looking at?
17 Wriggling eels, close-up.
18 Shot with wife and eels.

21

19 Small boy walks up and pokes eels with used lolly stick.
20 Wife pulls him away.
21 Boy remonstrates, moves off.
22 Shot of fishmonger.
23 Buying fish.
24 Lively cloth salesman, customers crowding round, backs to camera.
25 Customer turns round towards camera; it is your wife. At the same time large woman in red hat also turns round. Shot repeated, this time without red-hatted woman.
26 Salesman spots you, shouts and waves at camera (keep finger on button). People turn round and stare (stop camera).
27 Soap-box orator foretelling doom, one small boy watching.
28 Close-up of salesman again.
29 Salesman shouts at you again, comes forward (stop camera, beat hasty retreat into crowd).

 At this point it begins to rain and you run for shelter. Start filming afterwards.

30 Record stall.
31 Record going round.
32 Wife with screwed-up face, blocking ears.
33 Row of stalls.
34 Town Hall in background.
35 Haberdashery stall.
36 Butcher—chicken heads hanging in rows.
37 Egg stall—not colourful, but close-up of just neat rows of eggs quite interesting. Hand appears and removes one or two.
38 Stall with nylon stockings hanging down, kicking amusingly in breeze.
39 Nylon stocking blows round wife's face.
40 Wife films you buying flowers
41 Making up bouquet trying several different flowers and adding greenery.
42 General shot of flower stall.
43 Flowers only.
44 Blind man selling matches, people pass him by.
45 Heads, and balloons in distance over heads.
46 Balloon man with children.
47 Close-up of balloons.
48 Big close-up of balloon with face.
49 Small boy walking away with balloon.
50 Junk stall, no one around.
51 Pets, white mice, wife looking on.
52 Small boy and girl.
53 Monkey on salesman's shoulder.
54 Bright parrot, you on other side facing camera.

55 Hardware stall, move close to a pan, suddenly wife's face appears reflected in centre—or pretty girl.
56 Back to soap-box orator, close-up.
57 Small crowd, one of whom is now shouting back at orator. Book stall (miss that), jewellery (that also).
58 Fruit stall, colourful pyramids of oranges, etc.
59 Salesman demonstrating product.
60 Wife unimpressed turns away, now laden with purchases.
61 Wife emerges from crowd.
62 Return, loading shopping into car.
63 Car leaving, creeping past market, flash of colour.
64 Car going down road.
End

This sequence is quite satisfactory as it stands for family consumption. Even without editing, you have a pleasant and contrasting collection of little scenes. The jumbled quality of the film is not too bad in this particular case. It adds to the feeling of confusion you usually get in a market-place. The film does not fall to pieces. You or your wife turning up in every four or five scenes add a sense of continuity. Also the film has a devised beginning and end.

One shot follows another.

Editing would give you a chance to make improvements. You could cut out the scene spoiled by the red-hatted woman (don't shoot anything twice unless you intend to edit later—it looks silly). You should also trim up the shot of the salesman where everyone turned round and you jogged the camera badly near the end. More important, you could transfer the first soap-box orator shot to a place near the beginning and the second to one near the end to help unite the ends of the story. This sort of thing is especially important if you choose not to shoot arrival and departure sequences. One or two other shots could also be tidied up and you could take out the one where you forgot to focus.

23

Further improvements could be made by the rearrangement of several shots if you were prepared to do a considerable amount of cutting and splicing (see p. 192). Juxtaposing one shot with a certain other can sometimes improve both. A sudden change of subject, colour, etc., can produce effective or humorous results. It is difficult to resist doing this when you find a peculiar similarity between two subjects such as a bloodhound followed by a close-up of a man who looks like a bloodhound. At all times, of course, you must retain the sense of the film while you toss the scenes about.

FILMING FOR OTHERS

Now let us consider the market again. This time we are approaching it with a wider audience in mind. In this case you might shoot an entirely different sequence of shots.

Subject: As before.

Sequence of shots:

1 Opening shot from a distance showing some main features fairly large in frame, such as church, bridge or similar.
2 View on entering town. Not many people about (perhaps early morning when the town is still half asleep). No car included. No shots from travelling car needed.
3 Several shortish shots of empty streets, interesting views including old buildings and streets of character. In the market place some stalls being assembled (general view). A barrow being wheeled along, boxes, etc., a dog trotting past pausing to sniff at boxes.
4 Several shots of any incongruous or funny things you see in the market square. If you need someone in the picture you can include your wife in one or two shots but she mustn't look at the camera or wave! (Alfred Hitchcock appears somewhere in the background in all his films without looking out of place because he behaves naturally.)
5 An early customer making purchases. Shot away to more general view. Fade.
6 Town Hall clock showing 11 o'clock, pan down to market place general view showing bustle.
7 Same from another angle, people walking in from foreground.
8 Hat stall, coloured hats.
9 Women at hat stall trying hats, expressions whilst trying hats, women with ridiculous hats, reflection in mirror, shot of sales girl, a bought hat going off into the crowd.

24

10 Follow that woman, shot of her at fish stall, fishmonger at fish stall, pan down to eels, close-up wriggling eels.
11 Boy pokes eels with lolly stick, fishmonger, small boy poking, goes away.
12 Follow boy (if he goes to another interesting stall try there).
13 Cloth stall, crowd of women around. Salesman spots you, shouts at you, keep filming.
14 Soap-box orator, no audience.
15 Record stall, records revolving.
16 Row of stalls, Town Hall in background.
17 Haberdashery stall, butcher, fat man with round red face, chicken heads in rows, egg stall and hand appears and removes some.
18 Stall with nylon stockings hanging down kicking in breeze, begins to rain.
19 People scatter, umbrellas open, orator continues in rain.
20 Open stalls hastily covered, book stall closed, long-shot stalls, no customers,
21 Raindrops in puddle, orator finally takes cover.
22 Raindrops less in puddle, people emerging from shelter, going back to stalls, close-up of flowers, general shot of flower stall.
23 Blind man selling matches, people passing him.
24 Boy seen before, with another lolly.
25 Heads and balloons in distance over heads, balloon man with children, close-up of balloon, big close-up of balloon with face.
26 Junk stall, pet stall, small boy and girl looking on, monkey, bright parrot.
27 Hardware stall, soap-box orator with small crowd, one holding forth.
28 Book stall with bearded old man peering into book, jewellery stall, fruit stall, demonstrator, thinning crowds, people carrying heavy baskets.
29 First stalls being packed up, stalls selling off last goods, more stalls packing up, being wheeled away.
30 Town Hall clock, then to deserted market, rubbish everywhere.
31 Close-up of rubbish, coloured papers, etc., down street.
32 Round corner comes corporation dustcart, begins to clear rubbish.
33 Papers being collected, streets washed down.
34 Shot of cobbles, evening scene empty market place, evening sky.
End

Although in these two examples you have only one subject—a subject that you cannot control or alter in any way—by selecting certain aspects you can make two quite different films.

In the second version you may wish to add titles giving a more formal explanation of where the town is. But the signpost shot might do as in version one.

The first version is a personal record. A personal note is added to many scenes. Shots are rather haphazard. There is a happy-go-lucky air about it.

In the second version the approach is quite different. Here there is emphasis on the beauty of the setting (general view); the atmosphere of the market and way of life in the town (early morning streets, the dustcart), old buildings of interest, people's shopping habits (women and hats), behaviour of children (following the boy), and the elderly (old man at book stall). Also, there are far more things of purely filmic interest, shots with pictorial appeal (raindrops, flowers, coloured papers in street) and you are more concerned with real events (rainstorm) than with things at their best. The film gives a better impression of the times of day. Most important, there are no private jokes in the film—all the humour is of general appeal.

This film does not need the continuity link provided by your wife or friend in the first version. It is the story of the market itself and not of your visit. But it would benefit from some kind of visual link between the scenes to keep the story flowing all the way through.

One form of visual link could be made by filming a subject and then looking for a contrasting scene to put next to it. But you might spend hours prowling around without finding what you want and missing plenty of good shots in the meantime. In fact, in most cases it really isn't practicable, and should be left as a possibility only in editing.

A more dependable link could be formed by the same subject appearing again later in the film. This could be the second half of one shot, showing some development in the action.

A person can form a link.

Possibly you may again wish to use your wife as a continuity link through the film. In this case she must appear often and at regular intervals as she is visiting the place with the audience and they are seeing it through her eyes. This is also quite a good

method for joining together scenes not connected in other ways.

But if your wife is to appear incognito or just as a person in the picture, someone to fill an empty space, she must not appear more than twice. If she does, it will seem that you are making a point about her.

Always avoid changes of time in a film if possible. It is often difficult to indicate the passing of a few hours unless you can fade the picture (see page 179). Here we have used the town clock—a simple device that always works, even without a fade. But there is not always an obliging clock in the scene. The professional practice of using a subject in the picture for this purpose is a tricky one to do yourself. One method is to draw in very close to a small area or a neutral object and then move away again to show the same scene. Now, the shift in time when you see the scene again is made very obvious by considerable changes to it. A jump cut can work but often just looks wrong and makes the film disjointed. If you can fade a scene this is the ideal answer to show the passing of time.

You will probably feel more inclined to edit the second version of the market film than the first. Your task is to some extent easier because of the richness of the subject-matter. Glance at the material we have shot in the second version and see the possibilities for a nifty pair of scissors: the wriggling eels/the bustling crowd, hanging chickens/suspended nylon stockings, red balloon with face/red moon-face of fat man, junk stall/jewellery stall, and other possible juxtapositions.

Further improvements could be made by moving certain shots to other parts of the film. The small boy could be seen with his lolly early in the film and then later poking the eels with the used stick. Reversing shots 11 and 24 creates a little side story, and incidentally provides a good link in the film.

THE DIFFERENCE IN APPROACH

The above examples represent material that you *might* see in the market place. Perhaps you would consider yourself lucky to see and film such things in one day. But markets are fascinating places and there can be innumerable things going on that would give you material just as interesting as we have imagined.

The important thing is that you keep your eyes open all the time. We included the rain shower to show that if you are out to make an absorbing and interesting film you've got to stay on the job. The shower gives rise to interesting sidelights that you

would not otherwise see. It also has visual appeal. In your family film you probably wouldn't bother about it. But in a film for other people this is really good material. Surely you can work in the rain without getting your camera soaked!

It is especially important in a film made for general showing to have a proper beginning and end. The film should be self-explanatory at both these points. Don't start abruptly and don't leave the audience in mid-air.

Of course, you cannot always plan these things in advance, but certain preparatory work can be done before you plunge into the main part of the film. The beginning and end of a film can often be shot separately another time. A number of the shots in the sequences above could have been shot at spare moments that day or even on another day. The Town Hall clock is an example, or the empty street and market-place. Then you can cut them into the film and they will look as if they really were shot in sequence. Film has its useful deceptions!

The problem of shooting a film on different days is that for one reason or another changes may have taken place between-times. With a turn in the weather, sequences following one another are no longer continuous. This can often be overcome. The Town Hall clock in the above sequence could have been filmed in close-up. With the sky excluded from the picture the weather would not be important. The difference between sun and no sun is hardly visible. The clock might have been on the shady side of the building.

Care in choosing and placing your shots can add up to a film that other people will find very entertaining.

SHOW THEM THE FACTS

If you choose an entertaining subject your job is much simpler. People can enjoy even quite a poor film about a very good subject. But try to put it over as well as you can. A thoroughly bad film would spoil the subject altogether. Imagine, for example, that in a chimpanzees' tea party one of the chimps is just about to pour cold tea on another's head. The camera stops in mid-shot and an audible gasp of annoyance goes up from the audience watching the film.

Such a mistake is unforgivable. You cannot *explain* how funny was the outcome, and add cheerfully that you ran out of film. When you make a film for other people to see, that sort of thing just doesn't happen. Or, if it does, you certainly don't show the

results. Better to keep an eye on how much film you've got; every camera has a device for that purpose.

Your job is to do a good bit of cine work showing just what is going on—the important things—clearly and plainly. Trick shots and dazzling camerawork can wait until you are really experienced. Don't be bent on showing the audience how clever you are: first record the facts. Some people go zooming around and miss the subject altogether; their results could not interest anyone.

CAMERA ANGLES

Camera angles should be chosen to show the subject in the best way. Imagine that the five chimpanzees in the above-mentioned party are sitting round a table, two on one side and one each on the other sides. Normally you would shoot facing the two because of course you get an extra chimp in the picture. However, the one in front of you, being nearer and therefore appearing larger in the picture, tends to blot out the two facing him. The others appear in side view. Also there may be people in the background.

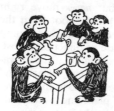

From the right angle you see all

If you move round slightly to the right, the chimp in front is in side view, so is the one on the right. The one opposite *him* is seen full face, which is what you want, and you can now see the other two also. Although there are people standing on the far side they are largely blotted out by the chimps' foreground left and right. You could have removed them from the picture by raising the camera and looking down on the whole ensemble. But from such a high angle the chimps' bodies appear disproportionate and you cannot see their faces so well, nor have you a good view of the action. Also there are disembodied feet in the background. From a level position you put your audience on a par with the chimps. They feel more involved with them.

You have now worked out the best camera angle to tell your audience about the subject. This will remain a good basic angle

for a general view unless one of the chimps gets up and scampers out of the picture. Your next shots may be close-ups of individual chimps' faces, the person in charge, hands grabbing things from the table and so on.

Such a scene presents very real problems to someone just making a straightforward film. Don't forget that on the spot you see many things that may not necessarily appear in the film. *You* can see that there are five chimps at a table but this is not apparent to the audience until you show them. Even if you show them a subject from the best viewpoint, you have not described the setting. You must imagine a camera as a one-eyed object that cannot compensate for a poor viewpoint by moving its head a little or seeing the scene in 3D as we can. Your subject on the screen is flat—it has no real depth. The audience can judge distance and the arrangement of things only by size and perspective. Moreover, a bystander may be able to see only a small part of the subject. He concentrates on this and mentally isolates it from its surroundings. A camera used from the same position won't do that because it isn't selective. You actually have to take a close-up of the subject to get the same impression across.

Change the camera angle frequently but *never* move right round a subject (that is, more than 180°) and shoot from the opposite direction. If you do, objects appear suddenly to jump to opposite sides of the screen and the sense of direction is lost.

All this is a matter of straightforward but thoughtful camerawork, selecting and showing as much as you can, clearly and without such frills as zooms or weird angles. These in the above-mentioned example would be quite out of place and would only serve to confuse everyone. Your purpose should be to *get on to the film the information that your audience needs.*

The path to clear filming is good camera technique. This problem of the chimps was assessed, then solved. Once you understand the method, such workings-out become second nature to you in any situation. You need basic technique first, then you can go on to explore unusual angles and special ways of shooting.

If your camera is simple to use, has few controls, and produces good results, you may wonder why other cameras can cost up to twenty times as much. What is the difference?

The expensive camera is more versatile. Properly used, it can do things beyond the scope of ordinary cameras. It is nearly always more robustly made and will probably last longer. It may be a precision-made instrument. Everything works smoothly to produce results of the highest quality. Nevertheless, it is more difficult to operate and needs more understanding before its advantages can be capitalised.

The inexpensive camera is designed to take good pictures under normal conditions. If yours is a simple camera you will be more certain of getting good results than if you had a complicated one, because there are no extra controls to confuse you. But the simple camera cannot cope with difficult or unusual situations.

You must know just what your camera can do and what it can't. Otherwise you will waste a lot of film.

Even if you are sure you know how to use the camera, read the instruction book. You may learn something you didn't know. Find out the normal limitations of the camera so that you can stay within them. Later on you may be able to experiment and overcome one or two of these limitations.

HOW THE SIMPLE CAMERA WORKS

Your camera, if a very simple one, is mainly designed to work under ordinary conditions, such as outdoors in good weather and with the average type of subject. It will do this without any bother. It may need a small adjustment or two to suit the situation in which you are working but these raise no problems.

Even some of the rather more expensive cameras make the work very easy by carrying out all adjustments themselves. They have an exposure meter built in which measures the light and

automatically adjusts to admit more or less light. With these automatic cameras you can get results under widely varying conditions. Although there are a few situations where they cannot cope, generally speaking you can rely on getting good quality pictures most of the time.

Only when you want special effects or you have to tackle difficult subjects do the drawbacks of the automatic camera become apparent. Many of them have no provision for anything other than straightforward automatic filming. Cameras giving a choice between automatic and manual control are usually quite expensive.

The simplest camera has a fixed-focus lens, which means that you do not have to make any adjustments for near or distant subjects. Instructions supplied with the camera tell you how close you can go before the subject becomes fuzzy, or out of focus.

You need an extra lens for close-ups.

Occasionally when you want to get very close you need an extra lens, known as a supplementary close-up lens (see page 86) to go over the front of the one in your camera. The firm that makes the camera can usually supply one.

The simple camera has only one filming speed, which is the rate at which the motor moves the film through the camera.

The little pictures give you movement.

Filming speed is normally measured in frames per second (fps). The frame is the little picture you get on the film, and you need a series of sixteen or eighteen of these for every second of filming

time in order to give the effect of movement. So most simple cameras have a speed of 16 or 18 fps.

More expensive cameras may have a whole range of filming speeds which can be used for special effects but the owner of the simple camera just has to do without those effects. The simple camera may, however, have a single-shot setting, which allows you to take one picture at each pressure of the button (see p. 35).

Many modern cameras are fitted with an electric motor to transport the film. Others have a clockwork one. The advantage of an electric motor is that it can run continuously until the batteries are exhausted. A clockwork motor has to be kept wound up all the time. Although there is not much to choose between the two in efficiency, the electric motor is more convenient in use.

Cameras are electric, or clockwork.

The special type of lens known as a zoom lens is now quite common on relatively inexpensive cameras. In many cases the word "zoom" is incorporated in the name of the camera, identifying those fitted with such a lens. A zoom lens enables the photographer to get different sized pictures of the subject without moving his position. A whole mass of interesting things can be done with the lens (see p. 84).

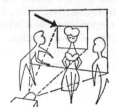

Zoom lenses make the subject big or small.

Other camera features are put there either to make the job of filming easier, or so that you can attach various gadgets which make the camera suitable for still more purposes. Some expensive cameras can be quite complicated and, as a beginner, you are

certainly better off owning a simple camera with, perhaps, only one or two of these special features. If at a later date you feel the need for more advanced equipment, you can move on gradually until your filming justifies the purchase of a really expensive camera. By this approach you only get equipment as advanced as you need. You will not be encumbered with an over-elaborate camera which is unnecessarily hard on your pocket.

Any cine camera will take pictures on a sunny day. You can hardly go wrong with the simple setting on very inexpensive models. Probably you only have to turn a ring to a symbol or engraving on the camera standing for sunny day photography. The camera may have several symbols representing various weather conditions or situations. Often each situation has a number which you just dial on a lens ring.

The aperture controls the light reaching the film.

Of course, the camera is not really concerned with the weather but with the *brightness* of the scene. Photographic film needs a certain amount of light in order to produce pictures. If the light is not at the right level you have to make up for this by regulating the camera accordingly. When you operate the control you are in fact letting more, or less, light in through the lens to the film. Depending upon which way you turn the control, the *aperture* (see p. 76) through which the light passes is made larger or smaller. On many cameras there are no more than four or five possible positions, or *stops* as they are called, to choose from.

WHAT IT WILL DO

Your camera can take most everyday subjects; rapid movement presents no difficulties, nor do any usual home or holiday activities at any time of the year or in any but really dull weather.

Moving subjects always make more interesting sequences than still ones. A simple camera can cope with virtually any moving

subject. Such popular subjects as people, children and animals are well within its capability—and in colour, too.

Cine cameras are designed also to make films indoors, though this nearly always involves the use of special lighting. Normal domestic indoor lamps are far too dim to take pictures by, but the bulbs may be replaced by inexpensive photographic flood-

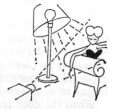

A photoflood bulb allows indoor filming.

lamps. The problems of indoor cine are mainly connected with illumination and not with the camera itself. Virtually any camera can be used indoors, with colour or black and white film.

As a rule you cannot film at night unless the subject is a very bright one such as festive illuminations, and you have a camera with the required controls. In story films you could get a night effect while shooting in the daytime (see p. 181)—as the professionals say, shooting "day for night".

SINGLE-FRAME SHOOTING

Many cameras are fitted with a single-frame device. This allows the film to be exposed one frame at a time just like a snapshot camera. Because the shutter speed is about twice as long as normal when shooting single frame you can sometimes take pictures of static subjects when the light is not bright enough for normal filming.

The single-frame device can also be used to make objects appear to move by themselves. You might need this for a scene where a door opens and closes with nobody apparently touching it, i.e. an invisible person walks through. To present this illusion, you set up the camera on a rock steady support, such as a tripod, and focus it on the door. Fit a cable release to the camera, if you have one.

Set the camera on the single-frame device and close the lens aperture down one stop from the normal reading, to compensate for the slower shutter speed. Alternatively, double the film speed setting on automatic cameras where there is no aperture control.

35

Close the door, then press the filming button (or cable release) about thirty times. Now you can open the door very slightly, say $\frac{1}{4}$ in. and give one exposure on the camera. Then move the door a further $\frac{1}{4}$ in. and give another single exposure, and so on until the door is fully open.

At each stage you must move the door by the same distance if you want it to open at a uniform speed. When you are experienced you will know how much to move the subject for the speed at which it will appear to move on the film. A door opening slowly could appear more sinister than one that opens quickly. Also when you really are used to it you may vary the speed by gradually increasing or decreasing the subject movement between each exposure. In our case this could look more realistic as a door begins to open slowly, speeds up and then slows to a halt.

When the door is fully open expose about 20 frames without moving the door to allow your "invisible man" to pass through. Then close the door by degrees again as in the opening sequence.

A subject which will remain fixed in any position without being held works much more successfully than one requiring props or sticky tape. A coin can be made to roll across a table, between obstacles and even up and down slopes, but it has to be secured for each shot with putty or Plasticine, which, of course, must not be visible.

Some subjects would clearly need very elaborate preparations: a telephone receiver would have to be carefully raised on threads that would not show on film, unless you can lay it on its side on a sheet of glass and shoot from above. But almost anything that does not need to be suspended in mid-air can easily be used for this trick.

Don't attempt to speed up the job of filming the parts of such sequences by running the camera on continuous filming and then changing to use single shot setting. The variation in shutter speed will give unequal exposures. Where the door remains open or closed, for instance, expose each of your 20 or so frames individually.

The camera must not be moved during any part of the filming or the whole effect will be ruined.

THE DISAPPEARING TRICK

This is a startling effect that you can do with any cine camera. A man is sitting in a chair; the next moment he has vanished into thin air.

Again the camera must be rigidly supported. Use a good solid tripod. Point the camera at the chair, with the man sitting in it, and film in the normal way. Now stop the camera and ask the man to get out of the chair and *out of sight of the camera*. Start the camera again and run on a few feet.

That is all there is to it! On the screen the man will just vanish. You can make him reappear in the same way. Stop the camera, ask him to sit in the chair again, and start the camera. You can make him appear and disappear at will.

Some cameras are likely to produce a "flash" frame at the point where they are restarted. This is an over-exposed frame which, when projected, appears as a white flash on the screen. It would spoil the disappearing trick unless removed in editing. However, it will not appear if you apply the single shot method, described above, to this trick. But in this case your subject would have to remain perfectly still while appearing in the picture.

With more elaborate cameras, you can do many more tricks (see p. 179).

HOLDING THE CAMERA

Now a few words about handling the camera.

You may think you are holding your camera quite steady as you film and yet be surprised how unsteady the picture is when the film is projected.

Ideally you would mount your camera on a tripod for every shot, but that is not practicable for most of the time; it limits camera movement, too.

Most cine shots are taken with the camera held in the hand. This is quite good enough if you hold it properly. The best way is to sit the camera in one hand and put the other over the top of the camera to steady it. The filming button may be operated from underneath by the index finger or in the case of some cameras where the button is on top, with the second finger of the steadying hand.

The design of cameras differs from one model to another, but the main idea is to gain support from both hands if possible while retaining sufficient freedom to operate the controls. Do not clutch the camera, let it rest in your hands. Keep both eyes open when you look through the viewfinder—you can see the subject better that way.

You may find that you can hold a camera better with a pistol grip attachment. This is a grip shaped like a pistol butt which

has a filming button in the trigger position. On some grips it is combined with a zoom control (p. 84) so that all operations can be carried out with one hand. Even with a pistol grip, however, you need to steady the top of the camera with the other hand. Some grips have a bush in the base. This is for a wrist strap, not a tripod. Don't use the pistol grip on a tripod unless you have to. It makes the whole assembly rather top heavy.

When filming, stand with your feet well apart and elbows tucked into your chest. If you expect to make some camera movement such as panning (see pp. 41 and 153) during a shot be sure that there is no obstruction.

Make use of any solid object for support. An obliging tree or gate post will do for the support of body or elbows. If possible rest the camera itself on the object. It may be held against some vertical surface such as the corner of a building or a telegraph pole. In sitting, crouching or lying positions the elbows are steadied while allowing some quite interesting camera angles.

However you choose to hold the camera, keep it upright unless you are seeking some special effect. If it leans to one side the horizon line will appear to slope. Cock-eyed horizons and leaning buildings cannot be corrected afterwards and they are always annoying to look at.

ASK QUESTIONS FIRST—SHOOT AFTERWARDS

Before setting out on a filming jaunt check that the camera is in fact loaded. See how much film there is left. You must know which type of film it is and you should always make a note of this when you load. Check the battery condition if the camera uses batteries. If in doubt, replace them. Always remove non-'alkaline' batteries when storing the camera, or if you suspect that they are exhausted. Battery leakage can cause a lot of damage.

With a clockwork-powered camera always rewind the motor fully after each shot.

Try to finish the colour film you are using rather than leave it in the camera for long periods as unexposed colour film gradually deteriorates with time. An expiry date is always marked on the carton and the film should be used before this date.

The image on an exposed film can deteriorate very rapidly. Always send the film for processing as soon as possible. Manufacturers recommend processing within two weeks for reliable results. After this period colour quality may suffer. Never store the camera loaded with film.

SHOOTING IN COLOUR

Until you actually see some film on the screen you may not think that the colour of the subject is particularly important but whenever you shoot in colour there are many points to watch.

As in all other aspects of film work, you are after variety. Landscape scenes often do not come out in as varied colours as you see in the original subject. On a fine day the picture might appear divided in two, a solid green mass in the lower half, solid blue in the top. Try to get some contrast of colour into individual shots as well as in the film as a whole. It won't be possible for all shots, true, but take every opportunity you can to liven up the scene.

It is often said that you should not include many colours in your shots although they may be in the scene. This is quite stupid. Do not be afraid of colour. If it is in abundance, shoot it; it is there to be enjoyed, and looks splendid on film. On the other

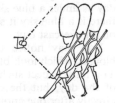

Take scenes with colour in them.

hand, variety should be the keynote of your film. If you have some scenes without much colour, the brilliantly-coloured scenes are more effective. You can certainly get tired of bright colours if they are on the screen all of the time.

If you want a particular person to stand out in a scene, dress him brightly like the principal character in a stage production. If little Tommy is supposed to be the centre of attention, let him wear his red jersey and he will be.

Tommy dressed in this way has another advantage. He can provide the sort of thread or visual link all the way through the film that helps to hold it together. The moment he turns up in any scene you know immediately who he is. Even a rather jumbled film is unified if he appears in it from time to time.

Although your colours may be bright you should not shoot clashing colours. If they clash when you look at them they will clash on the film. On the other hand some colours go so well together that it is fun to record them.

If you are fussy about colours and think you can remember them, you're in for a surprise. Colour film is much more fussy than you are. If you look at Tommy's red jersey at any time during the day it will always look the same to you. However, to the film it will look rather different. At the beginning and towards the end of day the light is actually redder, or warmer, than at midday. To the film, it is much more red, and so is the

Give the main character brighter clothes.

jersey. The jersey looks much the same to you on an overcast day as under a blue sky. But it doesn't to the colour film. When there is a blue sky it shows the red jersey as more purplish than on an overcast day.

You may notice this more with white things, shirts and blouses, which look bluish at midday and reddish in the evening. You must expect such things if you are shooting at these times of the day, but the chances are that unless the scenes follow directly after one another you won't notice the change. If it does bother you, you can use filters (p. 185) to correct the colour.

Some cameras filter indoor film for outdoor shooting.

The biggest change in colour is when you shoot indoors using artificial lights. Here the light is so red compared with outdoors that you would have to use a special filter in front of the lens to correct it if you were using outdoor film. In practice, this does not work very well and, for indoor shooting, you should always buy the proper film. This is called Type "A" film. Normally you use this in your camera without any filter, but you can use it

outdoors with the appropriate filter in front of the lens. In short, you can convert your artificial light film for shooting in daylight but not the other way round. Some cameras use Type "A" film only and have this special *colour correction filter* built into them. When you shoot outdoors the filter is always in place. When you fit a lamp on to the camera the filter is automatically removed to make the film suitable for indoor shooting.

SHOOTING MOVEMENT

You may meet your first real problem after it has happened. You were taking pictures at a cycle race and found a good place next to the track. You followed the cycles round with your camera, but somehow they always disappeared when they passed nearby. Although they were moving very fast so was your camera. Why didn't you manage to keep them in the viewfinder all the time?

Don't have a subject half out of the frame.

Following a moving subject by sweeping your camera round after it, is known as *panning* (short for panoraming). It takes a little practice, so before trying another film, or if you haven't yet tried one, practice panning the camera with some moving subjects. Hold the camera steadily in the shooting position and swing from the hips. A good hand-held pan looks almost mechanical. Avoid any jerkiness. The object is to make the camera movement so smooth that the audience will not notice it. They should not be conscious of the camera as such.

A fast motorway is a good place to gain experience of panning. Cars are going in both directions, at different speeds and distances. Don't put any film in the camera. Just point the camera at the cars and try to keep them in the frame as they pass. Try first without pressing the button. Then go on with some more trial runs, this time starting and stopping the button at the best places.

If you have a camera with adjustable filming speeds set it on the lowest one (e.g. 8 or 12 fps) when running it empty.

Any moving subject not held centrally in the picture area looks better with more space in front of it (i.e. the direction in which it is moving) than behind. You will get a far better appearance of movement by including some of the background which is rushing past. But if you are so close that you cannot even fit the whole subject in, the wheel of the car or legs of the horse would give the right impression. Unless you show some background, panning tends to minimise the effect of movement, a fact you may not notice while filming, but which is more apparent on the screen. This could take the excitement out of an event such as a car race.

Occasional close-ups add variety.

Don't eliminate close-ups altogether; occasional shots showing the expression on the driver's face, or the muscle movements of the horse add to the interest of the film, as they qualify the general shots.

At the beginning of your next film try a few practice pans to check and see if you have improved. You soon get the hang of it.

ADDING INTEREST

Empty-looking scenes are another common problem in film making and you usually notice them only when the film is projected. You cannot go back and correct the scene, so you can only watch that it doesn't happen again.

This is one of the things you have to carry in your mind's eye when you learn to take good pictures with your camera. Avoid scenes that look sparse in the viewfinder; try to find some significant foreground object, such as a tree, a house or a signpost, that will give scale to the view behind. The overhanging branches of a tree are useful for filling in some of the blank area of sky, particularly on a cloudless day. Clouds, too, can be attractive

and on exceptional days you may find them so good that you want to include as much sky as possible.

Try to find a point of interest in each picture, something that the picture can be about—even if it is not the theme of the film. A street scene might be improved by including a drinking fountain

Give scenes some foreground interest.

(or part of it) in the foreground. Don't take another shot with the same foreground or it may look as if the film is about drinking fountains. Visually, the fountain acts as a stepping stone for the eye to the scene beyond.

Clouds improve any scene with much sky.



TIME AND TIMING

In every film you are concerned with time. And in every film you can control time. A film is actually a number of bits of time added together—and you choose the most important bits to make the film.

If you film a motor race you don't film the whole event. That would be very expensive, and tedious to watch. You need only the more interesting parts—the start, the finish and some outstanding highlights. When the finished film is shown it takes a far shorter time on the screen than did the actual race. Monotonous parts are gone, leaving only the excitement. You have toyed about with time to your own advantage.

FILM LENGTH

The length of a film should suit the subject and the amount of interest it contains. Obviously, if you allow more time the subject can be treated more fully. But it is possible to exhaust the interest of a subject in a film.

Shoot only what is worth showing.

A film of a child painting should be short. You can entertain your audience with her expressions as she works. You can show what she is painting with a close-up of the work, her surroundings and the paraphernalia she is using. Perhaps you can move away from her altogether and return later when the painting is finished,

or nearly so. But that is about the limit—just a handful of shots. You can hardly make more from the subject than that.

A film of a country walk, on the other hand, could be much longer. The ever-changing scenery provides a constant supply of fresh material: leaving the car and walking down a leafy lane, a stream, waterfall, some birds, a squirrel who hasn't noticed you, your wife negotiating a stile, a friendly cow and ferocious bull, the view from the hilltop, the old church, weathered tombstones, and so on.

As a beginner you should concentrate on something short and sweet. A short film that makes a point clearly has more appeal than a long rambling story which explores every detail. It is easier to make a good short film than a good long one. The short film can leave its audience wanting more, while the long one might have them fidgeting in their seats.

Choose the subject for your short film carefully. Short films about complicated subjects are apt to be disjointed, abrupt, even meaningless.

One reel of film gives you four minutes running time. That is the *maximum* length of film you can make from one reel. But you will normally need to edit your film and you are quite likely to have to repeat a few shots. Allowing for wasted and unwanted shots and also the odd bits and pieces, you cannot expect more than two minutes of good quality film from that reel.

You would be well advised to make your first film on no more than two reels. There is so much you can learn by seeing the results before using up too much film. Make several short films like this to iron out your problems and then move on to something a little longer. Once you have got the "feel" of the camera and the film medium you could launch out with confidence into a much larger production.

If, as a novice, you were to embark on a lengthy project, even shooting it carefully reel by reel, your ability would be bound to improve before you got very far. You would become more and more aware of the shortcomings of earlier scenes. The result could be a very uneven film and it may mean that much of your best material is wasted because the early scenes let it down.

SHOT LENGTH

What should determine the length of each individual shot in a film?

Unfortunately, when we use the term "long shot" we are

normally talking about the way in which the subject appears on the screen, i.e. a shot taken at some distance and therefore covering a relatively large area. This is a confusing play on words in the cine vocabulary. But it is too well established in movie-making circles to be changed now.

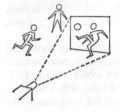

A long shot is taken at a distance.

The shot that lasts for a comparatively long time would better be called a lengthy shot or a shot of long duration. We sometimes say that such a shot is being "held" for a certain time. This refers to the length of time the shot is on the screen before changing to another. You can just as easily think of it as a long piece of cellulose acetate, the stuff that film is made of. The longer the strip of film, of course, the longer it appears on the screen.

Scenes in a film are not shot to any old length, although the length, or rather duration, of a shot depends upon how long you keep your finger on the camera button.

A long lengthy shot lasts a long time.

A beginner's mistake is often to keep his (or her) finger on the button for too long. It may seem ridiculous at first, but 6 seconds is quite long enough with many scenes, and sometimes a fair bit less will serve. A few scenes, particularly detailed ones, may need longer—perhaps 8 to 10 seconds.

As a general rule, scenes containing greater detail should be seen on the screen for a longer time; it stands to reason that the audience needs a longer time to take it all in. At the other extreme

46

a shot of a single object can usually be recognised immediately by the audience and so there is no need to dwell upon it.

A close-up of a telephone is a typical instance of this. It is so familiar an object that it would still be recognised if only flashed quickly on the screen. It is visible just long enough to register "telephone" in the mind. If you held a shot on this same phone for, say, twelve seconds, the thoughts of the audience would begin to wander—you are holding the phone but losing hold of the audience. You must keep them interested all through the film.

If you are not going to edit, the times we have mentioned are the actual times of each shot. On the other hand, a film can be tidied up considerably in editing, and it is usual to shoot a little more than you need so that later on you have the freedom to cut it in the best place. In this case you might cover a 6-second shot with an 8- or 9-second take, overlapping one or two seconds at each end.

Shoot longer than you need, to allow for cuts.

Remember, too, that you are only filming while your finger is on the button; watching the subject beforehand may make you think you have more on the film than there actually is.

YOU CONTROL THE PACE

Normally when we look at things, our eyes jump from subject to subject, although we are not aware of a mixed-up series of sights. The same happens in a film. But the difference is that the audience can only watch the screen; the rest of the room is in darkness. So the cameraman is in control of the rate at which everyone looking at the screen changes their view from one subject to the next.

In real life we look at a thing for only as long as we want to. When we have looked long enough we turn to something else. But when we watch a film we can't do that. We can look only at what we are shown. And the cameraman decides how long we

should look at it. He must keep his audience interested all the time and must not hang on to one scene for too long or they will find the film tedious.

If a shot is to appear on the screen for a long time, there must be a reason; something of interest, some point to make, or just that the scene needs a lot of taking in.

If the shot appears for too short a time no one has a chance to take it in; the audience don't really know what they've just seen and the shot cannot make its point. So they miss some of the story. You may have seen the film yourself many times before, but your audience have come fresh to it. It is easy to forget that, when you are editing. You can make the same mistake when shooting. Too short sequences cannot be any use, however interesting the subject.

MAKING THE DECISION

There are several ways to decide how long to shoot. The first, mentioned before, is where the subject dictates the time. In the second case you decide on a suitable time and fit the subject into it. You can often do that if you are building up the film from plans you have made beforehand.

Another way is to try the same shot a number of times, getting in just the part of the sequence you want. In a show-jumping scene, you might have several chances to film horse and rider going over the same ground. Always have a trial run before you

Simple subject, short shot, detailed subject lengthy shot.

shoot if you can. Rehearse the camera movement without actually running the camera but just counting the time and estimating roughly where to start and end. This makes it easier to shoot when everything is exactly as it should be.

The advantages of such rehearsals are overwhelming. The only snag is that with some subjects you lose the chance of anything spontaneous. The method is out of the question for most family films, especially with children.

Although you may know how long a shot should be, you can have difficulty putting it into practice. It is tricky at first to know how long you are actually holding the camera button when you shoot. This you learn by experience. Nevertheless, you can only get a rough sense of timing when using the camera. Absolute exactness is only possible by editing the film. Camera material always contains some dead wood.

PLAYING ABOUT WITH TIME

We have seen already that the film allows us to compress time so that a long event can be presented in a short film and yet still appear natural. We can stretch time, too, and even play the fool with it.

If a man comes in through a door in one shot and goes up the stairs in the next, then goes into a room, and in the final shot looks at himself in the mirror, you think you have seen the whole event. That is an illusion. If you had been looking at your watch at the same time, you would see that he got from the first door to the mirror in 15 seconds flat. It might take *you* some 30 seconds even if you were fairly nippy. But in the film he was certainly taking his time. The other 15 seconds or so seem to have vanished into thin air.

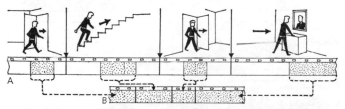

Short pieces selected from a long filmed sequence and joined together can quicken the action without losing any of the story.

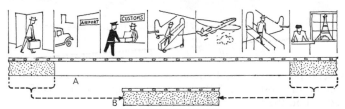

Some parts of the story are best told by shooting only a couple of explanatory scenes and avoiding all unnecessary details.

There is, of course, no need to show every moment of the man's journey just as there was no need to show every stage of the motor race at the beginning of this chapter. It would be a sheer waste of time and film to show him mounting every single step. Imagine the monotony if he had lived on the 16th floor and the lift was out of order!

You have to do this in any film where the story stretches over an appreciable time. If a character says: "I am going to Paris", you don't show him going through every phase of the journey— packing his bags, buying his ticket, travelling to the airport, sitting in the plane for half an hour or so, etc. Your next shot could actually show him in Paris, after perhaps a fade or dissolve (see page 179) or a shot of an aircraft in flight. The actual journey is immaterial unless anything happens during it that concerns the story. Several hours can be compressed into seconds and the audience will accept the result as perfectly natural.

Scenes can be chopped about to make the acting take longer than the actual event. A particularly thrilling moment might literally be only a moment in actual time. But you can stage it in

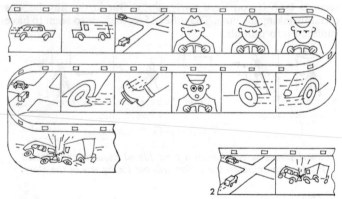

By filming various aspects (1) of an event the time taken for it to happen can be extended. This gives an effect of suspense missing in the event filmed in a straightforward way (2).

several takes that could stretch a few seconds action to half a minute or more. Carefully handled, it can still look perfectly natural on the screen.

Where, for example, a collision between two cars is obviously about to occur, you can stretch out the suspense by filming a

general shot of the two cars on a collision course, separate shots of each driver oblivious of what is ahead, further shots as they suddenly become aware of danger, feet pressing furiously on the brake pedal, hands twisting steering wheel, horrified expressions on onlookers' faces, and so on.

These are all filmed separately, of course. The point is that you can use all these different shots to heighten the suspense and prolong a sequence which, in real life, might have happened so quickly that the filmed version of it would be over before the audience even realised what was happening.

SHOTS YOU DON'T NEED

If you are going to cover a subject in a number of shots think before you shoot, especially if you don't want to be lavish with film. Try to find the heart of the matter each time and film that first; then you can add the trimmings and sidelights that give the main feature more meaning. If at that point you run short of stock you may still have a valid film—something you can use. The main parts come first and you add by stages until you think you have enough.

Perhaps, in an emergency, the main shot and only a couple of supporting ones would be sufficient. In this way you can handle a subject briefly, but without it looking as if you ran out of film.

This method teaches you to resist shooting at random, or overshooting. You will be surprised how your films get better and wastage goes down. Remember that a feeble shot or one that you don't really want costs you just as much as the best ones.

Repeating shots is a bad habit. Never take two shots unless there is a real necessity for doing so. If you weren't sure of your exposure or you forgot to do something, a repeat is, of course, warranted. If the new shot is a definite improvement with perhaps a figure in the foreground it is worth repeating. On rare occasions the subject is a difficult one and several "takes" are a sensible safety precaution.

Avoid superfluous details. Aim to include only what helps the story. You may find that many shots add nothing to the film except time. Take every opportunity of cutting them out. The extra details you *do* need will mostly be taken separately and can be used in a special way when putting the film together (p. 190).

On the odd occasion you can make something out of the details. In fact the details may be the point of the film. In a sequence such as giving the dog a shampoo, you don't want to

51

bore anyone by showing each stage of putting the things out in the garden and filling the tub with water. But you could make a humorous tale out of more significant details, for example:

Bath taken into garden, hose rigged up, tap turned on; dog washer walks back to end of hose; nothing comes out at first, then out comes water. Hose won't reach tub. Dog sleeping near tub oblivious of his fate; tub moved over to end of hose, tub filled with soap and water; now tub and hose won't reach dog; dog still asleep, tub lifted and carried to dog; splashes over,

Some subjects are suitable for short films, others for longer ones.
A child painting would be best covered by a few brief shots (1),
but a country walk (2) needs more detailed treatment, and should
include some lengthy shots.

soaking trousers; tub set down by dog; dog wakes; dog washer goes back to hose to get things, arranged by bowl; dog gets up and wanders few feet and settles again; dog washer advances, grabs him and drops him in water, perhaps he jumps wildly about, soaking shirt; dog escapes, he jumps out of tub tipping it up water drained out; dog careers off across lawn through neatly arranged objects for dog-washing operation.

Here the details are important because they add to the fun. But such a sequence would take some shooting and a pretty co-operative (or rebellious) hound.

52

CAMERAS AND EQUIPMENT

Up to this point, we have referred only to techniques within the range of a fairly simple camera. More advanced filming technique, discussed in later chapters, needs more refined equipment. At this stage then, we should make quite sure we know what a camera is all about, the way it does things and how cameras differ from one another.

BASIC CAMERA TYPES

The simplest of cine cameras has only the very basic requirements for taking pictures: a *lens* of good quality to form a sharp image on the film; an adjustable *diaphragm* with which you control the amount of light allowed to act on the film; a simple form of *shutter* which exposes the film frame by frame and will not develop a mechanical fault; a precision-made *gate* to hold

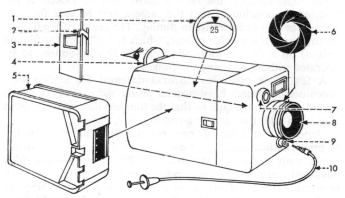

Features of a camera. (1) film counter; (2) claw that transports the film; (3) gate; (4) viewfinder eyepiece; (5) film cartridge; (6) diaphragm; (7) exposure meter cell; (8) lens; (9) filming button; (10) cable release.

the film in a flat plane while it runs through the camera; a reliable *transport mechanism* which will unspool the film from its reel, pass it through the gate at a constant speed and respool the exposed film properly; a *motor* to drive the film transport mechanism; a *viewfinder* through which you can view the subject clearly as you film; and a rigid *body* which is able to withstand a few bumps without falling apart.

These features carry out the basic functions of a camera. A few more are needed to operate them efficiently. The *film magazine* holds the film inside the camera while it is run through. The film may be loaded on a spool and the end threaded up through the gate and on to an empty spool, as with Double-run or Double-8 systems. Or the camera may be designed to take cassettes (or cartridges) loaded with films which need only to be dropped into the camera without any threading up, as with Super-8 or Single-8 systems. Super-8 and Single-8 were introduced to improve on, and eventually replace Double-8 altogether. Double-8 must therefore now be regarded as an obsolescent system.

Loading is usually through a hatch on one side of the camera, the door of which should lock securely so that no stray light enters the camera during filming. A *film counter* (or *footage counter*) tells you how much film has run through the camera and how much remains before the film must be changed for a fresh one.

On some cameras the *release button* can be locked in the 'pressed in' position so that the camera may be used for continuous as well as intermittent filming. The centre of the filming button may take a *cable release*, which is a plunger (or filming button) on a flexible lead, allowing the filming button to be operated without touching the camera.

A few more expensive cameras designed for filming with synchronised sound have special *sound pulse contacts* which record pulses on the tape so that the film and tape can be kept in step when later they are replayed together.

Opposite is a table of cameras roughly graded according to price and features. This is only a general guide to equipment. Some manufacturers may occasionally offer cameras with advanced features at a lower price than that quoted here. If so they are exceptional and may possibly have shortcomings in quality or lack certain other features, or simply benefit from special marketing arrangements. As with many other things, you get what you pay for.

Grade & Price	Lens	Features	Special Features
I £13–28	Medium aperture, e.g. f 1·9, symbol-settings, 2 or 3 stops	Electric or clockwork motor; straight-through viewfinder; usually exposure set from table (no meter); one filming speed	May take cartridges or an attachable cine light
II £23–30	Fixed focus (rarely zoom)	Automatic exposure control; reflex or bright line view-finder; pre-filming speed plus single frame setting	Continuous run and remote control; built-in A–D filter; under-exposure warning in viewfinder
III £30–40	Non-focusing zoom	Automatic exposure control but with optional manual override; 3 filming speeds plus single frame setting	Aperture setting visible in viewfinder
IV £40–50	Focusing zoom, powered by built-in electric motor	Built-in rangefinder; 4–5 filming speeds plus single frame, reverse running	Detachable power-zoom unit; battery condition indicator; under/over exposure check; automatic film load; built-in splicer
V £50–70	Longer zooming range (e.g. 4 : 1 ratio)	Fractional exposure control; end-of-film warning; 2-speed power zoom control	as IV
VI £70+	Extra range zoom (e.g. 6 : 1); sometimes per-mits very close focusing	Through the lens (TTL) exposure meter; 5 or 6 speeds and multi-speed reverse filming; frame and footage counter; sound coupling	Audible footage indicator; manual rewind; detachable 100-ft film magazine; wide range of accessories perhaps including sound pulse contacts

SUPER-8 LOADING

Your camera is designed from the outset to be loaded with film in a particular way. It cannot be loaded any other way. The two main systems in wide use today are Super-8 mm. and Double-8 mm. They differ in several respects, not only in the packing but in the film itself.

Super-8 mm. film is supplied already loaded in a light-proof plastic cartridge (sometimes called a magazine or cassette). This

cartridge is designed first and foremost for easy loading. You open the camera, drop in the cartridge, close the camera. Filming can begin the moment the cartridge is inserted.

After filming, the cartridge is returned to the processor without being opened. It is expendable and is broken up to get the film out. The processed film is returned on a spool ready for projection.

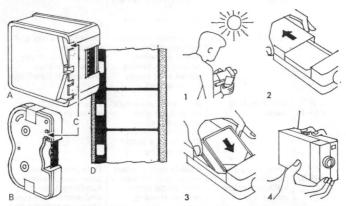

Super-8 film is supplied in a sealed daylight loading cartridge, (A), Single-8 special cassette (B). Coded keys (C) automatically set the meter for the correct film speed when the camera is loaded. The film (D) provides a large area for picture and perforations are small and widely spaced. Loading (1) is possible even in direct sunlight; (2) open the camera; (3) drop in the cartridge; (4) close the camera and you are ready to shoot.

The cartridge is designed to make certain settings in the camera automatically, to allow for the type and speed of film contained in it. Loading can be done in full daylight without risk of light leaks or spoiling the film. It will only fit in one direction and so cannot be wrongly loaded. The sole disadvantage with the system is that the film cannot be run in reverse, but only backwound, so certain tricks and effects (p. 185) cannot be carried out.

The film used is 8 mm. wide and coiled inside the cartridge in a continuous 50 ft. length. The whole film may be run through without removing or reversing the cartridge. The picture is larger than that on Double-8 mm. film and gives better image quality.

Single-8 is the name given to an alternative cartridge design which uses film very similar to Super-8. This may be used only in a camera specially designed to take it.

DOUBLE-8 LOADING

You buy Double-8 mm. film as a 25-ft. length 16 mm. wide, wound on a spool. The film is exposed first down one edge, then down the other. At the laboratory, after processing, the film is slit down the centre and the two halves are joined end to end to form one 50-ft. length. It is returned to you on a spool ready for projection. The film, however, is not, even in this form, similar to Super-8. Because the perforations are quite different, it may only be used on those projectors and viewers designed for it, or on machines designed for both formats.

Loading is not nearly as straightforward as with Super-8. To help you there is sometimes a loading diagram engraved inside the camera. This operation should be done methodically, step by step to ensure that nothing is forgotten. Load your camera as follows:

1 Open the magazine hatch, usually secured by a locking catch on one side.
2 Remove the take-up spool. Open the *gate* (see diag.). If it has a removable pressure pad, take that out also.
3 Dust out the inside with a sable brush taking care to go round the gate thoroughly. Be sure that the brush does not shed any hairs, which could spoil the film. Dust the other parts.
4 Replace the pressure pad, if removed. Open the gate.
5 Unwind about 18 in. of film from the spool. Now, holding the reel by the edges to prevent it from unwinding further, place it on the feed spindle.
6 Thread the film along the path indicated and through the gate. The emulsion, which is the non-glossy side of the film, must be facing the lens when in the gate. If it isn't, then the spool is upside down and must be taken o ut and turned over.
7 Close the gate, making sure the film is properly in place.
8 Take the other end of the film and thread it along the path round the appropriate rollers, etc.
9 Tuck the film end into the slot in the core of the empty take-up spool. Place the spool on its spindle, turning it to take up any slack film.
10 Press the filming button for a second or two to make certain that the film is running smoothly. Close the camera and lock it.
11 Make any settings for exposure, etc.
12 The film footage counter may be automatic or it may need setting. With either type, you must first run off a few feet of film as the end piece, or "leader", was exposed to the light when loading the camera.

If the camera has an *automatic counter* run the camera motor until the footage counter arrives at the "start" position usually

marked "S" or "0" or "50". If the counter is *non-automatic*, run the camera for 10 seconds. Set the footage counter on the start position. The camera is now ready for filming.

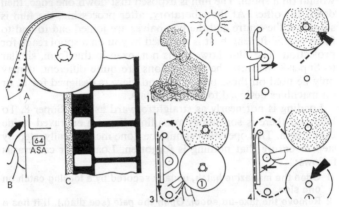

Double-8 film comes on a spool (A). It does not automatically set the film speed so you have to do this manually (B). The film itself has a small picture area and a large perforation (C). (1) Loading; it should not be done in strong direct light. (2) Insert the spool and pull off a few inches of film. Open the gate. (3) Thread the film through the gate, making a loop at either side, and on to the take up spool. (4) Insert the take up spool and close the gate.

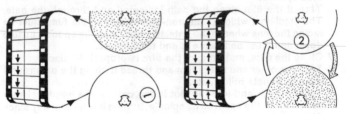

Double-8 film is exposed down one edge. The spools are then interchanged and turned over and the film exposed down the other edge.

Note: The correct position for reels can be confusing. Some cameras allow the reels to fit in one direction only. In a camera where the spools are placed one above the other the top one normally carries the feed spool and the bottom is the take-up. You can soon determine which is which by pressing the camera

button: the take-up spindle revolves. If the camera has been used correctly, the take-up spool always finishes back on the correct spindle when a film has been run through.

After 25 feet of filming, indicated on the counter, you must:

1 Run off the film completely. The counter will usually tell you when you have reached the end of the "trailer". It should be about 10 seconds, but if in doubt run it for longer.
2 Open the camera. All the film will now be on the take-up spool. Remove the empty spool. Open the gate.
3 Remove the full spool, turn it over and place it on the other spindle, pulling off about 18 in. of "leader" as you did before.
4 Thread the "leader" round any necessary posts and through the gate.
5 Close the gate. Check that it closes on the film properly.
6 Thread on to the empty spool and take up the slack.
7 Run for a second or two to check the transport.
8 Close and lock the camera.
9 Run off the "leader" until you reach the "start", "0" or "25" mark.

You are now ready to use the second 25 feet.

When the film is finished, run off the "trailer" as you did in (1). Put the film back into its tin and original packing and send it off for processing, labelling it *clearly*. To be sure that you do not accidentally use a film twice, you can wind the adhesive tape *across* the tin rather than *round* it.

BAG OR CASE?

Do you need a case for your camera? This rather depends on the case. The only function of a case is protection. Unfortunately, some cases protect the camera so well that they become inconvenient to use. A well-designed ever-ready case allows you to use all the controls easily and quickly. Nevertheless, most of them get in the way when you use a tripod.

Before you buy a case check that once the camera is installed you can still see properly through the viewfinder.

If you cannot find a case that suits you, you might be better off with a slip case or a zip bag. You need only one case, so decide on either a bag or a case—not both.

USING A TRIPOD

A tripod is the most useful support for a camera. The problem is to find one that is really rigid yet portable. Tripods are usually

made from steel, brass or alloy but choice of metal is not so important as how well the tripod is made.

Most tripods have multi-section, telescopic legs which collapse into a compact shape. The more joints you have in the legs, the less rigid the tripod will usually be, unless it is of very good quality. Joints are always suspect and although they may be rigid when demonstrated in the shop they could wear loose through constant use.

If you buy an inexpensive tripod make it a steel one. It may not be very compact or lightweight but it should be rigid and last a long time. Rigidity may depend on the size of your camera. Many lightweight tripods are not designed for cine use at all, although they might be suitable for very small cameras. A light-weight ultra-compact tripod is useless for the average cine camera.

To test a tripod, put the camera on top, wriggle it about and press it down. An unsatisfactory tripod will have whip in the legs and could even fold up under the weight of the camera! The feet of the tripod should have spike and rubber alternatives suitable for any surface from rough terrain to parquet floors.

You must have a *pan-and-tilt* head on the tripod for cine work. A ball and socket head is not designed for cine, and a tripod with one built-in is no good at all. The pan and tilt head goes on top of the tripod and the camera above that. It allows you to make the two main camera movements with great smoothness and accuracy. You can lock the movements separately. For a pan shot you would lock the tilt and vice versa. Occasionally you may want to use these movements simultaneously or lock them altogether for a static shot.

Any pan and tilt head may be an extra risk to rigidity so test it with the camera before buying.

Cameras with long heavy zoom lenses should be mounted with the lens directly over one of the legs for greater stability and for safety it should be returned to this position after use.

When setting up a tripod work out the best position by looking through the camera viewfinder, but take into account the fact that the tripod-mounted camera is usually rather lower than eye level. When you have decided on the best position pull out the tripod legs and lock them securely. Make sure the head is absolutely level, or it will seriously upset your pan and tilt movements. A tripod with a centre pillar can be lined up visually with the straight edge of some known upright nearby, such as the side of a building. Don't trust spirit levels on old equipment.

On uneven ground you may need to splay one leg more than

the others. Don't have the legs partly collapsed unless they are of the collar locking type which lock tightly at intermediate positions. On some tripods you can safely retract the leg by one section only but on others this tends to collapse the whole leg.

Lock all joints. Press the tripod down from the top and shake it to check that it will take the weight. Now attach the pan and tilt head. Mount the camera, lock the nut, lock pan and tilt. Now unlock the movement you require.

You can check for horizontal mounting by lining up on various vertical objects seen through the viewfinder as you pan the camera.

Any tilt will, of course, affect the pan, and the camera should be level when shooting tell-tale subjects such as buildings where the verticals will otherwise appear on a slant at the edge of the frame. Level horizons must always be level in the picture.

EXPOSURE METERS

Better cameras are fitted with an *exposure meter* which takes much of the guessing out of the correct exposure game. Alternatively, you may purchase an exposure meter separately to use with a camera that does not already have one built in. The separate meter has the advantage that it can be used independently of the camera, which is not an uncommon requirement in cine work.

An exposure meter has a light-sensitive cell which, when pointed at the subject reads off the amount of light reflected from that subject. This reading is shown on a dial on one side of the meter. The figure is then transferred to a calculator which tells you what aperture to use. Taking into account the speed of the film, you set the aperture on the camera. Some meters indicate the aperture directly, without a calculator.

Special cine meters are made, but you can use a meter designed for both cine and still photography. Two types of meter are available. The *selenium* type has a light-sensitive cell which generates a tiny electric current when light falls on to it. The current moves the indicator needle on the dial. This type of meter is very reliable and may require only occasional maintenance. The cell should last as long as the meter if treated properly.

The CdS (or cadmium sulphide) type of meter has to be powered by a battery because its light-sensitive part does not generate any current. It is more sensitive than the selenium type and can therefore take readings at lower light levels. It has other advantages. It is small, even with the battery, and so is more suitable

for building into a camera. It can be made to read the light over a small field, like that covered by the camera lens, whereas the selenium meter generally has a wider angle of acceptance. The advantage of this will be explained later (p. 99).

You can expect the mercury battery which powers the meter to last for at least a year before needing replacement. Good meters have a means of checking the condition of the battery to see if it should be changed. Not all batteries are the same and you must know the code number when buying a fresh one. This is generally given in the instruction book.

BUILT-IN METERS

Either type of meter may be built into a camera, though it is more usual to have a CdS meter nowadays. The meter may operate as an independent unit or it may be coupled to the lens aperture control for automatic exposure.

Where the meter is independent, exposure control is referred to as manual. This means that the meter advises you how to set the lens aperture. There are various ways in which this can be done and methods vary from one camera to another, but the general principle is much the same as when using a separate meter. The built-in, uncoupled meter is usually found on older cameras.

A more refined method is that offering *semi-automatic* exposure control. The built-in meter still actuates a needle or pointer, which is often visible in the viewfinder, but the aperture control is coupled to another needle which you line up with the meter needle to set the correct aperture. Alternatively, you bring a single pointer into line with a fixed mark. You can hold the camera to your eye all the time and simply keep the needle or needles in the proper position. You do not need to consult the *f*-numbers engraved on the aperture ring, but the meter reading may also be visible in a window on the outside of the camera.

More advanced still, though not necessarily more efficient, is the *fully automatic* exposure control method whereby the meter is made to operate the diaphragm itself. You simply point the camera at the subject and the aperture is automatically set to suit the prevailing conditions.

Some cameras of this type give no indication of the aperture actually used but others show the *f*-number in the viewfinder. This is useful if you are concerned about the depth of field.

Fully automatic control has a particular advantage in pan shots where one part of the subject may require more exposure than another. Automatic exposure control makes a gradual adjustment of exposure as you pan. This is very difficult to achieve manually.

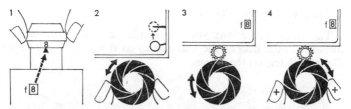

Exposure meters. (1) With uncoupled meters you have to set the indicated f number on the diaphragm control ring. (2) With a semi-automatic system you turn the diaphragm ring until two indicators visible in the viewfinder coincide. (3) With fully automatic the meter sets the diaphragm and may indicate the stop being used in the viewfinder. (4) Fully auto with manual override does the same but also allows you to control the diaphragm yourself when you need, working rather like (2).

The fully automatic camera does, however, have some limitations, so many are fitted with manual (or "manual override") controls. By disconnecting the meter from the aperture control, a reading may be obtained from the meter, but a different setting given to the diaphragm to compensate for some peculiarity of the subject, or when using filters, or even for deliberate over-exposure. A "backlight" control on some models slightly re-adjusts the indicated exposure to correct for special cases (p. 100). Optional exposure systems fitted to modern cameras offer the advantage of automation while allowing the flexibility and finer adjustments for which direct manual control is necessary.

THROUGH-THE-LENS METERS

Very advanced cameras are sometimes fitted with a through-the-lens exposure meter. This has a tiny light-sensitive cell positioned behind the lens. It does not interfere with the normal running of the camera and it gives a continuous reading while filming. The system is more accurate than other kinds of meter since the cell can only "see" that part of the scene which will actually go on to the film. Other meters take a far more general

view and are therefore subject to outside influences such as a bright object immediately outside the picture area or a strong oblique light striking the front of the camera. The through-the-lens is always the CdS type, using batteries which have to be replaced periodically.

OPTICAL VIEWFINDERS

The viewfinder allows you to see the amount of the scene included in the field of the lens exactly as it will appear on the film and, later, on the screen.

Frame viewfinders are found on some older cameras. You look through the small frame and the larger one denotes the field covered by the lens. The rear opening is adjustable for subjects between infinity (A) and nearer to the camera (B) when the effect of parallax comes into play.

On nearly all present-day cameras the viewfinder is contained within the body. Some older cameras have a "frame" finder in the form of two folding frames, usually metal or Perspex, mounted along the top or one side of the camera body. The optical type finder enclosed in the body is better and quicker to use.

Looking through the viewfinder you see a bright image of the subject in a rectangular field. Sometimes a small cross marks the

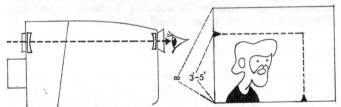

Optical viewfinders are built into the top of the camera. They show a reduced image of the subject. Two small marks indicate the framing for close range work where the effect of parallax is most apparent.

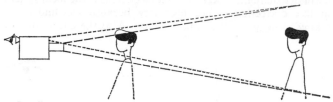

Parallax error arises because of the different positions of viewfinder and taking lens. This difference is not noticeable when shooting at normal or long ranges. But when the subject is very close to the camera the viewfinder covers a slightly different area from that of the taking lens. If the effect of parallax is ignored the subject will not appear correctly framed on the film and part of it may even be out of the picture altogether.

centre. Two other small marks, one at either side, indicate the framing for close-range work. This is necessary on cameras where the viewfinder is in a different position from the lens. In normal work this difference does not matter, but at close range the displacement becomes more marked and both viewfinder and lens see slightly different areas.

In order to frame the subject correctly when filming at close range the marks in the viewfinder must be treated as two sides of a second frame which is now in the true position. The second frame is the same size as the first, and you must imagine the other two sides of it continuing outside the field of view.

This slight shift off centre for nearby subjects is known as *parallax error*. It is common to all cameras with separate viewfinders, and you soon grow accustomed to it when you are filming closer than about 5 ft.

When you use a converter lens (see page 81) the field of view changes and the viewfinder may be marked with another rectangle to show the new field covered. Some cameras have an optical or mask attachment which slips over the front of the viewfinder to correct the field of view. Remember to remove the mask after use.

REFLEX VIEWFINDERS

A reflex viewfinder enables you to view the scene through the lens which forms the image on the film. All modern zoom cameras use this type of finder.

By a clever arrangement of mirror and prism, the lens and

viewfinder share the image of the subject. This is the ideal system. Parallax correction is not necessary because viewfinder and "taking" lens are in the same position. Also the effects of con-

Reflex viewfinders, by means of a tiny mirror in the light path, provide a view of the subject through the actual taking lens. So image size, focus, and framing are seen exactly as on the film.

verter or close-up lenses fitted to the camera can actually be seen because you are looking through them.

Visual focusing is possible through many reflex finders. As you turn the focusing ring you see the subject move in or out of focus. The relative sharpness of subject and background can be seen as it would appear on the film if the lens were at full aperture— i.e. with the minimum depth of field (p. 79).

Many reflex cameras have a rangefinder to help you focus the lens more accurately. This may be a *split-image* type set centrally in the field of view, where the subject appears as two displaced images of different parts of the subject broken by a vertical or horizontal line in a circular area. By rotating the focusing ring you shift one of them until the two images line up.

Rangefinders are a means of making focusing easier. In a coincident image finder (A) a small central area shows a second image of the subject. By turning the focus ring these images can be made to coincide, thus indicating correct focus distance. A split-image finder (B), where the subject is seen divided in the central area, is used the same way.

A *coincident image* finder presents two images of the same part of the subject which merge into one when the lens is focused.

Variations are ground glass screens where the image is focused until it appears sharp, and microprism screens where a shimmering fragmented image becomes still only when sharply focused.

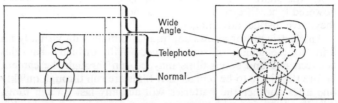

The effect of changing the focal length of the lens is clearly visible in a reflex viewfinder. The image is magnified or reduced in just the same way that it changes on the film. Wide angle, telephoto, and normal settings are often indicated on zoom lenses.

ALSO IN THE VIEWFINDER

Camera viewfinders often contain other indicators, dials and signals. The most usual is one to show that the film is running normally or has run out. On some models exposure meter warning signals appear when the scene is too dark or too bright for filming. Aperture scales are visible in the viewfinder of

Some cameras show a red indicator (1) in the viewfinder when you have run out of film. Another indicator shows when the scene is too dark (2) or too light (3) to film. A test indicator (B) shows the condition of the batteries.

some automatic cameras. In others there are needles for the "follow-pointer" method of exposure control. All these are intended as reminders, the idea being that as you are always looking through the viewfinder when filming you will always be aware of the message they convey. In fact, you have to remember

to watch out for them. If you are intent on the scene presented, these indicators often become "invisible".

THE MOTOR

Every cine camera has a small motor to transport the film and work the shutter. It is either a spring (clockwork) or battery powered type. Electric motors are almost always used today, as they have distinct advantages.

An electric motor allows continuous filming with virtually no limit to the length of scene filmed. With ordinary batteries between five and seven films may be run through the camera before they have to be replaced. If films are run through quickly one after another the batteries will actually last for ten films. Alkaline batteries, which are more expensive, have a longer life and do not deteriorate or leak if stored for a long time. They will provide power for between twelve and twenty films (or more) according to the individual camera, and of course, demands made on them by other powered features such as zoom lens and exposure meter.

Batteries are contained within the camera body in their own compartment, sometimes in a magazine-type container. Always check your batteries before filming and, if in doubt, put in a fresh set. They are far cheaper than wasted film!

Electric power maintains an even speed at all times with no vibration. The motor takes up little room and some of these electric cameras are very compact. A battery checker is sometimes fitted to indicate the condition of the cells at any time.

Clockwork motors may run up to thirty seconds before an automatic brake operates. It is claimed that they give a constant speed throughout this run, but in fact they never do.

It is advisable to rewind after every take to keep the speed as even as possible. As your average shots are normally less than ten seconds long the method works well. On some older cameras the spring may "jump" every so often. If so, it is in need of overhaul.

FILMING SPEEDS

The "normal" filming speed is the speed at which both camera and projector operate for all general filming. There are two "normal" speeds in current use and all cine equipment has been standardised accordingly. These are 16 frames per second and 18 frames per second. As far as the ordinary user is concerned these

speeds have the same effect. You run films taken at 16 fps on a projector designed to project at this speed, and similarly for those taken at 18 fps. In practice, the difference between these speeds is so small that you are unlikely to notice if a film taken at 18 fps, for instance, is projected at the lower speed. Hence the standard speed, whether 16 or 18 fps, need not worry you.

The 18 fps speed was introduced for reasons concerned with sound films. Most Double-8 cameras run at 16 fps for normal filming, while all Super-8 and Single-8 cameras use a standard speed of 18 fps. A simple camera will have just the one speed. Some more advanced and more expensive models have one or more additional filming speeds. The maximum is seven.

Certain cameras provide a 24 fps filming speed, which allows marginally better quality of sound than 18 fps if this is to be added to the film later. Some people feel that the higher filming speed also gives a better quality screen image with less noticcable flicker when projected. This may be true on some equipment, but the higher filming speed uses up much more film, and becomes rather expensive in the long run. Film shot at 24 fps is, of course, projected at that speed.

If you shoot a film at one speed and project it at another, the action appears either speeded up or slowed down. The difference between these speeds makes the film look odd, yet it is not enough of a change to give either a humorous speeded-up effect or a slow-motion sequence.

Other camera speeds are provided for these effects. A camera may have several of the filming speeds in the following series: 8, 12, 16 or 18, 24, 32, 48, 64 frames per second. The 12 and 8 fps speeds are for speeded up films. A film shot at 8 fps and projected at 16 fps shows the subject moving at twice the normal speed. A film shot at 12 fps has the same effect when projected at 24 fps but if projected at 16 fps the effect is less extreme, being only $1\frac{1}{2}$ times faster than normal. A film shot at a speed of 8 fps and projected at 24 gives an effect of movement three times faster than in real life!

Filming speeds of 32, 48 and 64 fps do the reverse. When projected at normal speed the subject appears in slow motion. Again the degree of effect depends upon whether the projector is running at 16 or 24 fps. A film shot at 32 fps and projected at 24 fps shows only very slight slowing up of the subject (which can be useful pictorially and with certain exposure problems). Projected at 16 fps it would appear half as fast as in real life. At this projection speed a film shot at 64 fps would give you a

true slow-motion effect, being only one quarter the speed of the real life subject. At this high speed the film is used up at a tremendous rate, so it is only used for very short sequences. An event taking not more than a few seconds, such as in athletics, is a typical subject for filming at this speed. The slowed-up movement in a pole vault is particularly interesting to watch, and may be used for analysing an athlete's good or bad points.

To sum up then, the slower filming speeds are for fast action and the faster speeds are for slow motion. Easy to remember, because it's the exact reverse of what you would expect!

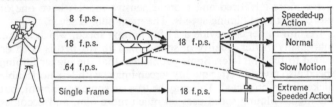

Filming speeds and their effect: on the left are camera filming speeds for those cameras which allow a choice. On the right is the effect that each filming speed has when projected at the standard 18 f.p.s. rate.

Whereas with normal speeds you can begin the shot the moment you press the camera button, at higher filming speeds the motor takes a second or two to reach full speed, particularly at the 64 fps setting. You should allow some build-up time at the beginning of each shot. At the end of the shot let go of the button decisively. The "chatter" of a filming button squeezed half-heartedly could do damage at high speed.

Many cameras, even simple ones, have a single frame setting. You press the button and it works like a snapshot camera, exposing just one frame on the film. You may expose repeatedly one frame at a time. At this setting, however, the motor has to overcome inertia for every frame and the effect is to more or less double the exposure. So the single-frame setting can, in fact, be used for filming a static subject where the light is not bright enough for normal filming. It is also useful for trick effects where an object moves of its own accord (see p. 35).

REVERSE ACTION

More sophisticated cameras may have a reverse filming control. This can take two forms. Either the film is manually wound back

to its previous point by a separate crank handle, or the motor actually powers the film in reverse at a constant speed.

The first method cannot be used for reverse-action filming. It is intended for dissolves and ghost or superimposing effects where a second image is required on the same piece of film (see page 179). Nevertheless, the shutter does operate on manual rewinding and the lens must be covered to protect the film.

A camera which runs in reverse under power may be used in the same way but it can also be used to film a reverse action sequence (p. 15). The camera is run forward with the lens covered for the required number of frames and then put in reverse. Filming in the normal way then puts the action in reverse on the film.

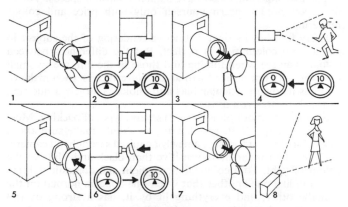

How to shoot reverse action: (1) cap the lens; (2) run on the required footage; (3) uncap the lens; (4) switch to reverse and film the subject; (5) cap the lens; (6) switch to forward and run the same footage; (7) uncap the lens; (8) resume normal filming.

Most cameras that run in reverse do so at only one speed, but a few offer a choice of up to three reverse filming speeds.

In older cameras, reverse running used to be a frequent cause of film jamming, but later, improved design eliminated this.

Super-8 cartridge-loading cameras cannot be reverse run under power though some models allow sufficient backwind to achieve dissolves between scenes (p. 179). The Single-8 design, on the other hand, has the special advantage of allowing powered reverse running.

THE COLOUR FILMS YOU CAN USE

Various makes of colour film are available in both Super-8 and Standard-8 formats. As well as slight fluctuations in price between makes, there are differences in colour balance, speed, colour rendition and general quality. Let's take a look at the various colour films and see how we can make a quick decision.

If you use Single-8, the decision is made for you. Only one make of film is available.

If you use Super-8 there are only two or three films to choose from. They work in conjunction with an automatic filter built into your camera and are therefore suited to indoor and outdoor filming. You need not worry about colour balance.

The available films also have similar emulsion speeds. Therefore, you need concern yourself only with price and colour rendering.

Every film has its own distinctive rendering of the subject in colour. No colour film is perfect. But the differences between colours you see when filming and those in the film are so small that you may not notice them at all. Nevertheless, each make of film has its own particular bias and choice is largely a question of which pleases you most.

Standard-8 colour films come in several types of packing. Most cameras use the 25-ft. spool, but you should make sure about this before buying for, say, a newly acquired secondhand camera.

Colour film is far more sensitive than black-and-white to the colour of light. To a colour film, daylight and domestic lighting are so unlike one another that when one appears normal on the film the other, and everything lit by it, has a strong overall colour cast. As we have seen (p. 40) some films are made in two forms—one for daylight and the other for artificial light. The advantage with artificial light film is that, with a filter (A-D) it can also be converted for use in daylight. You can shoot subjects indoors and outdoors on the same roll of film and get a good rendering for either. But the A-D conversion filter, in effect, reduces the speed of the film so you have to make some allowance for this when taking exposure readings and using automatic cameras, unless the camera automatically compensates for this change.

A colour film made to render all colours correctly when lit by either one source or another is said to be "balanced" for that particular light source. You cannot shoot a scene lit both by daylight and artificial light. If the light sources were mingled there

would be an unnatural colour cast over the whole scene. If the sources were separate, as in a room lit by photoflood and window light one or other area would appear bathed in a strong coloured light—either red or blue. The effect is most unpleasant.

For indoor work with Type A (artificial light) film, you can use photofloods, a cine light, or studio lamps. Ordinary tungsten domestic lighting is far too warm toned to use with any colour film.

The artificial light version of a film is usually faster than the daylight type. This is helpful because in most indoor scenes you have far less light available. The A-D filter brings the speed down to the same figure as the daylight film. So there is nothing to be gained that way, only the convenience of a double-purpose film, or the inconvenience of using a filter. The colours should appear the same in the daylight film and the artificial light film with a filter. Some people think they get better results using one rather than the other, but the difference is minute.

Most colour films have the same emulsion speed, 40 ASA in artificial light, 25 ASA in daylight. This gives a good quality image and is fast enough for general use. There is, however, a 100 ASA emulsion available. The prices of nearly all colour film includes the charge for processing.

BLACK-AND-WHITE FILMS

Black-and-white film has a charm all of its own. It is also easier to use and is made in a greater variety of emulsion speeds. It is less expensive than colour film and prices include processing except in one or two cases where you can do your own processing at home. This is useful if you want to do experiments and see the results quickly. But most people are content to leave the processing, which is rather tricky, to an experienced laboratory.

Modern black-and-white films are sensitive to all colours and give a fine range of tones. The very slow emulsions offer superb quality and there are several high-speed films for use where colour filming would be impossible. Slight inaccuracies in exposure are not so noticeable in black-and-white film; only the tone varies. The main disadvantage of faster films, however, is that they show an increased grain in the projected image which may obscure fine detail. For general use, choose a fine grain film of, say, 25 ASA and keep the faster films for indoor scenes where there is not much light available.

You can splice together scenes in black and white shot on

different films with little danger of the change in grain quality between one shot and the next becoming too obvious, especially in dark scenes. Always use the same *make* of film, however, as some have a warmer toned image than others.

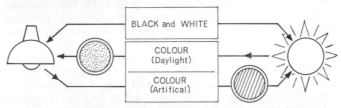

The correct light source for the film: black-and-white film may be used without a filter in daylight, or artificial light where it is a little slower. Daylight colour film needs a strong filter for indoor use and the drastic reduction in film speed makes it very difficult to use. But when indoor film is filtered for use outdoors there is only a small drop in speed.

With black and white you can freely mix light sources of different kinds, so a scene where daylight and artificial light are seen together poses no problem. There is, of course, no filtering to be done when filming by different lighting, although black and white film loses a little speed when used with tungsten illumination. You can compensate for this by resetting your meter; if the exposure change is very great the two speeds are printed on the film carton.

Whichever film you choose, colour or black and white, use one make only. If you decide later to edit and splice together scenes from different films the result will look very odd if more than one kind of colour film is involved. By using the same black and white film all the time you are far less likely to make errors in exposure, or forget to set the correct speed. It is better to get to know one film and what you can do with it than chop and change between a number of unknowns.

COLOUR OR BLACK AND WHITE?

Having considered the types of film stock available, you must now decide which is better for your film.

You will probably want to choose colour for your first film. It is more exciting than black and white and costs not very much more. It is particularly suitable for general interest films and those featuring nature in any shape or form.

Always shoot holiday or family films in colour, as well as weddings and any special occasions. Colour contributes a major part of the interest of these subjects in film form. You are especially conscious of colour in them; people expect to see it and are disappointed if they don't. Buy all your material in one batch for any one film and work with that only.

Other subjects need not comply with the colour rule. But why use black and white when colour is available? The fact is, black and white film has a rather special stark dramatic impact. You cannot get this particular quality with colour film. Hence many big film studios still use it for a few major productions. It is ideal for mystery, thriller or other dramatic story films. It complements the serious mood, essential to success in these fields. It suits action and sport films, too. They look more "graphic" and have the immediacy of a newsfilm.

Some instructional, how-to-do-it and industrial or work films are also suited to black and white, and this may save you some technical headaches, particularly with lighting and film speed. Similar considerations apply to trick filming.

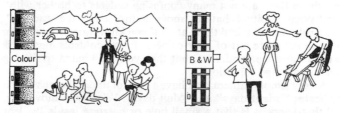

Choose a suitable film for your subject. For holidays, family, weddings, special occasions, and travel colour is best. Black and white is suitable for drama, how-to-do-it films, and is often easier to work with when doing tricks and special effects.

All these subjects may be quite adequately filmed in colour, of course, but the greater choice of film speeds and freedom from any colour correction makes black and white far more flexible and very interesting to use. In some places such as large ill-lit interiors only the faster black-and-white film will give you an image at all. At the other end of the scale the very slow-speed film is ideal for titling, giving you a pin-sharp image of the lettering with almost no visible grain.

Don't forget also that a black-and-white film can add variety to the film show in which colour predominates, even if it is only the first film shown.

Three things concern you when thinking about lenses: the *focus*, the *aperture* and the *focal length*. These things work together to give you the result you want.

However, on a simple camera you are often only concerned with the *aperture*. You have no control over the other two because the lens may not require focusing and the focal length (see p. 80) is unalterable.

It may seem a good thing to have few controls to cope with. Up to a point it is. It depends how you look at it: "Thank goodness there are not many confusing gadgets to bother with" or "What a pity I haven't more control over the camera". Controls are not a bad thing at all if you know how to use them, and so get more out of your camera. Fewer controls mean it is safer in average conditions, but then you are limited to filming only in average conditions.

A very simple camera may have a control under the lens which indicates "bright days" and "dull days". When you move this, all that happens is that a small hole or *aperture* inside the lens becomes larger or smaller, thus allowing more or less light to pass through the lens to the film. On a dull day you need more light, so the setting for dull days is the larger aperture.

Some lenses have adjustments for various intermediate conditions, which are set according to the weather, time of day and lightness in colour of the subject, which all affect the exposure given to the film by the lens aperture. A camera might have four settings. Sunshine (clear sky); hazy bright; cloudy (no sun); dull weather. For these there will be four different apertures in the lens ranging from very small to wide (full open) or in other words, *maximum aperture*.

For greater convenience different apertures are given numbers called *f-stops* instead of descriptions for weather conditions, subject, etc. These *f-stops* are used universally. The figure f 8 means just the same thing on all cameras, and if it is the correct

setting for one it is for the others also, provided a similar film is being used.

The *f*-stop (also called *f*-number) is not just an arbitrary figure, it bears a special relationship to the lens. We are not concerned here with how that is arrived at, but the usual sequence of numbers is 1, 1·4, 2, 2·8, 4, 5·6, 8, 11, 16 and 22. The smaller the

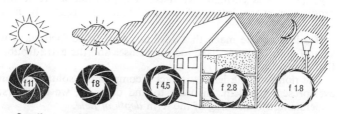

Small or medium apertures are most frequently used on bright days and with light-toned subjects. Wider apertures are normally required for dull days and indoor filming. Full aperture may be needed in poor light or when filming still subjects with the single frame device in circumstances where you cannot get a result any other way.

number the wider the aperture. A lens whose maximum aperture is say, *f* 2 lets in more light than a lens that will not open to more than *f* 4. In fact, it lets in four times as much light, because each smaller *f*-number represents a doubling in the light transmission of the lens.

A wide-aperture lens lets you take pictures in darker conditions, so most cine camera lenses have as wide an aperture as possible. However, very large aperture lenses are costly to make and have certain technical limitations in use. Manufacturers have found a compromise and mostly agree that for normal equipment a maximum aperture of about *f* 1·8 is the ideal and the lens fitted to your camera is probably this size.

You will notice that *f* 1·8 does not appear in the series given above. It falls between two recognised figures of *f* 1·4 and *f* 2. This need not worry us, because the difference between *f* 1·8 and these figures is very small indeed, and if we used the full aperture setting instead of either *f* 1·4 or *f* 2 the difference would be scarcely noticeable.

Although the *f*-number of the maximum aperture may be non-standard, the rest are always in the standard series: *f* 2, *f* 2·8, *f* 4, etc. The *f* 2 may sometimes be omitted where the maximum

aperture is f 1·8 or f 1·9. The f 22 setting is often omitted, too, f 16 being the smallest stop.

FOCUS

The simplest type of camera has a *fixed-focus* lens. That is to say, the lens is permanently fixed in a position where it will produce a sharp image of both distant and relatively near subjects.

If a lens can be made that does not need to be focused, why should other cameras have focusing lenses and the extra trouble that goes with them?

The non-focusing lens is in fact a compromise solution to an ever-present problem. In order to find out why, we must first understand the meaning of the term *depth of field.*

If you focus a lens on a subject and the subject then moves towards you, the image produced by the lens gradually becomes less sharp, until it reaches a point where it appears out of focus. If the subject moves away from you it again becomes less sharp until it is out of focus. The distance behind and in front of the point you focused on where the subject still appears acceptably sharp is the depth of field. Depth of field is always greater behind the point of focus than in front of it. Both points vary with the aperture you are using and with the focal length (see p. 80) of the lens. Other things being equal, the lens of shorter focal length gives greater depth of field. Depth of field also varies with the distance on which the lens is focused. At greater focused distances, depth of field is greater. The fixed-focus lens makes use of this fact as follows.

Subjects in the far distance are generally regarded as at *infinity*, denoted by the sign ∞. This sign is engraved on the lens of a focusing camera and is as far as the lens will revolve. Now, if you focus on an infinity subject and then gradually turn the lens back, the infinity subject remains sharp as the nearer objects come into focus.

At a certain focusing range the depth of field extends behind the subject just far enough to allow the most distant part of the scene to appear sharp. At the same time, the depth of field forward of that point allows objects which are quite nearby also to appear sharp. This is the focus setting at which the depth of field has been "spread" over the greatest range possible. Anything between "infinity" and a few feet from the lens appears tolerably sharp; anything closer does not.

78

A camera with a fixed-focus lens is permanently focused on this intermediate distance. It can therefore be used on any subject within this range, but not outside it. No adjustments are ever required. So much for the advantages.

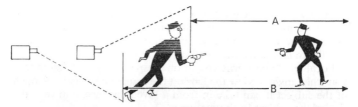

A fixed-focus lens gives a limited depth of sharpness, which may become noticeable when including a very nearby subject in the shot (A). Move back from the subject and this depth is greatly increased (B).

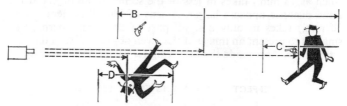

Depth of field extends further behind the focus point than in front. Focusing nearby gives you least depth (D). Focusing at a distant point gives greater depth but may not cover nearby subjects (C). By focusing a little forward of the middle distance you can manoeuvre the available depth to cover both subjects making them as sharp as possible if you wish (B).

While simplicity of operation is the keynote of a fixed-focus camera, the more critical you become of results the less satisfactory this will seem. As we said before, it is a compromise solution. Although the range of sharpness extends from infinity to a nearby point, sharpness is in fact gradually deteriorating the nearer to these extremes the subject is. Focus does not suddenly fall off at these points; it is a gradual lessening of sharpness towards either end of the depth of field. This may be good enough for some people, but others demand the sort of quality that can only be obtained with a focusing camera. Such a camera allows you to keep the subject always in the sharpest zone of focus.

Later we will discuss the way in which a focusing lens may be used as a fixed focus one and the advantages of "zone" focusing.

FOCAL LENGTH

The lens on your camera may be described with a measurement such as 13 mm. or 12·5 mm. This is the *focal length*. It is normally expressed in the metric scale though occasionally in inches and this figure is usually engraved on the lens mount.

Focal length concerns you in one respect only. The figure tells you what angle of view the lens on the camera has, i.e. how much of the subject it can take in from a given distance, and thus the size of the subject in the picture.

A lens with a short focal length (such as 8 mm.) takes in a great part of the scene and so an object at a given distance appears relatively small in the picture area. A lens of medium focal length (such as 13 mm.) takes in less of the scene but an object at the same distance appears larger. A lens of long focal length (say 30 mm.) takes in only a small part of the scene—perhaps so small as to present an image of the given object as if seen through a telescope. As a guide the following terms are normally used.

EFFECT OF CHANGING FOCAL LENGTH

Terms used	Focal length	In mm.	Subject appears
Wide angle	Short	From 6 mm.–11 mm.	Small
Normal or Standard	Medium	From 11 mm.–22mm.	Medium
Tele, Telephoto, Long focus	Long	From 22mm.–45 mm. +	Large

Note: zoom cameras are of variable focal length but such special lenses are dealt with on page 82.

A simple camera is usually fitted with a lens of normal focal length (e.g. 13 mm.). Fixed focus lenses may be of rather shorter focal length to make use of the greater depth of field that goes with shorter focal length.

On some cameras the lenses can be interchanged, so that you have a choice of different focal lengths and can take wide-angle pictures where filming conditions are cramped or use a tele lens to make a distant subject appear large on the film.

CONVERTER LENSES

On other cameras, instead of interchanging one lens for another, a special *converter* lens may be fitted on to the front of the camera lens. This may be a wide-angle or telephoto converter and will give you the same effect as using wide-angle or tele lenses.

These lenses should not be confused with *supplementary* lenses (see p. 86), which are simple one-glass affairs which permit close focusing only.

The *converter* lens on the other hand, literally converts the normal lens into a lens of longer or shorter focal length. You can focus over roughly the same range as without it but it gives you a larger or smaller image.

The telephoto converter is sometimes available for simple fixed focus cameras. When it is attached, the depth of field becomes so much less that focusing facilities must be provided. The converter is, therefore, fitted with a rotating ring marked in feet.

Converters made for cameras with focusing lenses normally have no additional controls, but they do need a special focusing scale, sometimes engraved on the standard lens, and you must remember to use this *only* when the converter lens is attached. The camera lens will probably have to be set at infinity before the lens is attached. Also, as the lens is now in effect a longer focus one, a new depth of field scale will obtain. Remember these three points and you won't go wrong.

Converter lenses are not available for all cameras and you have to enquire from the manufacturer or a camera dealer if you want one for your camera.

ZOOM LENSES

A zoom camera is a camera fitted with a zoom lens. Before cameras were made with a zoom lens permanently built in, the lenses were available separately and could be screwed into the lens flange in place of standard, wide-angle or telephoto lenses of the interchangeable type. Some models had lens turrets, with two or three flanges so that a lens could be rapidly changed to one of another focal length simply by rotating the turret.

Older zoom lenses were large and heavy and the camera became unbalanced when they were fitted. When fitted to turret models, they tended to pull the turret round.

The performance of early zoom lenses was not as good as equivalent lenses of each focal length. They could not give as

sharp an image and the very early "variable focus" types suffered from focus shift when changing from one focal length to another.

Today a zoom lens is free from these limitations. It gives a sharp picture all the time and it holds focus on a subject however much you zoom in or out. Of course, you need to focus on the subject in the first place, and the depth of field problem is still with you. These you cannot escape. But the overall performance is as good as you will get with a set of ordinary lenses.

Even the bulk problem has been largely overcome. The zoom lens is not usually intended to be removed from the camera and it is therefore built into the camera as an integral part of a balanced design.

ZOOMING RANGE

The "zooming range" of a lens is the range of focal lengths it can be adjusted to without using any additional optics. A lens may be marked 10–30 mm. This means that it can be adjusted to 10 mm. or 30 mm. or any intermediate focal length.

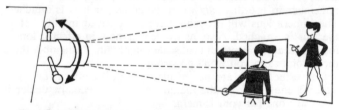

The effect of zooming is to magnify the image of the subject over a continuous range. The zoom operates by a simple control such as a lever mounted on the zoom ring.

This is also known as a 3 : 1 ratio zoom lens. The subject can be made to appear three times larger in the picture at one end of the range than at the other. The designation 8–32 mm. is a 4 : 1 ratio zoom. With this the subject can be made four times larger.

The larger zoom ratios are the result of very clever lens design and there is a limit to how far this can go. The greatest zoom range on an amateur camera so far is 12 : 1, an incredible feat which makes a very versatile lens indeed. Most zoom lenses have a more modest range than this, 3 : 1 and 4 : 1 are average.

The limit on the wide-angle setting is about 8 mm., though a few cameras have a shorter focal length. The average wide-angle

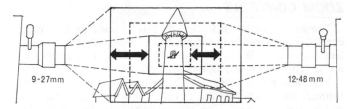

Zoom lenses fitted to cameras are not always the same. Some range over shorter lengths and some over longer. Also some have a greater range of focal length, expressed as the ratio e.g. 3 : 1 where the longest setting is three times the shortest.

setting is 10 or 11 mm. The long focal length may be between 30 and 35 mm. So, although many makers claim that your zoom can range from wide angle to telephoto, in fact you have a reasonably long telephoto but not much of a wide angle.

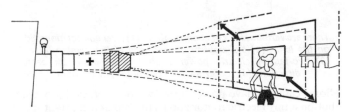

Some zoom lenses may be fitted with a converter lens so that the range of focal lengths may be shifted. In effect, there are then two ranges, i.e. it becomes a dual-range zoom lens.

DUAL-RANGE ZOOM

Long-ranging zoom lenses are costly and intricate, so range is normally extended by using a converter attachment. The lens is made to zoom from standard to telephoto lengths; when you attach the wide-angle converter you can zoom from standard to a true wide angle, say, 6 mm. You have in effect a dual range zoom providing a true wide-angle and true telephoto setting. Converter lenses for cine cameras are usually of the wide-angle type. As with fixed lenses, the converter has no effect on aperture, though it changes the focus and, of course, depth of field. Sometimes the lens is sold with the camera; with other models it is available as an optical extra and is a worthwhile investment.

ZOOM CONTROLS

The focal length on a zoom lens is selected by operating a control lever. On most cameras this is mounted radially on the lens. Other models have a to-and-fro pendulum type control, or a disc or wheel on one side of the body.

You work a zoom lens visually for most of the time. You look through the reflex viewfinder, turn the lever and zoom to the picture size you need. The zoom control usually has the focal lengths marked at each end of the range and at some other focal lengths in between. You may need these if you use depth of field tables, otherwise you need not pay attention to them.

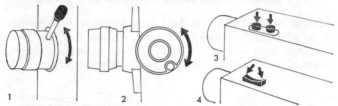

There are various kinds of zoom control : (1) lever control mounted on the lens; (2) dial control on one side of the camera body; (3) two-button electric power control, one button for each direction; (4) rocker switch control for power zoom.

Some cameras have power-operated zoom lenses. By pressing a button a tiny electric motor zooms the lens at a constant speed. Another button moves the zoom in the opposite direction. In better cameras the motor is powered by its own small dry cells contained in the camera, separate from those which power the camera motor. A few cameras have a two-speed motor for the zoom lens. Most power zooms can be operated manually as well: you do not always want power control. Some lower priced cameras without a separate zoom motor only power-zoom with the motor running, so to rehearse such a shot you have to zoom manually.

USING A ZOOM LENS

The great advantage of a zoom lens is that you can select almost any focal length to suit your subject with an exactitude that you could never match with interchangeable lenses. There is no need to compromise. You adjust the lens to fit the subject, switching from one focal length to another in an instant and without changing the camera position.

The zoom action may also be carried out while filming. This produces an effect rather like tracking the camera, but not quite the same. It will do as a substitute and is far easier.

Tracking (moving the camera bodily forward or backward) gives the true effect of approaching or moving away from a subject. As the camera approaches the subject there is a gradual change in perspective and nearby objects change in size compared with those farther away. With the zoom there is no change in perspective: the whole image grows larger in the picture area.

If the subject is a flat one and there are no foreground objects you hardly notice the difference, provided the zoom is well done without jerky movement. But in most cases a track and zoom appear rather different to the eye—although they may be used for the same purpose, e.g. gradually drawing attention to one particular part of a subject or drawing away to show the subject in the context of its surroundings.

Both techniques are useful when you begin to plan a film. You can turn two shots into one; a close-up into a medium shot or a medium into a long shot.

There are many other situations where a zoom shot may be used. A quick zoom can be most dramatic. But don't do it too often. Frequent zooming of any kind in a film destroys the impact and soon becomes tiresome. It draws attention to the camera and that is nearly always bad cine. An exception perhaps is in titling, where the zoom can be used frequently to increase or decrease the size of lettering on the screen. Zooming and tracking can be combined. You do not notice the zoom because the camera is actually moving. This way you can appear to give a much longer track without actually doing so. You might need only half the tracking distance to get the same effect.

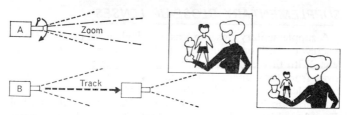

There is a difference between a zoom and a track. With a zoom the whole image is magnified uniformly. With a track there is also a change in perspective—the nearby subjects grow larger more rapidly than background ones.

The zoom movement should be smooth and gradual, with no jerks at beginning and end. Any camera movement, in fact, should be subtle enough for the audience to be unaware of it. The subject should come into view gradually as if the audience were moving towards it or were turning their heads to follow it. One way to get a smooth zoom action is to hold the lever firmly and with your wrist rigid, moving your whole lower arm as if it were the hand on a great clock.

Power zoom provides the mechanical answer to a smooth zooming action; but you are confined to the speed (or two speeds) of the zoom motor. Also, you must be careful to stop it just where you want—there is a tendency with power zooms to overshoot the desired framing. You should practise a little before using any film in the camera, so that you become accustomed to using the trigger and zoom control at the same time. Here a pistol grip can be useful. With this you can hold the camera and press the filming button with one hand, leaving the other free to zoom the lens. If at the same time you want to change focus as well you need an assistant! One or two cameras have both zoom *and* filming buttons on the pistrol grip, one operated with the index finger, the other with the thumb. This leaves your other hand free to focus, operate a fader, steady the camera, or hold your sandwiches.

Never hold the zoom lever unless you are intending to zoom during the shot. There is nothing worse than a straight shot with a slight jerk in it because you happened to have your hand on the zoom lever.

As a general rule, do not zoom back and forth in the same shot. Again, this is an unnatural effect that can disturb the audience.

SUPPLEMENTARY CLOSE-UP LENSES

A supplementary close-up lens is a single glass positive lens in a screw or push-on mount which fits on the front of the camera lens. With this lens you can focus on subjects only a few inches away from the camera. (Cameras fitted with so called "macro-zoom" lenses can do this without a supplementary.)

A close-up lens can often be useful. You may make a whole film of a subject in close-up or just take individual shots of very small subjects which must appear large enough to see on the screen. The lens is essential for shooting titles, and any animation work that you might do.

Close-up lenses are often made to fit a particular camera and it is worth asking the dealer if he can obtain one for you. Lenses made by other firms may be less expensive, but with some cameras there is a problem of fitting the lens satisfactorily to the lens mount. Lenses are available in various types and sizes of mount, and you should always take your camera to the shop to check that the lens you buy will fit properly.

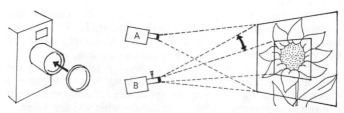

A close-up lens is a single glass that fits over the front of the camera lens. You can focus on nearby subjects (A) but with a zoom lens you can vary the size of your close-up much more conveniently.

Generally speaking, a reflex camera is better for close-up work as you can see the effect clearly in the viewfinder before you shoot. With a non-reflex camera, distances have to be measured and depth of field looked up in tables. But with practised methods, such as when always working at certain fixed distances, consistently good results can be achieved.

The lenses are available in various magnifying powers which are measured in the metric term *diopter*. Normally you buy a close-up lens of the power you need by asking for one out of a series of, say, three strengths available. The manufacturer quotes the focusing distances on a chart supplied with the lens. But you can be more specific when asking for a lens by working out the strength in diopters of the lens you need.

Suppose you want to focus on a subject a few inches from the camera. What power of close-up lens do you need?

Turn the subject distance into centimetres, divide this into 100 and the answer is the strength in diopters of the required lens. Take an example:

Distance of subject = 8 inches
Into centimetres = 20 centimetres
Divide into 100, = 5

Therefore you want a 5 diopter close-up lens. You can work it backwards. Suppose you already have a 4 diopter close-up lens and you want to know how far the subject should be from the camera.

Power of lens = 4 diopter
Divide into 100, = 25

Therefore your subject is sharp at 25 cm. or approximately 12 in. from the lens.

When using these figures you must have the camera lens focused on infinity but the focal length is immaterial. The close-up lens focuses at the same distance on any lens. Only the image size varies with the focal length of the camera lens.

You can get nearer still with a close-up lens by using the focusing movement of the camera lens, but this is recommended only where you have a complete set of the relevant tables, or if you use a reflex camera where you can see what you are doing.

USING CLOSE-UP LENSES

Unfortunately, when shooting with a close-up lens you have very limited depth of field. There is often only a fraction of an inch in front of and beyond the plane of sharpness.

It is a little tricky to film any but flat subjects at such close range, because only part of the subject appears sharp. On a manual camera, closing down the iris helps but you are still desperately short of depth even at f 16.

The knack with close-ups is to focus on the predominant part, or side of the subject, which is usually also the nearest point. The lesser parts can then fall off unnoticeably into the fuzzy background.

With some subjects you may want to emphasise a certain part which is more important than the rest. Here the shallow depth actually helps, because it makes this feature stand out from the rest. In the close-up of a flower, the inner parts of the bloom could be highlighted in this way.

Moving subjects in close-up are difficult to film. The great magnification causes the slightest subject movement to be grossly exaggerated on the film, since the movement also is magnified. The camera, too, has to be steady and should be on a tripod. Then, if you wish to film a small animated object you would do better to restrict the movement of the subject rather than try to follow it with the camera. Small insects would have to be kept between closely-spaced sheets of glass.

A larger subject such as a lizard wriggling across a sand box could be followed with a hand-held camera provided there was some support for the arms which did not interfere with camera movement.

This type of cine filming is specialised, and only experience, with perhaps a few home-made gadgets, will yield good results.

SPECIAL LENSES

Two types of special lens are occasionally available for an 8 mm. cine camera. Although they produce effects you would not get any other way, they are limited in use and therefore hardly an economic proposition for the average person.

Anamorphic lenses produce wide-screen images similar to those used in the cinema. The picture quality is usually very inferior because the tiny 8 mm. frame is "stretched" to cover a much greater screen area. An anamorphic lens must be used on both camera and projector and therefore it must be fully interchangeable. Wide screen for 8 mm., justly, has very few adherents.

Faceted lenses break the image up into pairs, segments or a honeycomb effect of very small, identical pictures. They have few uses outside the field of advertising and even there are very rarely used. They are not recommended for home movies.

WHAT IS FOCUS?

As a rule, the eye is attracted to the clearest part of a picture. Clarity, or sharp focus, is a means of drawing attention to a subject. Although we always like to see the things we look at as sharp, surrounding details need not be so, and in fact, if they are deliberately made unsharp in a picture the onlooker is more or less compelled to look only at the object in sharp focus. In this respect a film maker has control over his audience. He can make sure that they see what he wants to show them. Control of focus therefore is a useful instrument to anyone who knows how to use it.

At the first stages of film-making you are satisfied with an all-over sharp image on the film. As you become more ambitious, you have to be a little more selective. Having things out of focus becomes just as significant as having them sharp.

We are concerned here with the zone of sharp focus in the scene, the depth of that zone and how to use it. Later we will see how the depth can be varied.

Difference in focus between nearby and far objects gives a feeling of real depth to what is, in fact, a flat image on a screen. Sharp objects appear to come forward from an out-of-focus background; they appear to be actually behind a foreground object which is not sharp.

A problem with cine lenses is that you often get too much depth of field. Attention is drawn to a subject by separating it from its surroundings with the use of focus. Only when you have a shallow depth of field can the difference in sharpness be enough to pick out your area of main interest in this way.

Playing with the focus to get this separation of planes is made more difficult with modern cine lenses which offer such great depth of field, i.e. producing sharp images of both near and distant objects. For general work this great depth is undoubtedly a virtue. But selecting your exact plane of focus, or *differential focus* as it is called, is more tricky with such a lens.

This focusing technique is only effective if there is a wide difference between sharp and unsharp objects. It must be done properly or not done at all.

FOREGROUND AND BACKGROUND

Background features in a scene may suit the subject but tend to dominate it. If they are "thrown" out of focus correctly, they are still noticed but become secondary to the subject. We say "correctly" because if they are just a little unsharp it could look as if you meant to get them sharp but didn't quite make it.

Backgrounds can be visually more appealing when sufficiently defocused. Patterns of light are formed which flatter the subject. Ugly or unsuitable backgrounds can be almost eliminated by throwing them far enough out of focus. Nevertheless, backgrounds should not often need such cavalier treatment. They should add atmosphere and should not generally be so fuzzy as to be unrecognisable.

Normally, you avoid large and out-of-focus objects in the foreground. On some occasions, however, they can be very dramatic, especially when the sharp subject is seen *through* an unsharp foreground. The foreground shape may be attractive in itself, or it may add to the story. It can even do both. A man may be led into a room and seen through the huge fuzzy shape of a

If the background is needed (1) do not let it go so far out of focus that it is unrecognisable. If the background is unwanted and confusing (2) it is better right out of focus. You can have a sharp background seen through a fuzzy shape in the foreground (3).

noose. This could not only save two shots (first the man entering, then a shot of the noose), but could also make the foreground object an attractive part of the composition and add some further dimension to the story.

Do not shoot out-of-focus foreground objects against fussy backgrounds which are also out of focus. Either keep the background sharp or find one which is fairly even in tone. Unsharp foregrounds and backgrounds on top of one another tend to fuse together and the depth effect is lost.

FOCUS AND MOVEMENT

Control of the zone of sharp focus (depth of field) is effected mainly by varying the lens aperture. At large apertures (small *f*-numbers) the depth of field is most restricted (see pp. 78, 95).

At medium or small apertures the depth of field is normally enough to maintain a sharp image of subjects moving from moderate to far distance. When large apertures are used and the subject movement is towards the camera rather than across or away from it, focusing must be more precise. Difficulties also arise when long-focus lenses are used (see p. 80).

Conditions that allow less critical focusing are: bright scene and fast film and therefore small aperture; subject a fair distance

from camera; a wide-angle lens (or zoom on a wide-angle setting) and a static subject. Conditions where focusing becomes more critical are: dull scene and slow film and therefore a larger aperture; subject fairly near to the camera; a lens of longer focal length (or zoom on a long setting) and a moving subject.

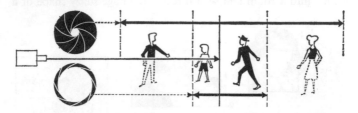

The smaller the aperture in use the greater the depth of field you get at any given distance. This can alter the appearance of your shot considerably and may in effect exclude part of the subject from the picture.

When subject movement is towards or away from the camera, rather than across its view, constant refocusing is more likely to be needed.

A moving subject which is followed by the camera must be kept in focus all the time. In good conditions this area of move-

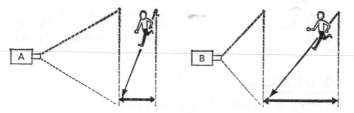

Direction of subject movement affects the depth of field you need to keep it sharp. Where the subject moves across in front of the camera little is required. Where it moves somewhat towards or away from the camera you need greater depth unless you can change focus during the shot.

ment may be within the available depth of field, so that the lens need not be refocused. If the subject comes towards the camera or the camera moves towards the subject, however, you should rotate the focus ring gradually so that at any distance, the focus

ring is at the corresponding setting. You may do it by watching the subject through the viewfinder if it is the focusing type, though this is difficult. Or you may do it by touch, knowing how near the subject will come.

Alternatively, someone else may turn the lens for you, like a professional "focus-puller", as you film. This is quite a skilled job and you should try a number of practice runs before depending on it.

Indoors, where focusing may be more critical still, your assistant can use a simple guide method. Assume the subject is a person who enters a room, pauses, and ambles about in it. Note the distance of, say, three objects spaced between the camera and the door where the subject will enter. Let us say the door is at 15 ft., a chest at 11 ft. and a chair at 8 ft. As the subject moves towards each object your assistant moves the lens gradually to the appropriate distance. It can be a tricky operation and will undoubtedly need rehearsing, but it is the only way to get first-class results all the time.

If you have no assistant, you can try holding the lens with your arm straight out in a radial direction like a zoom lever. Find the focus settings you want and note the position of your arm, being careful not to bend it at the wrist. Then film the scene using your arm so held as a focusing indicator.

USING DEPTH OF FIELD TABLES

Depth of field tables are often printed in the instruction book supplied with a camera. These tell you in how much depth you can get your scene sharp with the lens fitted to your camera.

Tables are set out in different ways. Sometimes they are in columns of figures, but in other cases a chart using plotted lines is used. The tabulated type is more usual.

Apertures are usually ranged along one side and focused distance at the top or vice versa. The figures in the body of the table are the near and far limits of the depth of field measured from the camera film plane mark.

Say we set a 15 mm. lens at $f 5.6$ and focus it on 4 ft. We want to know the extent of the depth of field. Read down the $f 8$ column and across from 4 ft. The two figures given may be 2·5 and 9·7. This means that everything will appear sharp from 2·5 ft. to 9·7 ft. and anything moving within that field will appear constantly sharp.

But suppose you want the background sharp? That means you

want to increase the depth of field. You could use a smaller aperture but you cannot use that without affecting the exposure. Another alternative would be to fit a lens of shorter focal length but that may be either impossible or impracticable. Fortunately, there is a further method. You can alter your focused distance, while keeping the camera 4 ft. from the subject.

The depth of field table shows that if you focus on 7 ft. the depth of field extends from 3·5 ft. to ∞ (infinity). It is therefore possible, using the entire depth of field at a 7-ft. setting, to produce a sharp image both of the subject at 4 ft. and the background.

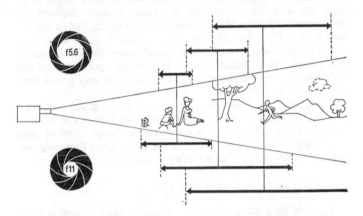

Outdoors, when you can work with only one aperture, with a certain shot you may be worried about getting everything sharp. Use depth of field tables or the scale on the lens mount to see how much depth you get at that distance. When you are taking many shots of a troublesome subject start out with a faster film which gives smaller working apertures and more depth.

Of course, if you are looking for the maximum depth of field you do not do it in this roundabout way. Just glance down the aperture column until you find the sort of depth you need, set the lens on the corresponding distance in the focus setting column and place your subject or subjects within the stated depth.

For the full effect of differential focus you can place the subject at the far end of the depth of field so that infinity is out of focus. The subjects should be near enough to the camera to have the background well out of range.

DEPTH OF FIELD AND FOCAL LENGTH

Depth of field is related also to the focal length of the lens in use. Wide-angle lenses can give greater depth of field than long focus ones. These lenses can also be just as handy for deliberately controlled depth of field as for their different fields of view.

You might use a long focus lens with a subject at normal distance in order to throw the background out of focus. With a normal focal length lens it would have appeared sharp.

Where you want maximum depth, say for a golf ball just in front of the camera and two figures walking towards it, the wide-angle lens can provide a sharp image of both ball and figures.

Essentially, there is no difference between the depths of field you get with separate lenses and the same focal length settings on a zoom lens. Of course, your zoom lens offers an infinite range of intermediate focal lengths with corresponding depths of field.

For all practical purposes, these intermediate settings are of no importance as far as depth of field is concerned; there is far too little difference between them. You have to make a big change in zoom focal length in order to notice much difference in depth of field.

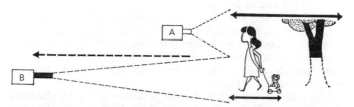

Depth of field varies with the focal length you use. To keep the background out of focus without changing the size of the main subject too much, move a little further away and use a much longer focal length

So zoom lenses are normally supplied with tables for certain main intermediate focal lengths, say, three or four positions on the whole range. You take the nearest figure and use the appropriate table.

Most zoom cameras have a reflex viewfinder, but the tiny mirror reflecting the scene to the viewfinder is usually positioned in front of the diaphragm to give a constantly bright image.

So you see the depth of field effect as if working at full aperture, regardless of the actual f stop in use. Visual judgments must take this into account. Many people find even this more useful than trying to conjure up a visual effect from a set of tables.

If you use the zoom action while filming, take care that an important part of the subject does not fall outside the depth of field at the longer setting. If you intend to zoom in, you should do so first to check focus, otherwise you may zoom in to an unsatisfactory close-up.

IMAGE SIZE AND PERSPECTIVE

Lenses of different focal lengths, whether separate lenses or various settings on a zoom lens, give different sized images from the same shooting distance. You can alter the size of the image produced by a given lens by altering your shooting distance but the effect is not the same as that provided by changing the lens or zoom setting.

You can easily distinguish between a shot taken at a distance with a long focus lens, and one taken nearby with a standard lens, even though the main subject may be the same size on the screen. The difference is in perspective. Perspective changes the relative size of objects which are at different distances. You can see this by a simple experiment.

Stand somebody a few feet behind and to one side of a pillarbox so that figure and pillarbox seem to be of the same height in your viewfinder. You can make the pillarbox larger by moving forward. The figure also becomes larger, but the pillarbox grows more quickly and, eventually becomes much larger than the person standing behind it.

Alternatively you can make the pillarbox larger by changing the lens to one of longer focal length. Now both the pillarbox and

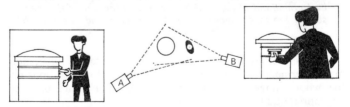

A change in viewpoint can vary the size of objects in relation to one another. This is useful if you want to stress the importance of one or the other yet keep them both sharp.

figure are magnified equally and they remain the same height as each other.

But something else happens too. The pillarbox and person appear to be closer together. Your distant viewpoint closes up the separation between them by an effect known as *flattening of perspective*. This is only noticeable when you use lenses of fairly long focal length, but it is not the lens itself that causes it. It is the distant viewpoint. The same effect would be obtained if you projected only part of the picture taken with a shorter-focus lens from the same viewpoint.

FUN WITH LENSES

You can use these effects to get an unusual slant on the subject. If, for example, you change to a wide-angle lens and go very close to a dog you can make him look larger than his owner at the other end of the lead. You can make a modest yacht look like a great ocean-going schooner by shooting from very close to its bows. There are many ways in which you can play about with the relative sizes of objects or parts of the same object for dramatic or humorous effect.

The idea of varying the relative sizes of objects can be pushed to extremes, for effect. By taking up the right position a small object can dominate a large one, or the bulk of an object may be exaggerated to an absurd degree.

Flattening of perspective can be used deliberately to make objects appear closer together than they are. A pedestrian dodging in and out of traffic seems to have some narrow escapes when seen through a longer focus lens. Similarly, the ferocious bull and the small boy, the distance home and the front gate can be pulled closer together if required. Anybody approaching the

camera seems to take a long time to cover any distance when shot through a long-focus lens. In fact, a most comical effect is obtained if you shoot a runner head on and operate your zoom control to keep him the same size in the viewfinder. No matter how hard he runs, he makes no apparent progress. This is, of course, an extreme effect, you would only get it with a very long focus lens.

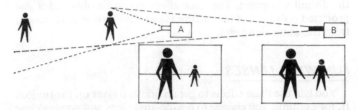

You can alter the relative sizes of subjects by moving further away and using a longer focus lens. The distant subject then appears larger although the foreground one is the same size. The subjects also appear closer together.

A properly exposed film reproduces the scene in all the brilliance and colour of the original. Incorrect exposure is often the cause of poor quality or an indistinct image on the film.

When a film has been over-exposed the image appears "thin" and the colours pale and washed out, in extreme cases light-coloured parts of the scene appear as pure white.

With under-exposure the reverse happens. Colours appear darker than normal, the subject is shadowy and shadow areas are totally black. Even highlights appear as middle tones, and a sunlit scene looks as if it was taken by moonlight.

For ordinary day-to-day shooting you need only worry about the occasional snag which may crop up here and there with a tricky subject. You are just aiming to get the subject on the film.

If you have a more ambitious film in mind you must pay particular attention to exposure. You do not, for instance, wish to lose some important background detail that might have a vital part to play in telling the story. Nor do you want it to look patchy. The appearance of the film must remain fairly consistent in various shots of the same scene, even though some may have been filmed on different days and required alteration of exposure as conditions varied. A pale-green dress must appear pale green in all the shots taken of it, never bleached white or drenched with the sort of blue cast sometimes caused by filming in shadow.

HOW THE METER CAN BE FOOLED

Any exposure meter takes the average of all light and dark tones in the part of the subject it can see and assumes that, when those tones are mixed together they approximate to a mid-tone. It recommends an exposure to produce just such a result. If the tones in the scene do not mix, or integrate, to a mid-tone, the exposure meter is misled and can give the wrong recommendation. If, for example, light tones predominate in the scene, the meter

may give a recommendation that would result in under-exposure. If your scene contains a large dark background this will influence the meter and cause it to recommend a greater exposure. All the details of this dark background will be visible. If the main point of interest in the scene is a medium- or light-toned subject, such as a human figure, it is liable in these circumstances to appear over-exposed.

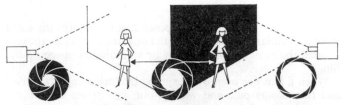

The exposure meter takes a reading of the general scene. It is unselective. So where you have a small middle-toned subject against a large light or large dark background the exposure indicated may not be correct for the subject.

The meter was directed at the subject but it saw mostly dark areas and gave an appropriately long exposure. The area of light tone (your human figure) was too small to influence the meter, which took only an *average* or *general* reading and could not be selective. A meter may also be misled by influences outside the scene itself. Sunshine may reach the front of the meter from one side at an oblique angle. This is particularly so with older cameras where the built-in selenium meter is often unscreened. Cameras with CdS meters are not usually subject to this, and with through-the-lens types the hazard disappears altogether.

Watch out for wrong readings when shooting from a sunlit

When taking exposure readings, or using an automatic camera, beware of: (1) oblique sun rays striking the lens and strong glare from the ground particularly from water; (2) wrong readings when shooting from a sunlit position with shadow areas; (3) glare from walls or buildings.

position into a shadow area. You should be suspicious if the meter gives you an unusually high reading from this position. You may need to shade the meter from the sunlight with one hand, or get someone to do this for you if it is difficult while filming.

Glare from the ground is sometimes intense enough to mislead the meter. Beware of this when shooting on sea beaches, light surfaced roads, concreted areas and other such places. Light-coloured walls and nearby buildings may cause the same effect if the sun is shining straight on to them.

FILM CONTRAST AND SHADOW AREAS

Exposure difficulties arise because of the restricted contrast range that the film is able to handle, a characteristic of all makes of film material, both black and white and colour. It is impossible to make a film which can register the full range of brightness to darkness that you get in a brilliantly sunlit outdoor scene. You can only have a part of this range on the film.

In most scenes you are mainly interested in the middle-tone and highlight areas; shadow details are not important, so the shadows can go black. Try to exclude large dense shadow areas from the picture, or at least keep them to a minimum. As well as causing the exposure problem we have just met, they are not pleasant to look at on the screen.

This does not, of course, mean that you cannot shoot into the shadows if you wish, only that shadows cause trouble with a generally well-lit scene when the main point of interest is itself well lit.

If you intend to pan slowly across a subject think about the light and dark areas of the shot as a whole. Will you need to vary the exposure during the pan? If you have an automatic meter and you pan across from a light to a dark area the sky, too, will change in tone and with colour film will also change in colour. Such a change is not so noticeable if the sky is only a small part of the picture.

Look out for sunlight, or its reflection off water, in pan shots. Be sure that your pan does not end up facing the sun.

AUTOMATIC AND MANUAL

You will find an automatic meter can cope with the majority of situations. Just remember that the sky is many times brighter

than the average subject. If yours is the kind of meter that reads only the immediate area of the subject you are filming, as CdS and through-the-lens types do, and you want to expose for darker parts of the scene, keep the sky out of the picture.

Suppose you are filming a feature high on a building, such as a decorative gargoyle. If you include much sky, the gargoyle might be so under-exposed on the film that it appears almost as a silhouette. From another angle the background to the gargoyle might be stonework without sky, which although it is rather similar in tone and colour, would show you the details of the grotesque face far more clearly.

These are the two effects which can be obtained with an automatic camera; the one where you are going to get a stark

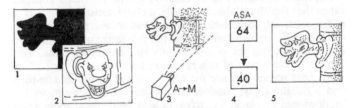

Exposure control: Auto (1) bright sky behind makes a silhouette. (2) Mid-tone background gives background detail. Manual (3) base setting on mid-tone or, shift film speed to get sky plus detail (5).

impact, the shape outlined against the sky, and the other where you want to *describe* the subject to the audience. Be sure to do it to look right in the sort of film you are making.

The example of the gargoyle shows why manual control on a camera gives us the upper hand. To get the exposure right with the automatic control we had to change the background. With a manually controlled camera you do not have to do this. You would find the correct exposure for the gargoyle and expose for that. The result would be a detailed subject against a sky background. The background might be badly over-exposed, but that is unavoidable.

With manual control you can vary the amount of exposure at will, making the subject detailed or in semi-silhouette, full silhouette, or even against an "evening" sky. You can get as near the ideal exposure as possible for each particular subject, or deliberately give the incorrect exposure for special effects.

For general work the automatic control will give you an

acceptable and often very good result. Automatic exposure is easy, you just point the camera and shoot; you only have to watch for the warning indicator which tells you when you can't.

For the best of both worlds some cameras offer either system: you can switch from one to the other as you wish. You can use the manual "override" for difficult situations and special exposure effects, and the automatic control for quick working and panned shots.

Many cameras do not offer manual control, but can be controlled manually to some extent by altering the ASA speed ring. Where extra exposure is required for a particular shot you can set the ASA control to a lower figure as if to expose for a slower film, but in effect giving extra exposure to the film actually being used. You must remember to reset it after taking the shot, otherwise all subsequent shots will be over-exposed.

Unfortunately, this adjustment is not possible with Super-8 cameras because they set the ASA speed automatically when you drop in the cartridge.

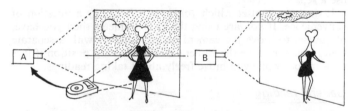

When finding the exposure with a manual-control camera set it for a reading from the subject, without including too much sky (A). With an automatic camera you can play safe by keeping the sky as much out of the background as possible (B).

Some automatic cameras have a "fractional exposure control" it is also sometimes called a "blacklight correction" control. This gives you an extra stop (more exposure) when filming against the light, or for subjects against bright backgrounds where you want shadow details. Some automatic cameras not fitted with this control can nevertheless be used as though they do have it. Point the camera at the subject and watch the exposure *f*-number indicated in the viewfinder. Put your finger over the meter cell partially blocking off the light until the meter needle moves up by one stop. Now shoot.

Circular cell flanges can be fitted with caps with holes in the centre made to different sizes, e.g. one stop, two stops, etc. These would offer a regularised form of exposure control for fully automatic cameras. Cameras with through-the-lens (TTL) meters (p. 63) do not permit this blocking off technique as any such obstruction would also obstruct the lens.

Although automatic exposure control offers so many advantages in normal work, full manual control is still the best way to control the diaphragm independently for depth of field effects (p. 94).

MANUAL: FINDING THE EXPOSURE

There are several methods of determining the correct exposure for setting manually on the camera. On many auto/manual cameras you can use the built-in meter independently of the exposure mechanism, but on some the meter shuts off altogether when you switch to manual control. With the first type you use the camera as an exposure meter but with the second you must use a separate meter.

It does not matter which you use; it is chiefly a question of convenience. If you are using the built-in meter then you have, of course, to move the camera about, whereas with a separate meter you can leave the camera in the shooting position if it is on a tripod, while you move freely about taking readings.

General reading

To take a general reading you point the meter at the subject and measure the reflected light for the whole scene. As we have already seen, this is what the built-in automatic meter does. But whereas the automatic meter reads for the subject and sky and so tends to under-expose the subject if there is much sky in the scene, in taking a general reading manually you can exclude most of the offending bit of sky by pointing the meter *slightly* downwards. This method is especially useful for open scenery in bright weather, but don't overdo it by pointing the meter at foreground objects of vastly different brightness from your subject, such as water reflections.

Reading off the subject

Suppose you have a figure against a background of varied tones. He is the most important part of the scene so you want to

expose for him. The correct method is to take a close-up reading of the light reflected from his face, because flesh tones are the most important part of such a subject and are reasonably near the mid-tone for which your meter is calibrated. Don't in doing so, allow a shadow from your hand or the meter to fall across your subject or this will give you a wrong reading. This method is simple, and perhaps the best one. But in many cases it is inconvenient to go up to your subject—you may be taking candid shots, you may not be able to get to him easily, or you may not have the time. Then you must find a substitute.

Reading off your hand

Your hand has roughly the same tonal value as your subject's face, so for exposures based on flesh tone you may take a reading of your own hand without leaving the camera position *provided that the same amount of light is falling on your hand as on the subject*. If not, you must move to a position where it is or use another method.

You can, in fact, use this method for all types of scene, not just for flesh-toned subjects. Your hand is a constant colour. The reading you get off it will vary only with the amount of light falling on it, so you can use it as the basis for all your exposure readings by treating it as a middle tone.

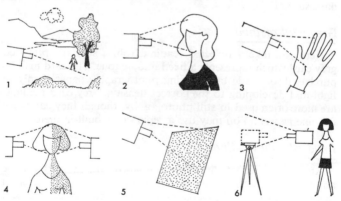

To find the exposure with a manually controlled camera you can take a reading: (1) generally; (2) off the subject; (3) from your hand; (4) of highlight and shadow areas and set exposure midway; (5) from a grey card; (6) by the incident light method.

First you take your reading then you ask yourself whether the subject is lighter or darker than your hand. If it is darker you give 1–2 stops extra exposure, depending how much darker. If lighter you give 1–2 stops less. With practice you will know how much to give for any subject.

Hold your hand close to the meter, close enough to fill its field of view, again avoiding the shadow. If the colour of your skin is very different from that of your human subject you must allow for this in the exposure just as you would for any other subject.

The average reading

An average reading is taken by first measuring the highlights of a subject, then the darkest shadow areas, and setting the camera at the middle point between these two readings. The method works well with subjects where the range of tones is evenly distributed throughout. You avoid the strong light and other influences that might upset a general reading. But you need to get near to the subject for these reflected readings and you need time to do it properly. It takes account only of the bright and dark areas, not how those areas are distributed in the scene or how important they are. The method can be modified by giving a subject which is generally bright a slight exposure bias in favour of the bright area; and the same for a predominantly dark subject.

Grey card method

Here you take a reflected reading from a specially prepared grey card which represents a fixed middle tone. The card may be purchased, or made by exposing photographic paper evenly to light and developing to the correct density. Grey card readings are more often used in still photography, though they can work for cine as well. You may use a separate or built-in meter.

Incident light readings

Any subject reflects light in accordance with two values: the amount of light that reaches it, and the amount it will reflect (a matter of whether it is a dark- or light-toned subject). Incident readings differ from the others in that you are measuring the amount of light *falling* on the subject. You base your exposure on this reading alone. There is nothing more to do because the reading it gives is designed to reproduce adequately all the tones

of a normal subject. It should, in fact, give virtually the same reading as the grey-card method.

This is the simplest way of finding an exposure with the surest results. It can be used with most subjects but only with a separate meter designed to take incident readings.

The meter has a white opal baffle which is fitted over the light-sensitive cell. You take a reading by going over to your subject and pointing the meter back in the direction of the camera. (Do not try to get a reading by pointing the meter at the light source.) In cases where you cannot walk over to the subject you can normally do it just as well from the camera position. Stand with your back to the subject and, holding the meter level, take a reading pointing the meter in the same direction as you would have done if you were standing in front of the subject facing the camera (i.e. in line with the camera and subject).

Whichever method you use, keep to it. The ideal one is the one you can work with best. You may go astray on your first films, but as with most tricky things in cine you will get a "sense" about it if you practice often enough. A very experienced photographer can look at most scenes and tell you the exposure without even a glance at his meter.

Use the same speed of film for all your work and save yourself the trouble of resetting the appropriate dials.

Films are nearly always about people or have people involved in them somewhere. It is often just the inclusion of a person that gives the subject some relationship to the audience or ourselves.

A human figure can give scale to a subject. A group of buildings could be any size until we see someone walking in front of them.

The personal approach appeals to an audience. If someone has created a splendid garden, the audience likes to see him and how he did it. So we show him actually in the garden carefully putting in a bulb. We don't include him in every shot, nor do we show him making the whole garden, but we give an indication that the garden is his creation.

PEOPLE ARE USEFUL

The main attraction of including people in the picture is that they move. This is quite unlike still photography. The movement is, of course, the whole point of cine. Where your subject-matter is static, and sometimes it cannot be avoided, the inclusion of a strolling figure retains the idea of animation.

Naturally, to make a cine film your choice of subject would tend towards the animated where possible; but don't make an absolute rule of this, or you will find yourself too often restricted. Where you feel you must have some movement, think first of the human figure. It is just about the easiest prop to get hold of. It isn't difficult to perusade a passer-by to walk in front of the camera; they do it only too often without being asked! What other prop could you get of such size and usefulness without paying for transport, construction, painting, etc?

If you are taking some village scenes don't wait until everyone has passed unless you are making a film of the 'Deserted Village'. People are part of the village scene, even if they are only tourists like yourself. With snapshots it is natural to want people out of the way. Not so with cine. If people obligingly stop to let you

take your picture wave them on. If anybody hesitates in front of the camera and stares into the lens stop and reshoot the sequence when they have exhausted their curiosity.

Watch out for people in the foreground. The occasional person passing close by need not spoil the shot and could even add depth to it, but if you feel unhappy about this, wait until they pass. In any case, you don't want a large group of people parading slowly in front of your camera obscuring the subject.

Your problem when you can't control the people is to try to be unnoticed. This is more difficult with a cine camera because you keep it to your eye for longer. Your choice of shooting position has a lot to do with it and the advantages of a small camera become apparent. You may feel proud of your cine camera, but if you would rather not have people staring out of your screen don't brandish the camera under their noses.

CANDID SHOTS

It is not likely that in general street scenes anybody will object to being filmed, but if you are concentrating on individuals, it is wise to be as tactful and as inconspicuous as possible. For this type of candid approach, the cine camera is unfortunately far from ideal for it has to be raised to the eye in order to frame the subject. Waist level operation as with a snapshot camera is impracticable. On the other hand lenses fitted to some cine cameras enable you to work from farther away and still give the impression that you are near to the subject. You are likely to be unnoticed and the greater choice of vantage points means you are less likely to be jostled in the crowd.

You must not forget that steadiness is imperative with a cine camera. If someone bangs into you while you are filming it ruins the shot. You only need to hold a snapshot camera steady for a fraction of a second but the cine camera may need several seconds. Make sure you have got plenty of elbow room, especially if you plan to move the camera during a shot.

Another disadvantage with candid cine is that you are not able to wait for the best movement or expression in your subject. It has to come as part of a sequence, not as an isolated shot. Moreover, if the subject suddenly spots you the shot has to end there, because he will almost certainly become camera conscious and cease to act naturally.

If you are anxious to get that particular sequence, move away slowly and as conspicuously as possible and then come back

again later! Or change position. In a small crowd you could pop up anywhere and get a few shots.

PEOPLE AS PEOPLE

Although people make fine subjects for a film, you need to be selective in shooting them, especially if it is a film about the family. Don't waste film by shooting people in obvious or mundane circumstances. You don't have to show them getting up in the morning and proceeding in orderly fashion to bathroom, breakfast and so on. Pick out the action pertinent to your story—even if you have to wait for it.

Although film, not time, is your most valuable commodity, with a human subject outside your control you must be prepared for some extravagance. You may take half a dozen shots to get the good one. But this extravagance can get completely out of hand if you do not at the same time discriminate between potentially good and worthless subjects. A sequence in which a person is the centre of interest must really be interesting to get it off the ground at all.

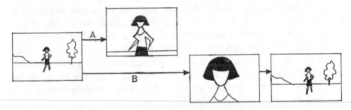

A small figure in LS on the screen cannot easily be identified. If you want them to appear as a recognisable character either: (A) shoot them MS, or (B) shoot them first in close-up to establish their identity then continue in LS.

When people are the subject of the film, they usually have to be identified. In the family film, for example, the audience wants to know who everybody is and what position they hold in the family. So you must show their faces. From then on they can be identified by what they are wearing but faces are important in family films and should be shown as frequently as possible.

In general films, however, the persons themselves may not be so important as the fact that they are there. It is enough to follow a series of scenes with a girl in a blue dress without knowing it is

110

Molly Brown. If she is being used as a link to tie up the various scenes in the film her dress must be noticeable. If she is to be seen in crowd scenes it should be very striking otherwise she may as well not be there.

Figures appear in small scale on a cine screen, so they need to stand out against the background. In most cases, bright coloured clothes are the answer, but be on the lookout for possible colour clashes in the subject and act accordingly. It is usually better to keep the figures larger in the picture area, even though this might restrict their movement.

The problem of the small picture size is really acute when you want to identify individual persons or characters. They must appear large enough in the screen to see the face distinctly. Matchstick men on the horizon are no good at all. Your best idea is to mix the shots showing them at different distances, but always referring back to close shots for faces and expressions.

Even today small-gauge movies work at the absolute technical limits of the materials. Go beyond those limits and the film cannot take it. Stay within them and your results will be good. You need to realise that the tiny picture in the camera is magnified about 200 times to give you an image on your screen. So make it a bold image and you won't be dismayed.

CHILDREN

Today's children are the best-recorded generation. Twenty or thirty years hence many thousands of adults will be able to look back at the scenes of their childhood faithfully recorded in colour, dating from times even further back than they can remember. Some parents might almost regard it as a duty not to disappoint them when they come to look at the films. The question is how best to record them on film and do justice to them as a cine subject.

Again you must be prepared to waste a lot of film if you are after good results. With such an unpredictable subject many scenes are likely to be spoiled and many more seem rather aimless. You must not be mean with film, and in the long run it is better to waste film—to overshoot—than to miss something good. The camera should preferably be loaded and ready for action all the time.

Give older children time to get used to the camera. You can play around with it, running it empty and pointing it at them. Until they are used to a camera, children will start showing

off and making faces the moment it is turned on them. They are the biggest "hams" in the world when consciously acting. Wait until they are absorbed in whatever they are doing so that they can be shown acting naturally.

If a child says "take me doing this", don't. Pictures of them standing on their heads and pulling faces may be funny at the time but will be regretted later when the films are treasured records. If you encourage them the chances of any good film become more remote and the appearance of the camera will be a sign for them to play the fool.

Nevertheless, you cannot direct children as you would adults. They must believe in or enjoy what you ask them to do, and they must lose themselves in it and become oblivious to the camera before you will get good pictures. If you make them too conscious of the fact that they are being filmed, they may stand still as soon as you point the camera at them—as, indeed, so many adults do. This is, of course, fatal to cine, which is primarily concerned with movement and life.

The best way to cure this is to get your children thoroughly used to seeing you playing about with a camera and pointing it at them. They will gradually grow to realise that the camera is not always loaded and there is no need to "act-up". Then, they will provide the best pictures—and of course, the camera will be empty!

DIRECTING CHILDREN

Older children are more likely to co-operate with you if you try to direct them. They can also be asked to repeat something they have done so that it can be filmed, though the second time may not be so spontaneous. It rather depends what the action is. Something straightforward like leaping into a swimming pool would look just as good the second time. If you ask a child to repeat an expression the result will be hopeless, if not grotesque.

With family records it is the characteristic things that you are after and these are the things you want to remember them by. All children have peculiar habits; your object is to try to get those on film—naturally. Some people believe that you can get the best results by playing with children while you film them. This is surely a matter of personality. You may be good at it, and if you are you should certainly carry on in this way.

CHILDREN ON THE MOVE

Among purely technical problems with child movie-making, the fact that your subject is mobile is undoubtedly the greatest. You are not able to pursue a child with a cine camera in quite the same way as for a still; the camera will be running and must be held steady during the shot. Only between shots can you hope to catch up with the child. The technique involved is a swift change from one position to another taking each shot carefully and making any necessary adjustments to the camera between times. The result must be a series of shots from sufficiently varied viewpoints each of which is technically as good as the previous one.

The zoom lens might seem to be a great help here but you would find it very difficult to keep up with a child while zooming and also coping with the refocusing that might be required. It is easier and generally more satisfactory to shoot from varied viewpoints.

Focusing can be a problem with children who are constantly wandering around. The simple fixed-focus camera gives no trouble unless you go too close, but the camera with a focusing lens is not so easy to use. Indeed, it is often advisable to set such a lens to act as a fixed focus one by making use of the zone focusing method described on page 89. Even then you should still aim to vary your viewpoint.

Some interesting activity will occasionally root the children to a single spot so that you can shoot freely without movemen problems. As long as the children are not altogether static this is fine. On outdoor locations especially try to keep them in a restricted space where possible. At the seaside on a wide open beach they will tend to separate and run all over the place, making it very difficult to film them all. If you could get them interested in a rockpool or some beach object you have a better chance.

Climbing is a good activity to film, because although they are moving, the children do not pass quickly out of range—unless they drop out of the tree!

You can easily occupy the attention of the child with pets, but then certain pets are liable to cause more wild movement than you would get without them. Children with small sized pets such as white mice would be quite tricky to film because of the wide difference in scale, but larger pets can provide the answer to movement and interest, and are worth considering for a child film.

We have not mentioned audiences because most child films are made for family consumption. Only in a more advanced type of

113

film would you make up stories about a child's life. These could be factual, although in the long run the success of such a film would depend on the ideas put into it. The film could be centred around the child's particular interest, even if it is something as simple as sticking stamps in an album. The story could be developed from that.

A really ambitious film might trace the whole sequence of events. For instance, if the child's hobby was building models, the story could start at the point where the model is bought, follow through the building of it, to the time when it gets trodden on. This is the kind of film that could interest a very wide audience.

FRIENDS

Before asking your friends to appear in front of your camera or otherwise assist in your film making, you must ensure that you are completely familiar with your equipment. You may have to think of about a dozen things at once without paying much attention to the camera. Its operation should have become second nature to you.

If you want to make a film with the help of others, you must at all costs not waste their time. The quicker you can work the better it is. Even professional film-making involves a great deal of hanging about doing nothing, but professionals are paid for their time.

The amateur film has to be organised. You have to persuade people or suggest that they might do something so that it makes sense to them. It is no good issuing commands unless you are "mock-bullying" people you know very well. Even that joke can wear thin in a surprisingly short time. You must always remain in control and you can do that without making yourself unpopular.

You will often feel that you want to move people about rapidly like props. You may become irritated when they seem to carry things out sluggishly, but it is probably because they are bewildered. Remember that it is much more difficult to carry out instructions in front of the camera than issue them from behind it. Above all you must not show exasperation. You must make them think you are pleased with how things are going even if it isn't true. A little practice with handling people will give you a formula to work to.

As well as organising, you need to keep yourself open to new ideas. Your friends might make useful suggestions and you should

incorporate their ideas wherever possible. But don't let them take over. Just try the idea and *acknowledge their helpfulness*. If their suggestion is ridiculous, which may often be the case with people who have little understanding of the problems of cine work, still thank them but explain that it is unfortunately not technically possible or that it would not work out in editing. Alternatively counter with an even better suggestion yourself.

Try not to limit yourself by making a film too dependent upon the co-operation of other people. It serves as a good safety valve to remain fairly lighthearted about the whole affair. The spirit you project into the thing will be reflected in the reactions of your helpers. It is up to you entirely.

If, for instance, your film concerns a group and yourself on holiday you should try to share the film and not bludgeon everyone into your way of thinking. Other people might want a record of their part as well! If you want to make a serious film, you will have to make the two simultaneously. You have a camera with you, they will expect to be filmed and you must accept this. It would be a miserable holiday partner who avidly filmed every monument in sight and wouldn't spare more than a few frames on his companions. Your dreams of making a serious travel film when in a group are in any case much less likely to come true. Such a film can be made more easily on your own or with someone who doesn't mind patiently waiting.

Making your film from a friend's ideas or subject would seem difficult, but in fact if you are relying on him for the information you can concentrate all the more on making the film itself worthy of it. This kind of co-operation can work out extremely well if your respective spheres of interest complement one another.

SOMEBODY ELSE'S FILM

At some time or another, someone will probably ask you to make a film for them. It may just be a question of filming children, wife or house. Or it may be something more difficult, such as recording their hobby or something they have constructed.

You can learn a great deal by making films for other people. The restrictions it imposes upon you may be a challenge to your ingenuity. Practice in adapting yourself to things outside your control is bound to improve your technique.

First find out exactly what kind of film is wanted. Your "sponsor" may not be very clear in his mind himself. He may be thinking of it in terms of what he has seen on television or at

the cinema. This may be impossible for you to do and you must say so.

Will the film be shown to other people? Is it to be in black and white or colour? How many copies are required? Get the cost worked out at an early stage so that you both know where you stand. Your sponsor may not realise how costly a long film can be. He may say he doesn't want a very long film—just half an hour or so! You must explain that a film of that length would probably take weeks or months to prepare and would cost quite a lot. The subject can probably be fully covered in ten minutes or less, anyway.

All these matters can be discussed without getting tied up in technicalities. But keep your feet on the ground; be sure that you can carry out your argument in practice, that you can do what is wanted. You can explain how editing can play an important part—some shots can be cut out, others may be rearranged. You should not undertake to produce a professional job, but if your costs are being paid you must supply at least a competent record.

If it is a family film you should try to make the film as if the family is your own, not for a wider audience. Don't ignore or overrule all your sponsor's ideas unless they are quite impossible —it is his film, after all. Find a balance between his ideas and your own so that you are not pushed into making a bad film that you must take the blame for afterwards.

DOMESTIC ANIMALS

Like children, animals are unpredictable in their movements and anyone attempting a film should be prepared for a good deal of wastage. One advantage with animals though, is that you can check their movements by persuasion or bait, or in the case of dogs by command.

Domestic pets are by far the most popular subjects for animal films. They are much easier to film outdoors where there is plenty of light. Indoor filming always means powerful lamps, which are disturbing to animals as well as creating awkward shadows. Outdoors, the animals can be placed against a natural background which excludes large dominant objects or distracting patterns.

Where the animal is the true object of the film and not just a participant, the background should accord with his nature. Animals that are normally on the ground, like rabbits or tortoises,

should not be filmed against a sky background, but the cat, who is a climber, may be shown either way.

Most pets are best filmed from a level near their own viewpoint. When they are on the ground the cine camera is very low down yet at the same time should be free for movement. The camera must be held in the hand; a tripod will not give sufficient freedom.

Bright sunlight outdoors is very strong and it may be impossible to use a reflector unless the animal is staying fairly still. Natural reflectors such as concrete paving or a wall will improve the situation.

Dogs look their best in an active sequence, such as retrieving a ball or jumping in the air. This rapid movement is a great problem. If the dog is crossing the field of view a pan shot from a distance using a long focus or zoom lens would make it easier to keep him in the frame. Puppies can be more interesting and simpler to film as they are often content to perform their antics at a short distance with perhaps just an old slipper. Two puppies scrapping may also stay put long enough for a sequence.

Food is the best means of control for most pets. Many can be successfully filmed in groups only by this means. Interest wanes after just a few shots if the food is given to them. If they have to attain the food then some good sequences could be devised.

Cats are nearly always filmed more or less in close-up, as the cat must appear large in the screen. Many cameras need a special close-up attachment for such subjects and even with some zoom cameras the focusing range may not come close enough for a sharp picture.

Cats are moody creatures and are better filmed only when they show signs of co-operation. Kittens are a splendid subject; their inquisitive nature and playfulness can be aroused quite

It is easier to film an animal if you keep him within a limited radius of action. Devices such as (1) a piece of cotton ; (2) a bowl of food ; (3) a naturally restricting plane such as the top of a wall ; and (4) a glass sheet lowered into a tank for fish or reptiles.

117

easily and to very good effect. A piece of string works as well as anything, but some assistance is needed to keep up the fun while you are filming.

Although for technical reasons you want to restrict the area of action, too much control is likely to produce some rather static results, the exact reverse of what you aim to achieve with a cine camera. On the other hand, a natural restriction such as the top of a wall or branch of a tree may give you the activity without the difficulties of focusing. But be careful about exposure. Set manually if possible, because a bright sky background will mislead an automatic camera.

Rabbits' cages are usually too cramped for cine. Take the rabbits out and put them on the grass, short grass if possible, or have them held by someone. They will stay put for long enough for some good pair, or group shots.

Although they lack colour, horses and ponies are a most interesting subject for cine films. They can be shown in all the activities of the stable or in spectacular studies of action when racing, in show-jumping, etc. In nearly all cases the action is under complete control and the large size of the animal makes him a straightforward subject for a cameraman.

SMALL ANIMALS

Mice and most pet birds are very small subjects and need a constant check on focus as you film. Mice are better taken out of their cage and held in the hand or perhaps placed on the sleeve or shoulder of an assistant. Birds cannot be removed from their cage outdoors but their bright plumage makes up in colour for anything lacking in movement. The cage will keep them in a small area, but even this becomes rather large in terms of the focusing necessary where you are working in close-up. Fortunately, the narrow depth of field makes the cage bars rather indistinct when the camera is very close. A reflex camera can tell you just how much out of focus they will actually appear.

Remove from the cage any bright things that reflect the sunlight directly into the camera lens. Keep the background colour distinct from but, if possible, harmonious with the colour of the bird.

A tortoise, though a rather inactive creature can quickly move out of focus when you are working at close range. Tortoises may be filmed satisfactorily in groups; low-angled lighting is preferable and wetted shells have more colour.

Fish can be tackled best by lowering a sheet of glass into the tank, leaving a small space between that and the side of the tank. Use a dark background and be careful of strong reflections from the glass if you are using additional lighting. The tank should of course be clean inside and out. You will be working very close up and should only attempt it with a reflex camera.

When shooting through the water's surface, reflections are your chief trouble. You can reduce this effect by placing a sheet of dark card opposite and at right angles to the camera (which should always be pointing obliquely into the water) just above the surface. As you change position you move the dark card around so that you are always shooting through the dark non-reflecting area.

Alternatively, a large curtain of dark colour could be suspended on the other side of the tank, provided that this does not interfere with the lighting arrangements. With the curtain you are restricted to shooting from one side only; moving the curtain would be a major operation involving replacement of the lights. It would, however, provide a suitably dark background if you switched to shooting through the side of the tank.

Insects are a fascinating subject for the cine camera, but unless they are the larger species they cannot be filmed without a camera fitted with special lenses. A subject of, say $\frac{3}{4}$ inch in length can be tackled with many ordinary cameras if fitted with the correct close-up lens. Only a reflex camera is suitable for this work, the subject being so close to the lens that a straight-through view-finder would miss it altogether. A zoom reflex would offer greater flexibility. At such close range with insects care must be taken to avoid casting the shadow of the camera over the subject; it would spoil the lighting and many insects would take it as a warning signal of approaching danger. (See Close-up pp. 32 and 86.)

WILD LIFE AND ZOO ANIMALS

Wild-life cine can be extremely difficult. The noise of the camera precludes you from filming many subjects. Filming from a down-wind position often helps, so that your scent and the camera motor sound are carried away from the subject. On the other hand, help may be needed to stir some sluggish subject into life, particularly when it is used to humans or indifferent to them.

Zoo subjects are a favourite. You have every advantage, particularly in a zoo without bars. In other cases you can often

119

eliminate the netting by placing the camera lens right up against it but there are two dangers here. The animal might take an unexpected swipe at the camera or you might scratch the lens on the wire. You may use a lens hood to prevent this but press it against the wire—not right through or the animal might have a metal supper left sticking in the wire.

Zoo filming is so easy, one is inclined to overlook the often unglamorous background. Try to draw out the subject. You may be able to see it easily enough in life but on the screen you are reducing a three-dimensional subject to a flat picture and you need any illusion of depth that you can get. This is usually provided by lighting, but at the zoo you only have the sun, if that, to help out. Use the sun if you can, otherwise select another camera position with a suitably toned background. If the background consists of other people, they should preferably be out of focus or they will draw attention from the animal.

Feeding time at the zoo is the period of greatest activity. Fine action sequences can be filmed of a really exciting subject like seals, plenty of splashing, flying fish, heads in the water, wobbling and flapping round the keeper, etc. Find out the feeding times and go and get your place early. Select it carefully, as free from obstructions as possible, because you may have to hold it and take all your shots from there. The best position will give you a clear view with several possible backgrounds depending on the positions of the animals. Take care with exposures when using bright sky backgrounds or filming a subject sitting on sun-drenched concrete. An automatic camera can easily be misled in such circumstances.

SPORT

Sport is a most exciting subject to film. Movement is at the basis of every sport, just as it is with cine photography. Whether it is the celebrated runner or school sports day being put on film, a permanent record of the actual motion is clearly more satisfactory than a single snapshot taken somewhere during the event. Moreover, it is very difficult to take a snapshot that really tells you anything, whereas a movie sequence is, in many ways, easier to make well. Nevertheless, as with other subjects, you need forethought as well as technique to get the best results from your equipment.

A simple cine camera is adequate for those forms of sport where you can secure a reasonably close viewpoint. If you are

barred from close contact with the event by spectators, you must be satisfied with general views unless you have more elaborate equipment. It is better to be too close than too distant. In sports work close shots often have far greater impact.

If you intend to do a lot of sports filming the camera with a zoom lens is really the only sensible choice. In all track events and most field games the cameraman must expect to be some distance from the action. Moreover, this distance will be constantly fluctuating, and he must be able to change the size of the image quickly enough to get the next shot without fuss. The zoom lens is the perfect answer. No wonder that since its invention, this has been the favourite lens for TV cameramen working on sports programmes.

With all track events you can anticipate the movement of the subject. It is therefore very important to choose the right position on the track, the place from which you will get the best view. Always try to be clear of the spectators' heads so that you can move the camera freely, especially for panning shots. Motor racing films for instance tend to be rather monotonous if all the shots are from one position. Choose a point giving a clear view down the width of the track but with the possibility of some other point of interest.

The finishing line with all such events is obviously a must, but you need some other point as well for variety, such as a corner. You cannot alone hope to cover the whole event and it is usually better to attempt a film about racing than a certain race.

A complete sports film on such a subject would have to be cheated, taking shots from each event and changing camera position between times. These cheats would not be so obvious in the finished film.

Horse-racing scenes must include shots from near the start and finishing lines and at the jumps, but the bends in the course can also serve to draw the horses closer together. A long-focus shot down the course can have the same effect, owing to the natural effect of the distant viewpoint.

With speedway racing it is often possible to cover the whole track from one position even without special lenses. At local meetings you may be able to change your shooting position during an event but it is safest to assume that you will not be able to move while the race is on. If you do you may not get another place good enough for filming.

The same technique applies to other field events such as running and hurdling, except that a head-on or near head-on view is

occasionally possible which will make an interesting change. On short races find a position near the finish so that the competitors approach the camera to the finish.

In those forms of athletics that use a relatively small piece of ground such as jumping, throwing the discus or javelin, putting the shot, or other athletic demonstrations, the interest is centred on a small spot. Either you must get close or use a long-focus lens. Here attention is far more on the individual and the effort rather than the ground he covers. Filming the javelin event, for instance, you would concentrate on the preparation and throw. It will generally be impossible to follow the javelin through the air but you can always try to film a different javelin falling to the ground.

Water sports such as swimming, diving and water polo need a high viewpoint for good coverage. Humidity in some baths may mist up the camera lens but this will clear after a few minutes. Any condensation that forms on the outside of the camera should not affect the inside but you should keep well enough away to avoid water splashes on your equipment.

Unfortunately many events such as swimming and greyhound racing take place indoors and even early evening light through a glass roof makes shooting well-nigh impossible. You will have to get all your material some time before dusk, as the artificial lights are normally far too feeble to work by.

For sport pick shooting positions that offer the best view of movement or crucial movements. For example, good viewpoints for rowing are: (A) from one end of a bridge or, (B) from the river bank. In football good positions are: (A) on the goal line near the posts or (B) about 25 yards up one side of the field shooting into the goal mouth.

Rowing leaves you little choice of position. The best vantage points are either the river bank or one end of a bridge (not the centre) because an oblique angle is far more indicative of movement.

The best positions for football are a couple of dozen yards up the side of the field shooting into the goal mouth, and on the goal-line near one of the posts. The touch-line position works well for Rugby, too.

With many sports played on a small field it is possible to set your lens to be constantly in focus wherever the players may be. With lawn tennis and badminton the best place is at one end of the net for shots of each player in turn or high up at one end to picture any exciting rallies.

Ski-jumping scenes can be taken from one side of the jump a short way down from the take-off point. Interesting scenes can also be taken at the end of the run when the skier finishes.

With all sport, take plenty of additional shots of a more general nature. The action shots are bound to be disjointed and you will need a shot of the crowd or a general view of the arena to avoid a sudden cut from, for example, the high jump to the 100 yards sprint. Horse racing could be accompanied by scenes in the paddock, athletic events by some sidelights such as refreshments or last-minute words from the trainer and so on. The big events may be the most important, but they will hang together much better with the sideshows included as well.

Indoor sports such as boxing, wrestling, fencing, are normally beyond the reach of the amateur cine camera because the illumination is not bright enough. But occasionally television cameras are also present so then you may use their lighting!

SPECIAL INTERESTS

Cine can sometimes be used in conjunction with other hobbies. It is by no means a "one and only" pastime, needing all your time as well as a deep pocket. It is not just the pleasure of combining the interests but the genuine help that film can give. Suppose you wished to show someone, even some society overseas, your collection of china ornaments or the layout of your model railway. A film with a written or spoken commentary might just fit the bill. You would not be very keen to send the pottery overseas owing to the risk of breakage and the expense of packing and insurance. You could send photographs or even transparencies. But a film is far superior, because the subject may be revolved and seen in changing light and the items can be shown in the correct sequence. Also, more people can see them properly. With a model railway layout, the advantages of film are even more obvious.

If your film is intended to be instructional, allow for the possibility that other people will take longer to grasp its essentials. To your eyes it should look a *little* long winded, then it may be right for your audience who are new to the ideas. You cannot teach effectively at breakneck speed. You may remember yourself that it is possible to sit through a film and be no wiser at the end of it!

A film can explain a hobby or it can just be about the hobby in general. It may be used to isolate an event or an aspect: film has a great power to concentrate attention, avoiding side issues by carefully excluding them.

Whether your hobby is making, growing, collecting, restoring, improving, converting or even destroying things, the camera may suddenly come in handy. It can even be useful applied in the arts where musical performances, painting, theatricals, etc., may be filmed. A film is a very compact means of storing information and details that might be forgotten or take too long to preserve any other way.

Have you such an idea? Such a problem? Perhaps you can solve it with your camera.

WEDDINGS

You may be asked to take some film at someone's wedding. You want to oblige. The point is, should you? A wedding is a responsibility; the couple may depend on you for their record. Fortunately, most people have still pictures taken at a wedding and cine is only an adjunct to this—if they have movies at all.

If you are to be the sole photographer there, it is a responsibility indeed. If this is so, and you are doubtful about your abilities then you should refuse. You can explain why; a sensible couple are sure to sympathise. By not accepting, you yourself are adopting a responsible attitude and show that you do not treat the matter lightly. If something goes wrong they cannot give you a repeat performance. The trouble is, when anyone is under duress, they tend to forget the simplest things—it's just human nature. Everything must be right, the pictures must come out, there can be no question of error.

Do you want to take it on? You must know your equipment well enough to operate it instinctively. The general excitement can be distracting, and a witty comment thrown in your direction might, if you are at all sensitive, fluster you at the wrong moment.

A simple camera is best and you should take the outdoor

scenes only, unless you are experienced with lighting. Use your normal film and don't do anything different from normal. Use a familiar camera; a strange, borrowed one is as good as no camera at all in these circumstances. If you have settings to make, ignore the people you are filming for a moment and check again. If you always hold the camera in your hand, don't use this occasion to try out a new pistol grip.

You should take extra care with the preparations beforehand, such as cleaning lenses, the inside of the camera and replacing the motor or meter batteries if required.

There is nothing special about the technique—do as you normally do. If you are asked to "do some filming" at the wedding you should find out beforehand what type of film record the couple want. Will they want the whole event or just scenes outside the church? You may make some suggestions. Do they want scenes of the groom in his last moments of freedom? Or the bride being dressed like a queen? Sometimes such a plan requires you to be in two places at once. In that case you may have to cheat a little. Film the bride trying on her dress the day before—if she'll let you. Maybe the film could go back to the beginnings where the material is chosen for the bridesmaids' dresses, then show them being made.

However detailed the film will be, some scenes can be filmed in advance. Shots of the church for instance, and shots of confetti on the ground, from some previous weddings, of course!

A professional wedding photographer will probably be employed for the occasion. As he is trusted with the job, you should not obstruct him. Although they occasionally clash with enthusiastic amateur still photographers, professional wedding operators have no objection to people shooting cine films, which are not competitive. Some amateurs, however, cause friction by always being in the way. You must realise that the professional is more important than you and his pictures come first. Keep out of his way. He can, of course, appear in your film, taking pictures. That is, after all, typical of almost every wedding.

Even today many wedding groups are still posed in a stuffy and unnatural manner. With a cine camera you can film scenes of the people behaving naturally. After they have tensed for the still pictures they will break up and disperse in a casual and pleasant way.

This is a time to catch them, while they are still grouped close enough to fill the screen without empty space, but at the same time talking amongst themselves. You need this animation for the

film. Don't shoot them in all their static arrangements (unless for the scene including the photographer that we discussed above). That will result in a film of immobile persons and will look absurd.

There are many moments of action a still photographer tries to capture that you can do much better on film. The couple hurry to the car, confetti is thrown. Such scenes can be very charming from the right angles. If the couple stop at the car door and hold a frozen grin for a slow photographer try not to film it. Make a quick change of camera position and film them getting in and driving away.

If a full film is being made it is important to cover all the main stages of the ceremony:

1 Arrival of the bridegroom and the best man.
2 Arrival of the bridesmaids.
3 The bride arrives (if it is not a white wedding, make sure you know who the right person is).
4 The ceremony (generally cine cannot be used).
5 After the ceremony, groups of all important people outside the church with the church in the background.
6 Bride and groom walking towards the car.
7 Bride and groom getting into car, confetti thrown, onlookers.
8 Car drives off.

Keep the position of the sun in mind. Some pictures will be taken against it and some with the sun behind, especially of the groups, when you are likely to move around and shoot from different angles.

Keep shooting in one direction for general shots, say on one side of the path, otherwise people will appear to be walking in different directions. If you are doing many close-ups a sense of direction is not so important, the main thing is to get what you want, expressions, people, faces and the bridal pair.

There is much jostling and excitement as the couple leave, so keep your camera clear. A long shot with a tele lens would be a better solution than a black eye, although a jostled camera (wide-angle lens) at close range conveys some of the excitement of the crowd. You could in a frolicsome situation hold the camera in front of your face and point it in the general direction. Confetti-throwing arms are apt to knock anything.

Be at the church early, certainly before the bridegroom and best man arrive. Shoot some of the guests but make sure you have time to reload, if necessary, before the bride arrives. Film the arrival of the bridesmaids and their entry into the church.

The arrival of the bride is the highlight of this first part. The bride, with her father, will walk up to the church after posing for photographs. Shoot the arrival first. Then when they stop for photographs you can go farther up the path and shoot them approaching the church doors.

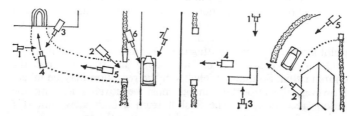

With weddings, determine first the direction you want the action to flow in. Later you can move about for individual CU shots of people. Some good positions to choose from (left) might be (1) (3) and (2) to cover arrival and departure of groom, brides-maids, and bride, (4) for gateway outside the church door after the ceremony and (6) would be ideal for the car or failing that (7) but not both. Outdoor reception (right) (1) receiving the guests, (2) general view from high window, (3) cutting the cake, (4) groups, (5) departure scenes. These diagrams are only to give an idea, actual layouts will differ with every location.

The ceremony itself cannot be filmed but the time can be bridged by a few shots suggestive of the marriage such as the cross, stained glass windows, or some other church feature. This would be particularly effective in a sound film if a recording of the service had been made. These extra shots would be taken with permission some other time when the church is not in use. Alternatively you could fade the scene before and after the ceremony.

After the ceremony, the couple are usually posed at the church door. They can be filmed then, even though the shots may be rather static. (Incidentally, if the photographer uses a flash gun the flash will also appear on one frame of the film. All white flashes, even single frames, show up on the screen and have to be cut out later. This can usually be done without producing a "jump".)

Scenes taken after the ceremony also include the couple going down the path to the car. A high viewpoint shows the couple and the confetti-throwers more clearly.

Any special or experimental-type shots such as the bride reflected in a polished headlamp or confetti-throwing in slow motion may be effective, but they must always come *after the essential shots have been taken*. Be absolutely sure to readjust back to normal any controls you have reset on your camera. These ideas are better avoided unless you are fully experienced.

Indoor receptions are normally very difficult unless you can make special arrangements for lighting. Then the procedure is: bride and groom receiving the guests, where again a high viewpoint is advantageous; cutting the cake; and speech making.

Outdoor receptions offer more scope and freedom than the church ritual. So many sidelights of the reception may be taken. However, the important things must be covered as with the indoor reception. A general shot from a high viewpoint (for instance from a window) is good for setting the scene.

Other special occasions may present all kinds of filming opportunities. With all these if you have been asked to make a film use a simple approach. A neat little film only one reel long will be better appreciated than a confused rambler with many gimmicky shots but no clear idea of just what is going on.

TRAVEL

The success of a travel film depends mainly on preparation. You need adequate equipment in full working order and enough film. But don't load yourself up so much that you won't bother to take the camera farther than your hotel room.

It is nearly always best to buy your film from your usual supplier and take it with you. It is often more expensive abroad and your favourite brand may not be easily available. It would be very unwise to try to mix in shots taken with a different make of film. The colours just will not match.

If you plan a really ambitious film, find out beforehand what restrictions there are on taking photographic film in and out of the country and what processing facilities are available. Unfamiliar makes of film may be difficult to get processed and even the same make abroad may use a modified process. Find out if there are any restrictions on photography, too. Even where there are, it may be possible to obtain permission to film by paying a small fee.

Read any available literature on the place you are going to visit and decide how visually interesting it is. The ardent cine enthusiast may even work it round the other way, choosing a

holiday place that will make a good film. Having done so, decide on the treatment, as exemplified in the market scene (p. 21), bearing in mind your prospective audience.

Your treatment of the locale can be interesting even if the place is a familiar one. For instance, you may start a film on Rome by a shot of the Colosseum. Then you hardly need a title, because everyone knows where the Colosseum is. From one or two world famous landmarks you can then diversify the material, and bring in your own personal interests. It is, after all, a film of your holiday.

The "landmark" shots may seem corny but don't despise them: imagine a film about Rome *without* the Colosseum. Include people in your scenes, local people where possible. Adopt the methods we discussed before (p. 108).

You can find interesting places and sights that no one else knows if you use your eyes. In an English town you may find a view that looks like a Mediterranean resort, not that you want to make the town look like somewhere else but you might like to show its diversity of interest.

Take some basic shots to tie your special ones together. In Rome, for instance, some of the quaintly narrow streets and beautiful fountains will help. If you are interested in Roman ruins they can be cut in where appropriate amongst the other shots to supply background continuity. It is only too easy to forget to get an overall coverage of your holiday. So take a few shots of seemingly ordinary subjects to fill out with, and to help unite some of the other shots.

Local characters are to be found everywhere. Candid shots are by far the best and in a noisy place your camera is unlikely to be heard. If a companion can oblige as a shield, you may be able to film unnoticed by shooting from behind him.

In a travel film certain basic ingredients that help are: (1) a landmark to set the scene; (2) local characters or natives, (3) maps or old engravings for describing journeys or to give the historical angle.

Always have your camera at the ready. The most interesting subject on your holiday is usually an unexpected one, whether a character, scene or event. Parades, carnivals and processions provide thrilling material for travel films.

Scenes from moving vehicles can be taken if the vibration is not too great. Aircraft are smooth enough, so are trains and mountain cable cars, provided in all cases that the camera is not held against the vehicle itself, such as a railway carriage window. Where possible shoot with the window open to improve the quality of the results. Scenes cannot be taken from buses or cars without vibration unless they are running on exceptionally smooth surfaces.

European scenes can be much brighter than anything encountered in Britain. Strong sun, a cloudless sky, total lack of atmospheric haze combined with white buildings may give you a very high exposure-meter reading. On cameras where the exposure is adjustable these optimistic exposure readings can be troublesome. There are likely to be some dark shadows and the brilliant light will make it all the more difficult to get detail in the shadow area, unless care is taken. Exclude the misleading bright areas from the view of the meter. With automatic cameras this means getting much closer to the subject than normal. (For exposure technique see pp. 102–7.)

Local interest films are more difficult. Something new has to be said about the place. Alternatively, it must be looked at in an unfamiliar way. Occasionally people are more keen to see the place in which they live on film than a travelogue of some foreign city. Local enthusiasm may be aroused if you can explain things that people had never thought about before. This may involve delving into local records and histories and even the use of old prints or drawings that will explain how the toll gate came to be where it is, why the town hall has a curious roof, or where the flowers come from that decorate the town all through the summer.

FAMILY

Family films probably represent by far the larger proportion of amateur movies. Yet they are not without problems.

Actually, the conditions under which most such films are made ask more of the cameraman and his equipment than he would reasonably expect with his general filming. Consider why.

With a family film you wish to film indoors as well as outdoors, sometimes on the same film. Indoors you are working in a con-

130

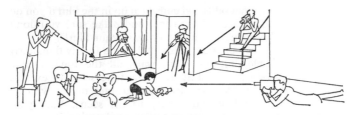

With indoor films, even in a small space there is still scope for trying a number of different shooting angles. Chairs, windows, open doors and stairs offer support or a choice of heights. An object in the room may add foreground interest to a shot.

fined space—no room to move—not enough to go farther back and "get it all in". Outside, often as not you confine yourself to the garden. It depends on the garden, of course, but if it is a small one you've the same problem as indoors: backgrounds in the garden are not always what you desire. Children are involved somewhere—and they are never easy to film. Add to this a host of other disadvantages that arise whenever the family demesne becomes a film studio and you have a packet of troubles that would make any professional scratch his head.

Despite this, family films get made—and well. The best are rarely carefully planned. The planned family film turns out not to be a family film at all. It seems unnatural and although outsiders may find it interesting or amusing, the family themselves remember that they were playing a part. They prefer to see natural action, preferably when they were unaware of the camera. You may have to shoot in a very random manner to obtain such shots.

When shooting outdoors use 'open' and 'closed' backgrounds, i.e. distant views or nearby foliage. Take advantage of any special features or incidents that offer themselves but don't let them take over the scene or detract from the main subject.

It is surprising what odds and ends turn up in the film if you do not take care. Tidy around the room and make sure you don't include a load of camera gear and cases in your film!

Any normal room backgrounds will do for a family film, fairly simple if possible, but not plain walls all the time. Drawn curtains may be useful and at the same time serve to exclude unwanted daylight. Occasionally a foreground object with an interesting shape might add variety to the scene. Vary your camera angle, too, by standing on a chair or shooting from a low viewpoint as if presenting a child's-eye view.

Don't restrict yourself to one room—use the whole house—the stairs can be useful for angle shots.

Many houses do not allow much space for filming, you can feel quite cramped with a camera even in a home of medium size. Be prepared to shoot through open doors, even from cupboards to get the extra distance. Alternatively you may be able to get a wide angle attachment for your camera so that it takes in a larger part of the scene from the same position. Look in the camera instruction booklet or enquire from the manufacturer.

Parties and Christmas celebrations provide heaps of material for interesting shots ranging from decorations to squabbling children. Film the colourful side of things as well as the strait-laced. Show the children lined up demurely at the table as well as the kid bending a spoon.

Outdoors, the garden or park is the usual location, and undoubtedly the best, unless it is a family outing. Foliage will provide a good background in most cases. It is usually medium-toned or dark and always looks right somehow. If you have no high foliage and you would like to exclude the surroundings you have two alternatives open to you. If you shoot from a low angle the sky fills the background but you may have trouble with exposure (p. 102). If you shoot from a high viewpoint the ground will be the background. This latter is normally the best solution, and will work provided the subject is not too distant.

Parks present an assortment of picture opportunities; choose carefully. A good backdrop of trees or slopes with some fore-ground object such as a tree or a fountain adds more interest to the scenes than you get with just green grass. Keep your eyes peeled for these possibilities.

Adults in the family can be very camera-conscious and you can only overcome their rigid behaviour by tricking them. But you'll have to work at it. Make them think you are filming when you aren't; if you do that often enough they will get tired of being

formal and acting up to the camera. Do not expect good pictures to start with. You may get some, but later on you will do much better—it always happens this way.

COMPOSING THE PICTURE

Whatever your subject, you need to fit it pleasingly into the picture frame. That is composition.

Rules of composition are similar to those in painting or still photography. Make the picture harmonious and balanced, and keep it from splitting into halves.

Every shot should start and end in a good composition, even if the middle part of the take does not allow any careful arrangement. Try to make subject movement towards the centre of the frame rather than away from it, but avoid placing the main object right in the middle. Strangely enough, it is the weakest point, not the strongest. Move the camera a little to one side.

The strong points of the picture area are said to be where the thirds intersect. These are the four points of intersection of lines dividing the picture area into nine equal parts. Treat this theory as a reminder rather than a guide. Don't take it too seriously:

Composition must be considered for every shot. Ideally, each shot should begin and end in a good composition. A shot does not work too well where the picture seems to split in two (1). A well balanced framing (2) is more interesting (here divided by thirds, see text). A shot is dull (3) where the subject is right in the centre. Don't make the shot too symmetrical (4) and use a foreground object (5). Sometimes objects at various distances (6) give an illusion of depth.

133

it is difficult to think of every subject through an imaginary grid.

When talking about "balance" in composition we refer to the arrangement of light and dark areas with respect to their size. Thus in a landscape shot where a large tree is seen in the right side foreground and the remainder of the scene is lighter in tone, a corresponding dark area of smaller size on the left would balance the picture. The two subjects should not be the same size or the result will be too symmetrical, which pictorially is very dull.

A large area on the left would balance with a smaller one on the right. Now suppose we move the tree farther towards the centre of the picture. The counterweight required on the left side diminishes, the picture appears balanced as it is.

Try to have a notable foreground object in some of your exterior shots. This will add an illusion of depth, especially when filming rather flat-toned scenery. But do not let the nearby subject blot out vital parts of the scene itself. Better still, arrange your scene using several subject distances. You can often use another person in the middle distance to give depth, or a tree, gate or some other fixture. Make sure, however, that there is a main point of interest on which the eye can come to rest. Don't allow a profusion of disconnected pieces to confuse the picture.

Try to fill in large areas of empty sky by using the overhanging branches of a tree. Sometimes you can even exclude the sky altogether.

The best places to cut the human body when framing are: (1) knees; (2) waist; (3) chest; (4) just below the top of the shoulder and (5) cutting a little from the top of the head, which should preferably be slightly off-centre in the frame.

Make the subject as large as possible in the picture area but not so large that you cut off important parts; and don't chop off any part of the subject if it should really be seen in its entirety. The best points at which to cut off the human body are at the knees, waist, chest, and, in close-up, just below the shoulder line.

In a big close-up, the cut should be a little below the chin and some part of the top of the head can also be excluded to keep the eyes, the centre of interest in any shot of a person, a little above the centre of the frame. The eyes must always be in sharp focus.

Avoid close-ups of people in conversation. They draw attention to the absence of sound. Shoot at longer range and accompany the words with action. There can be no meaning in people just standing and talking in a silent film. Make the action tell the story wherever possible.

A lively film always has variety in its individual parts. Use unusual camera angles where they make sense, but don't overdo it.

The art of composition is often thought of as a natural gift exclusive to certain people, an art that cannot be taught. This is quite wrong. In the past, painters have learned certain kinds of composition by following the example set by others. But as you are working with a moving subject, you should look to films and television for an example to follow.

MORE AMBITIOUS FILMS

The methodical type of person always has the advantage when working on more ambitious projects. If this is not in your nature you must work to a form laid down at the beginning. In big professional film companies where you have hundreds of staff running hither and thither while the film is under way, a special code of social behaviour and an established working method ensures that the whole project, however large, never gets out of control. On a minor scale you have just this situation. You must marshall your ideas properly and guide those who help you according to the plan. Ambitious productions must involve more preparation and you ignore this fact only at your peril.

SCRIPT

If a script is worth doing it's worth doing properly. Nevertheless, it is, in silent films, simply a guide to shooting. You don't have to be a gifted author to prepare one.

A script is compiled in three stages. First you write a *treatment*. This is just another word for the story, a draft of your ideas that you can alter without undoing any carefully prepared work.

Having settled this and set out what you want to do you proceed to the next stage, which is a *synopsis* or *scenario*. A scenario is a summary of the film story event by event, in the order in which they will take place.

At this stage the story becomes a coherent whole and you will use this detailed account of the film as a basis for the final stage which is the *shooting script*. This is based on the detailed synopsis but broken down into numbered camera shots with the time that each will take and any other important technical points. This is in fact a version, in words, of the final film. If you wish to make alterations you can constantly refer back to the synopsis which will make sure that you do not deviate from the story and film something that will not fit in.

The particular advantage of the shooting script is that you can treat each scene or take as a separate entity and therefore shoot them in any order you wish. Whne the different pieces are assembled at the end, the film will still make perfect sense. As an example, here is a short extract from a *treatment*:

At last Mary decides she must break her promise and open the old chest. So she does and inside . . .

In the *scenario* this becomes:

Mary ponders over the old chest, then goes to drawer and gets the key. It is a rusty key and the lock is a bit stiff but at last she succeeds and is horrified to find inside . . .

A simple shooting script may be all you need. You may feel you can work out the details when it comes to shooting. Beware! There are a thousand things that go unnoticed when filming. Don't lay yourself open to them, at the beginning at any rate.

Now, this is how the sequence appears in the shooting script:

SHOOTING SCRIPT

Shot No.	Type of shot	Action
56	LS	Sitting room, door in background, chest large in foreground, glint of light on metal bands from a table lamp nearby. Mary enters, pauses.
57	MS	Mary stands there looking agitated.
58	CU	The chest (from Mary's viewpoint).
59	CU	Mary's face, eyes fixed on chest.
60	CU	Chest (as 58).
61	MS	Mary turns and walks to desk (pan camera), opens drawer.
62	CU	Her hand reaches for key.
63	MS	Shot from behind chest, Mary approaches (walks through into crosslighting) holding key crouches
	CU	down close to camera.
64	CU	Key in lock.
65	CU	Mary's face (crosslit).
66	CU	Key in lock.
67	CU	Mary's face (crosslit) (as 65).
68	CU	Key turns.
69	CU	Mary, from other side of lid, raises lid into picture. Horror on her face.

LS = Long shot. MS = Medium shot. CU = Close-up.

This is a far more detailed account than before. You can locate the camera quickly according to plan and in fact cover the scene rapidly and dramatically, and with a far better result than if Mary had entered and just been followed about the room with the camera. It gives you a chance to work out dramatic points before you try them. You can put all other information and ideas on lighting, camera positioning and the actors' movements and behaviour in this script too, using it as pre-shooting memorandum.

Good ideas thought up beforehand are often lost unless they can be put down in a tangible form that reminds you at the time of filming the scene. Every reasoned argument is in favour of a script wherever it can be used.

You may wish to go a stage further. Some people produce lighting and camera diagrams to go with their camera script so that they know, immediately they tackle the scene, where to place everything. If it doesn't work you can move it, and alter the script and the script itself will remind you to alter any other scenes for the sake of continuity.

A storyboard extract from the sequence: (1) shot 56, door in background, chest in foreground. Mary enters, pauses; (2) shot 51, Mary stands there looking agitated; (3) shot 58, the chest from Mary's viewpoint; (4) shot 59 Mary's face, eyes fixed on chest.

Some people also draw up a storyboard, or series of little pictures showing each scene as seen by the camera.

A planned shooting script immediately shows up any short cuts you can make in setting up the camera, lighting and taking the shot. In our example, for instance, shots 58 and 60 are the same. One long take could be cut in two (probably you would use a longer piece for the first shot) without moving camera or lights. Shots 57 and 59 are similar except for expressions and could be done one after the other without much rearrangement.

Shots of this kind will occur repeatedly. Work out the easiest way to tackle each part of the film without going back to a set-up

you've already done. Shots can often be grouped together for convenience in shooting. But remember that the further you depart from shooting in chronological order the more chance there is of continuity errors. Think also about cut-aways—shots you can use to fill up gaps when editing.

The above script is a detailed one. You may prefer something a little simpler, leaving scope to improvise as you go along. A simple version might just state the shots without repeats or shooting times, without diagrams, or storyboard. If you work this way be extra careful not to slip up with continuity. Notes about any particular shot you have visualised clearly beforehand could be added where needed. The script could be just a broken up version of the scenario thus:

SHORTENED SCRIPT

Shot No.	Action
56	Mary ponders.
57	The old chest.
58	She goes to drawer.
59	Gets key.
60	Tries it, it is a bit stiff.
61	She opens the chest (shot from other side of chest, lid comes up into frame).

You will need more cut-aways to liven up your results when editing, than you would for the fully planned script where the cut-aways are already incorporated. Here we have only six shots. Obviously by using a piece only of 56 and 57, you would make a more dramatic effect and you may meet all your editing requirements from just these six shots, if you have not skimped and made them too short to cut. Other "superfluous" cut-away shots might be very useful.

A good film never remains exactly as it is shot; every film can be improved in editing. You must take editing into account when shooting. The detailed type of script sets out to do just that. It has an advantage when time is short, where you cannot afford to hang around working out your manoeuvres for every take. With a long elaborate film you must script in detail.

FROM PAPER TO FILM

When you begin shooting the film you should mark off on the script each scene as you shoot it. This way you can avoid repeating

shots and be sure you don't miss any out. You might find it handy to prepare a separate camera sheet listing the shots and takes one by one. This you would keep on you all the time, and refer to the main script only when taking a new scene.

As you may be something of a one-man-band you may also need the camera sheet to note positions of actors, props and other items of continuity. Identify each take by first shooting a slate with title, scene and shot number chalked up. This is for sorting out shots in editing later on.

If you work in a group there is an even greater need for this camera sheet because the script will be with the director and he has things other than shot and take numbers to think about.

In these group efforts where close co-operation can put a strain on everyone, separate note-keeping will help rectify any errors that creep in.

Marking the remaining footage on the camera sheet shot by shot reminds the cameraman when a reloading is imminent, so he can warn everyone and not bleat, "Sorry, I've run out", just after a ten-minute rehearsal has finally attained perfection! A note of the footage may also indicate when a particularly lengthy shot cannot be done without changing reels.

UNPLANNED FILMS

Some films cannot be planned, and no species of script will help. Where you are shooting scenes of wild life you could get almost anything and possibly not what you set out to get at all. You may gather some related sequences that can be made up into a film afterwards.

If you contain your field of interest within a small area, you can practise a kind of planning but filming a nesting bird from a hide is not really the sort of thing you can script beforehand. Inevitably it is freely shot material or *wild* shooting, as it is called.

If the film ranges over a wider group of happenings a sort of scenario in which you can work out your ideas may possibly be of use. Generally, however, the only planning these films get is at the editing stage.

PLANNING BEYOND THE SCRIPT

Outdoor scenes usually mean travel, and travel is expense. All these scenes must be sorted out and grouped together for shooting like those indoors. Check your equipment and see that

you have everything you need, and the correct arrangements made for people who will help and on whom you depend.

LOCATIONS AND ARRANGEMENTS

Locations create the mood and atmosphere of your film. You should look thoroughly for the right setting but not too far afield. You may be able to use a distant place for a brief insert that can be shot in one day but locations taking up a major part of the film should be near enough for your volunteers to reach easily.

Even if you provide the transport, and you must pay any fares, a long journey knocks the enthusiasm out of any volunteer. Repeated takes tire them even more.

Do not choose a background just because it is your favourite spot. It should be interesting, but its correctness for the film itself is paramount. You want it, not just to impart information but to lend variety to your scenes as well as atmosphere.

Locations are not just backgrounds. They should have more than one feature of interest. Repeated appearances of the same fir tree or garden ornament make the audience think it has some special significance. If it hasn't let it appear once only or twice at the most.

At various times of the day your selected location can look quite different. You get quite different moods at: (1) early morning; (2) midday; (3) afternoon and (4) evening. Find the right time for the scene in question.

Any seasonal aspects, opening times, possible obstructions, etc., must be taken into account when choosing a location. The time of day can also make a huge difference. Check that half your location won't be in deep shadow when you arrive.

You may have to obtain permission to film in some locations. Check sufficiently early to enable any necessary formalities to be completed.

Generally speaking, you are free to use a hand-held camera in almost any outdoor place, but controlling bodies for certain parks and outdoor spaces forbid the use of tripods without a special permit. You are not allowed to erect a tripod on the pavement in many city areas. Clear up these points, too, or use a hand-held camera for the shots.

Charity organisations or trusts will probably give you a free rein over their property for a small consideration.

SHOOTING WITH ACTORS

The more ambitious your film, the longer you need for shooting it. You are only a part-timer, so a big film may take you weeks or even months to shoot. Many things can change over such a period of time. This is why your order of shooting is important.

If outsiders are to take part in the film, and you depend on them, try to group all their appearances together in your shooting schedule. Their interest will be more easily sustained than if you call them once every two or three weeks for another scene. Also, one of your actresses, particularly a young girl, may change her hairdo in that time and put paid to your continuity! Fit in each actor's scenes as closely together as possible. You may be commandeering all their free time for a while but they'll certainly enjoy it more, and the film will make greater sense.

You can of course shoot all the year round. But for a big production where you need a whole year, the seasons seem designed for film making, plan in spring, shoot in summer, indoor scenes in autumn, edit on dark winter evenings.

Naturally, you have to weigh other points against this, such as seasonal changes, weather and other problems which are discussed beforehand. The shorter your film, obviously the less of a problem this is.

With a long film, it is very nice to do your shooting in the

mild months and leave the editing as an occupation for the long winter evenings. You may not be able to, or you may want a winter setting for the film. But generally, indoor scenes are more easily under your control than outdoor ones. So take the opportunity of suitable outdoor conditions while you can; you don't want to wait a whole year for them to come round again! To stop before you have really finished could ruin your film. Next year the actors may not be available.

Don't ask somebody to help with your film and then delay the actual filming for months. Any initial enthusiasm you have created may well be dissipated. Similarly, once you have started filming, organise your shooting to suit your helpers and to avoid long gaps between their activities. You might have a 10-minute script needing two actors—Miss X appearing for 8 minutes and Mr. Y for 6 minutes. The film is to take place both indoors and outdoors. Some scenes require them together, others singly, indoors and outdoors. Some scenes require neither.

Shoot the big scenes as soon as you can, i.e. the ones in which both characters appear. Concentrate on these, especially the outdoor ones. You can fill in with other outdoor scenes using just one character when the other is not available—in this case preferably Miss X because she appears in more scenes.

Only when neither are available should you continue with your (preferably) outdoor scenes in which no characters appear. True, it is easier to visualise a film shot in chronological order, but you must forget this if you have any kind of a script to work to.

Continue until all the double outdoor scenes are shot, then do the double indoor scenes, catching up on any other single character outdoor sequences that remain to be done. When you need only one character ask only one, don't have the other standing about.

If you shoot all the scenes with one character in succession he will more easily gain confidence and give a better performance. He will have a chance to "warm up"—a thing that film actors can rarely do as they can in the theatre, because a film is shot in tiny snippets.

Next, work on indoor single character scenes, filling in with any remaining outdoor scenes without actors. Finally, do the remaining indoor scenes where no characters appear and wind up with the extra scenes, titles or effects that may be embellishments rather than essentials.

Though this is the working procedure for only one kind of film project, the general idea should be the same for all films. Tackle

the most demanding first, so that if arrangements fail you can push them further forward on your schedule without harming the film. Don't be left at the end of the whole film with one vital missing scene that means the recall of your volunteers, who may by that time have forgotten all about you.

Helpers are often friends of friends. If so, don't rely on the intermediary after introduction. *Get the address of your helper and do the asking yourself.*

You may sometimes require helpers just to "walk on" rather than to act—simply to walk past the camera or open a door and pass through. Such help can often be obtained on the spot, although it would be unwise to rely on it.

At the mention of making a film many people are only too glad to lend a hand. Offers like these are valuable and such people should not be frightened off by the threat of having to act, even if it is your intention that they shall. You may have to resort to low cunning and push them into the scene at the last moment. This would probably work for a walk-on part.

With some films you may need the constant help of another person over a long period, perhaps as a link in the film to hold the scenes together. Travel, holiday or topographical films often use this method to connect up a jumble of scenes. A young couple may be seen at moments throughout the film—not in every scene, that would be too much—but at appropriate times here and there.

In a film like that, you need people who are available whenever you want them—people you can really depend on. Of course, they, too, will be depending on you to see that the scenes work out all right without too much fiddling about and that the pictures actually come out. You must not take unreasonable advantage by keeping them hanging about doing nothing while you shoot the rest of your film.

FINDING THE ACTORS

The first place to look for actors for a film is the local dramatic society or any nearby drama group. They are likely to be more enthusiastic than the average person. Moreover, they will lend their services free of charge and this is the only way of getting a sizeable group of people with dramatic knowhow for a non-profit-making film project.

If such an arrangement reaches fruition you must realise that from now on your film is a partnership. This way, your actors

are less likely to stage a dramatic walk-out if things go awry leaving you with several hundred feet of useless film.

You, as director, must maintain overall control, as you are creating a film, not a play, and are probably providing most in terms of film material and equipment. Even so, the leader of the drama group may have pretty firm ideas about what is effective and what is not. You should get your relationship on the right footing from the start. Show him the script. If he is interested he may suggest changes. Note these and try to be flexible even though you love every scene you have dreamed up.

Having agreed the script you must also make it understood that henceforth major alterations will be out of the question. If you start making changes so that you have to go back and re-do scenes the whole thing may go stale on you. Changes in the script can also upset the continuity.

You may have to make small changes as you go along, of course, but be sure that these do not trip you up. You and the leading actor will work side by side, each within his respective field. It is his job to handle the actors, yours to do the filming. Each should be open to the suggestions or opinion of the other.

If your drama group has no leader, they will have to get together and appoint one. You want to concentrate on the filming and that might lead you to handle the actors in a rather off-handed fashion. They will take direction far more willingly from their own appointed leader.

Another possible source of actor is a local school, using sixth-form pupils out of school hours. Young people are usually keen to help with this type of project and some surprising talent may emerge. The English or drama teacher may willingly co-operate. Also the local cine society may have used people before who have an aptitude for amateur film acting and might be able to help.

Where only one or two people are required you would probably get by with friends or people suggested by others you know. Any story film will be brightened up by a pretty young girl. Documentary subjects also. Good looks and a lively disposition count for a great deal in a film.

A young couple is naturally the favourite formula for a story film and especially for a travel documentary. The romantic element is sure to make the audience feel involved.

Do not introduce too many characters in any film, and in a short one two are quite enough. When you use people for the first time in your film be content with one or two. Later on you will discover how to handle larger numbers.

Larger groups of recognisable characters are more difficult with 8 mm. films for purely technical reasons. But a few main actors, say two or three, against a background of a larger number of supporting characters or extras works very well.

In all film making there is a fair amount of hanging about. Try to keep the actors busy but have frequent breaks between shooting scenes, so that they can relax a bit. Use the time spent setting up the camera to explain what you want for the next shot.

A relaxed atmosphere is incomparably the best to work in, so don't show anxiety or anger even if you feel it. Any false starts and you will lose your actors' attention and perhaps even their respect. When you ask them to take up position you must have everything ready. Those who are not appearing in the scene should always stand well *behind* the camera, otherwise their shadows, if not themselves, may creep into the picture. Somehow, these things will happen—the spare elbow spoils the pan shot. Do not permit them to distract those who are performing.

The basic instinct of any photographer makes him want to guard the camera especially when it is on a tripod, but you may find the best way to organise the actors is to go among them rather than bellow dictats from behind the camera. Settle your ideas fully in your mind before placing them. It is very confusing for an actor if you are always dithering and trying alternatives.

One or two simple tricks might help the actors to get a better result. If, through careful arrangement, the whole effect becomes too stiff looking, ask them to break ranks and then come back and take up their positions again. If you want the impression of a person out of breath get them to do a real sprint beforehand.

There is a danger with drama club people that they may over act. Tell them to play down considerably. Explain that for film the style of portrayal must be far less broad than in the theatre. The most effective style is a slightly heightened form of real life behaviour.

Constant relaxation is as important for the actors as script and preparation is for you. They will enjoy helping you far more if they feel you are competent and working at a good pace without appearing hurried. Always aim to do your bit as fast as possible when you have actors. You can take your time with the other scenes.

Keep calm all the time even if things are going wrong. Do not despair if you get a patch of slightly woolly acting here and there. You will find at the editing stage that realism in a film can be

created without great actors. You can juggle with your scenes and make amends for many things.

COLOUR IN YOUR FILM

You do not need sunshine for filming in colour. On sunless bays colour gives its own brilliance to the scene in a way that black and white film cannot.

When planning a good film you should pay close attention to colour. Sensitive use of colour in a film is appreciated by an audience. Think of your colour film with the premise that you need harmony most of the time and contrast sometimes.

Scenes with great colour contrasts can be used for occasional impact. Too frequent use of this device naturally lessens its effect.

The balance of colour in a scene can be affected by the viewpoint. It is possible, by choosing the wrong viewpoint, to drown the colour in your main subject with the colour in a subsidiary one. The flowers in a window box would look insignificant with a great area of red curtain in the foreground. Give bright coloured, but unimportant, features only a small share of the picture area. In this case a narrow strip of curtain would do, or no curtains at all.

If indoor lights or strong sunlight fall on the red curtains you would clearly have more of a problem than if they were in shadow.

Where you want the colour to give impact to the scene take the opposite view. Make it bold. Give it a large share of the picture area. Colours you wish to visually comment upon are lost if they only occupy a small part of the screen.

Watch out all the time for these snags. Before you shoot, look through the viewfinder and ask yourself if everything is all right with the colour. It is surprising how soon you begin to notice colours and see them in a new way. The way you see them will emerge also in your films.

We have seen that as a rule warm colours appear to come forward in a picture and colder colours recede. Knowing this, you can give your scenes an illusion of extra depth. By deliberately having your warmer colours forward they will separate naturally from the background. If you arranged them the other way about it is a contradiction of nature and the effect will not be so striking.

Always try to delineate any human figures by having them dressed in colours that differ from the background. A girl in a

green dress almost disappears when filmed on a grassy slope, as does a girl in a beige dress walking through a cornfield.

To all these general rules there are the once-only exceptions. It might be effective for the girl in a beige dress to walk through corn and out again just to get the very effect you would normally try to avoid. It is the exception which, in the time-honoured phrase, proves the rule.

Be particularly careful with exposure when shooting colour in a generally light-toned scene. Sometimes you have to take the risk that part of the scene will be colour-distorted. You will find that such distortion is much more noticeable in light scenes than in darker ones. This is no doubt because we are used to colour becoming rather subdued in poor light conditions.

If you want detail in a shadow area you have to give more exposure by opening the aperture diaphragm or using the fractional exposure control on your camera. The sky then appears very pale or totally white. When shooting against the light the same thing happens. In both cases try to exclude the sky from the scene or the lack of colour will be very noticeable.

COLOUR CONTINUITY

It is essential to maintain a consistent quality of colour throughout the film. Try to shoot all related sequences together, to avoid differences in the sky colour.

You should not have widely differing weather conditions for scenes supposed to be on the same day. Avoid joining scenes together that were shot in the early morning or midday even if you used a correction filter. The light is still different—it comes from a different angle and the colour cannot be exactly the same. You can sometimes get away with it, depending on the scenes, but it is better not to take the risk. You may be able to use early morning shots as evening ones and vice versa provided the direction of the light does not give the game away.

Although modern colour film has greatly improved, its exposure latitude, i.e. its ability to cope with departures from the ideal exposure, is still narrow. With incorrect exposure you can get an image but the colour is distorted and occasional distorted colour spoils the continuity of the film.

Colour film has reasonable exposure latitude for still photography but in cine it is wise to treat it as non-existent so that you can maintain a high standard. In tricky situations, such as with

subjects against the light, try two exposures and pick the better.

CONTROLLING THE COLOUR

The overall blue tone, or cast, frequently seen in film is commonly caused by light reaching the subject directly from a blue sky or indirectly by reflection off water or other surfaces. Snow scenes produce this very noticeably. This same blue sky light bouncing around in the atmosphere gives a blue haze to distant views.

A slight correction can be made with a haze filter, which is generally faintly yellow or pink tinted. A medium haze filter lessens the blueness in scenes filmed on dull days. On clear days the blueness can be much greater and a stronger haze filter might be required.

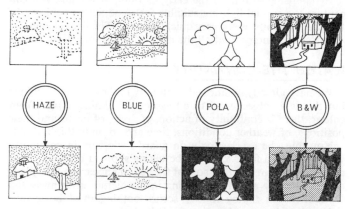

The colour in a scene can be controlled to a certain extent by using filters. The light cast from, sky, water and snow can be reduced with a haze filter. A pale blue morning-and-evening filter alters the reddish colour to that of midday. A pola filter can darken a blue sky but keep the clouds white. Colour filters can be used with black and white film to modify the tones.

In the early morning and late evening, the opposite effect is encountered. The proportion of red in sunlight is greater at these times and the film may take on a reddish cast. If you are actually depicting early morning or, particularly, late evening, this effect

need not be corrected. Otherwise you can use a slightly blue-tinted "morning and evening" filter to cut out the excess red.

You can sometimes alter the colour in your subject to suit the subject of your film. A polarising filter, for example, deepens the blue in the sky when you are shooting in certain directions. The effect can be seen in a reflex camera by holding the filter over the lens and looking through the viewfinder. Rotate the filter slowly until the sky deepens to the desired extent.

You may also deepen the blue of the sky by intentionally under-exposing but, of course, this under-exposes the subject as well.

For special effects, you can even use the more deeply coloured filters intended for use with black and white film. They give a heavy overall cast of their own colour when used with a colour film. This could be effective for some trick scene, but use them very sparingly.

By choosing to film in the early morning or evening you can capture the special lighting suitable for some fiction subjects. In this case you must work very quickly indeed. The light changes in a matter of minutes, and all the magic disappears with it.

WATCH THE CONTINUITY

We have already mentioned continuity in the context of colour but this is a subject vital to all aspects of filming. Apart from colour, there is continuity of action, of dress, of props and their positions, of weather conditions, time and so on to think about.

You must be everlastingly on guard for errors in continuity when making a film. You will be taking shots at different times and joining them together so that the action appears to take place at one time. Be sure that nothing in the picture gives away the truth. Between taking indoor scenes nothing must be moved unless there is an explanation for it in the story.

Imagine a scene when a girl gets up early and rushes off to work leaving a half empty glass of milk on the table. When she returns in the evening everything should, of course, be just as she left it, unless somebody else has been in the house. If the curtains were half drawn, they must be again; the half empty glass of milk must be in just the same position as before.

The furniture, the bedclothes and any other items in the room must be exactly as they were. A tablelight must not suddenly appear switched on as if by magic.

Professional film studios have a continuity girl who notes all

these things and takes pictures of them so that they can be rearranged exactly when filming recommences. Lacking such professional assistance, you can minimise the risk by shooting all scenes of one set-up together. The longer the time lapse between shootings the greater is the chance of a slip in continuity. If you cannot do that, make detailed notes of how things were arranged, and if possible, take a still photograph of the scene as well. A snapshot is a useful aide-memoire.

When taking shots at different times and reassembling the scene watch out for continuity errors. In these two scenes several points have been overlooked. In the re-established shot, the bottle should be a glass, the vase has suddenly lost its flowers, the man holding a glass has it in the wrong hand, and the glass is not properly filled.

When the scene is actually supposed to be taking place at another time it is equally important to make such changes as could reasonably have happened between the two times. A girl might wear a different dress. Objects in the room might have moved—you would not expect to see the same half empty glass on the table three weeks later—but the grandfather clock should not disappear without explanation.

CONTINUITY OF ACTION

Here you must actually plan your continuity. The object of doing so is that the action at the end of one shot must tie up with the next shot of the same action taken from a different angle.

Take an example where someone puts down the phone after a call (medium shot) and then walks away from the phone (long shot). If at the end of the first shot the hand can still be seen on the phone, then it must start from that position in the next shot. You cannot have a jump where a person or object is in one position in one shot and moved in the next shot of the same scene. In editing you may be able to find the exact positions at

the end of the first and beginning of the second *provided that you have filmed enough overlap to cut these together*. This smoothing of the action is part of the job of editing as we shall see later.

A second and more common example is where two shots show someone passing through a doorway. In the first a man opens the door and steps into the room. The next shot, from the other side of the door shows him entering. At the beginning of the second shot, the door must be in the same position as it was at the end

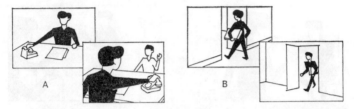

Where shots immediately follow one another the action should follow through correctly. (A) cut on a man who replaces the phone to a rear view where his hand is still on it. (B) cut on a man going through a door, so that from the other side he starts at the same position.

of the previous shot, perhaps half open. If the door were wide open there would be a bad jump in continuity which would be obvious on the screen.

This is not as easy as it sounds because, if you have only one camera, the character has to "act" his entrance in two parts, getting out of the way between times for you and your camera to pass through the door and line up the shot from the other side.

For most people the camera is confined to two movements while filming; pan and tilt. These are easiest to do with the camera mounted on a tripod. You can, of course, imitate them with the camera held in the hand, but the result is unlikely to be so smooth.

TRACK AND PAN

Tracking may also interest you. This involves the bodily movement of both camera and support and can be towards the subject, crabwise across in front of it or a mixture of the two, e.g., a diagonal movement towards and across the subject such as you often see on television.

The pan can be used to follow a moving subject or it can allow the camera to range over different features of a large scene. Similarly, tracking can be combined with a pan to concentrate on one part of the scene (the main subject) or it can scan across the subject by sideways or diagonal movement.

Tracking can be done in two ways, neither of them very easy. You can use some form of trolley as a mobile camera support or you can hand-hold the camera and carry out the various movements yourself. A trolley to be used for tracking must have very good suspension and large soft tyres. Even then, it can be used only on very even surfaces. As a specially designed trolley is out of the question for most people, they sometimes make do with some other suitable wheeled vehicle.

Various movements can be carried out with a hand-held camera. The amateur is unlikely to have equipment suitable for a rising shot, where the camera rises from the ground, or for a turning shot, where the camera moves round the subject. Both these movements can, however, be made with a hand-held camera provided the cameraman is very steady. A rising shot means bending the knees and it can give a rise of about two feet—

enough only for small subjects or for shooting over the head of a seated person.

For walking shots you hold the camera firmly and walk with the knees slightly flexed. You have complete freedom and can follow your subject anywhere, pan, tilt and track all by hand, but only if you move fairly slowly. Even then, it is extremely difficult to do well. If you resort to this method you should take the shot several times over to make sure of a reasonable one.

Walking shots are often used by professional documentary film makers. They can rarely afford the elaborate equipment that would otherwise be necessary.

WHEN TO PAN

Panning has several uses. It can give a wider view over a subject than the lens on the camera normally permits. By passing slowly over the subject you can take in each part in detail. It can be used as a transition from one shot to another, or switch from one person to another.

A *zip pan* is a very quick pan and can give dramatic emphasis to the subject you pan to. A shot of a safebreaker at work for example, could be panned very swiftly to a figure silhouetted in the doorway, representing the safebreaker's sudden realisation that he has been discovered.

The zip pan can also be used for a change of place or time. In this case the zip pan should last fractionally longer than usual. It is used instead of a fade or dissolve.

A dramatic pan must, of course, end on a significant point because it is drawing attention to it.

Any pan and, in fact, any camera movement, should always start and end with a good composition, and this composition should be held for a few seconds at both ends of the pan shot.

Slow pans must be at an even speed and slow enough to avoid the infuriating flicker effect where you cannot see anything. A faster filming speed, of course, allows a quicker pan and some people find the result smoother when it is subsequently projected at the normal speed.

Pans should not be used too often in a film but when they are, they should move in one direction only, preferably from left to right. Never move the camera in all directions over a subject. Where a pan is used to follow a moving subject, keep the subject in the same part of the frame all the time.

For editing you sometimes want to use a rapid pan shot as a

dramatic cut from one scene to another. You can do this while actually filming the scenes concerned, but if you forget or the idea is an afterthought, you can make a substitute shot at any time.

A *pan cut-away* is a rapidly panned shot where no subject is identifiable. However, the tone and colour of the pan should resemble that of the two scenes to be united. If they are exteriors, with green fields and blue sky, then you should make your pan shot in these conditions. If it is indoors do it in a room.

Set the camera up on a tripod with a pan head. Lock it on running and swivel it quickly round through nearly a full circle. The cut-away should be fairly long so that you can cut it later to a suitable length. Try several at different speeds of rotation and pick the best.

WHEN TO TILT

A tilted camera exaggerates the size of the subject. From a low angle, perspective distortion makes the subject appear large and dominating. A medium-sized building can look enormous. On the other hand a high angle shot say, filmed from another building looking down, has the opposite effect, the subject seems diminutive.

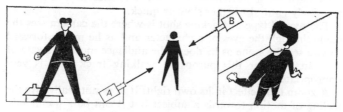

When you tilt the camera you change the perspective and apparent size of the subject. From a low angle (A) the subject seems to dominate or threaten. From a high angle (B) he appears diminutive and perhaps the victim of the subject in A.

These illusions can be used creatively when filming people. The villain, if shot from a low angle, appears menacing to the victim who, shot from a high angle, seems bound to suffer the unthinkable fate.

In some instances you have to follow strict logic to get the camera angle correct. If a person looks up, and the following

shot is supposed to be seen through his eyes, the camera too must be pointing upwards. If he then looks down at something on the ground the camera must point down to the object. Wherever a person looks at something, if the following shot is to show it as he sees it, it must be shot from his eye level. Two people, one seated, one standing, looking at one another should each be filmed from their respective eye levels or along the *eye line* as it is called.

TRACK OR ZOOM?

In a tracking shot the subject becomes larger on the screen, so the background becomes relatively smaller and the foreground relatively larger. This is the gradual change in perspective caused by different viewpoints. In zooming there is no change in perspective because the viewpoint remains the same. The whole image of the subject is magnified, the sizes of various objects in the picture remaining in the same proportions. In a tracking shot you appear to be moving towards the subject, but this is not so in a zoom.

A tracking shot is used in two main ways. In the first you are almost unconsciously drawing towards the subject to get a better view as you do in real life by concentrating on only a part of it. This must be a movement that the audience is unaware of, seemingly natural whether slow or quick.

The second type of tracking shot is where the camera sees the scene through the eyes of a character and as he moves forward so you see the scene as he does. The audience must be aware of this. In fact, for this purpose a walking track shot is very appropriate.

A zoom is an effect in its own right. It does not really give the feeling of motion towards a subject but it can be a useful substitute. A sudden zoom has a powerful effect that you cannot get with tracking. It pinpoints a feature and slams up to it. Also you can sometimes zoom in places where it would be impossible to track. Never, as you may with tracking, zoom in and then out again. Tracking shots do not tire the audience in the same way that repeated zooms do.

A gradual zoom may look more like a tracking shot if you pan at the same time. It is not the same but the image movement slightly disguises the zoom. It can be totally disguised if you track and zoom at the same time. This gives you the effect of a far longer track than you actually have. If there are obstacles in

your path you can get the full track effect that would be impossible even if you had the equipment to do it.

You can, of course, zoom or track backwards, withdrawing from a scene, perhaps, to reveal something that the characters cannot see. For instance, two men could be seen playing cards at a table in the middle of the room. The camera draws back to reveal a figure behind the curtain holding a gun.

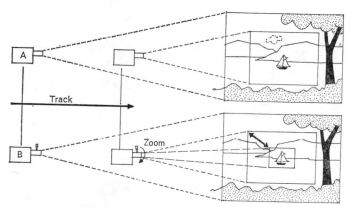

A zoom and a track may be combined. In this case the zoom effect is not noticeable, the whole thing appears like a track. But you get the effect of a much longer track than you have actually made.

The same technique can be used for comic effect. Imagine a shot purporting to show that a particular village still has its old village green. Then the camera draws back to reveal that the said green is only a tiny grass patch on a road island. Or you may see a sun-tanned girl basking in the sun to the sound of Tahiti music. The camera draws back and reveals that she is lying on a rooftop in a smokey, industrial town, the music coming from a radio beside her.

VIBRATING THE CAMERA

To depict a scene of violence through the eyes of a participant you could vibrate the camera or wave it about and get a realistic result. Do not move the camera too rapidly and make sure that the opponents and significant objects remain in the screen for

157

long enough to preserve the atmosphere. An angry expression and a clenched first would have greater effect if the camera lunged forward, twisted and vibrated. Characters taking part in a brawl should be shown in side view as well as head on, and such shots as running feet or tumbling milk bottles add to the realism.

Lighting for indoor filming may consist of a photoflood bulb inserted in the socket of the ordinary overhead domestic fitting. But this is not lighting the subject, it is simply producing enough brightness to film by. Good lighting, as we shall see later, is the very basis of indoor work and just as important as correct use of the camera. It is a creative job and for any such job you need the right tools. The tools in this case are a range of different lighting units each of which provides light of a different sort or in a different way.

This does not necessarily mean expense. As in many other fields, the manufacturer sets out to woo his customer to the particular merits of this or that piece of equipment and tries to make him feel that he cannot possibly proceed without it. You can, of course, proceed with next to nothing and a touch of ingenuity will give results without expense. The types of unit available may be roughly categorised as follows.

Floodlight The floodlight is by far the most useful cine light; you can produce good lighting using two of these only. It is simply a photoflood lamp in a reflector. It may be mounted on a stand, or have a clip attachment or some other means of support. It gives a soft even flood of light over a wide area. Shadows are there, but soft. They can be made softer still by fitting a gauze diffuser over the front of the reflector bowl.

Some lights have a back reflector fitted in front of the lamp, which throws light from the front of the bulb back into the reflector bowl so that all light reaching the subject comes from the bowl and not direct from the lamp, thus giving a softer light.

Floodlights are inexpensive, though the back reflector type costs a little more. They are robust, light in weight, and apart from occasional replacement of the lamp, they need no maintenance. The lamps are cheap to replace. They consume only 225 watts but, being overrun, give an effective output of 7–800 watts. Four can be run from a 5-amp socket.

Spotlight The spotlight is basically a lamp with a polished reflector behind and a lens in front, arranged in a ventilated tube. It produces a narrow beam which gives intense light over a small area.

Most spotlights have a focusing adjuster so that the light can be spread over a larger or smaller area, though this area is always far smaller than that of any other kind of light. The larger the pool of light the less brilliant it is, the smaller the brighter, rather as it would be if the whole lamp were moved backward or forward. A typical lamp can be adjusted from an 8° to a 40° beam.

The light gives hard black shadows and is always used in conjunction with photofloods. It is particularly useful for producing small, controlled highlights that add depth or drama to the scene. It may be used to bring up detail in small shadow areas without upsetting the other lighting. From an oblique position it can show up the surface texture and shape of a subject.

A spotlight is more expensive than a flood, but you may want only one or, perhaps, two. It is nearly always used on a stand, and usually has provision for filters, diffusers and other fittings to be placed on the front.

Some baby spotlights are powered by a projector lamp which is designed to burn in an upright position only. You must take care not to use the light at extreme angles. Spots using projector bulbs are not corrected for colour film; their light will seem slightly yellowish compared with more powerful units. A few of the smaller spotlights cannot be adjusted for focus, the whole unit must be moved back and forth.

No lamp should ever be moved while it is switched on, nor must water be splashed on a hot lamp. Adjustments should be made gently without vibrating the lighting unit. If you ignore these points you will shorten the life of the lamp considerably.

Cinelight Also sometimes known as a movielight or Sun Gun, the cinelight is a lighting unit of medium power mounted on a hand grip. It can be used from an on-camera position and has either a sealed beam or tungsten halogen lamp.

The tungsten halogen lamp is mounted in a metal reflector and may have a quartz envelope which should only be handled in a glove or handkerchief. It is designed to burn for a long time without discolouring the envelope—which is a drawback of the photoflood—and will run from 12 to 15 hours with a 650-watt output. It is also more compact than a photoflood.

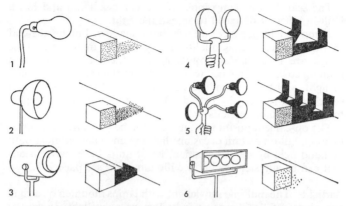

Lights and their effects: (1) a naked photoflood lamp gives quite low contrast lighting but fairly well defined shadows and not much brightness because a large portion of the light is wasted; (2) with a reflector it is stronger and more diffuse and contrast is increased; (3) a spotlight gives bright, high contrast lighting with deep sharp-edged shadows; (4) a twin head cine light gives two quite hard-edged shadows with high contrast and is very directional unless well diffused; (5) a bar light gives high output and multiple shadows of slightly lower contrast unless the lamps are diffused, but the heads can be repositioned for this effect; (6) a trough gives a very soft even flood of light with hardly any shadow and has an exceptionally high output.

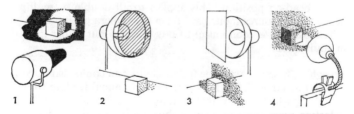

Light from lamps can be further controlled: (1) a snoot fitted to a spotlight gives a small bright pool of light with a quite well defined edge; (2) a diffusing screen on a flood reduces shadows and contrast; (3) a shading card screening the lamp gives totally diffused illumination but the card cuts the light in a hard edge; (4) a clip-on light can be used from nearby to brighten small areas of the subject.

The sealed-beam lamp looks like a car headlamp and has a built-in reflector designed to spread the light.

A movielight produces a fairly hard shadow. For off-the-cuff shooting where lighting quality is of secondary importance these lamps are most useful. Points against them are rather high running cost, the tendency to a hot spot in the centre of the pool of light, and the tremendous heat produced by the lamp when switched on for lengthy periods. The unit is, however, intended for use over short periods only.

The on-camera position is far from the best position for direct lighting, but on certain occasions lighting and camera must both be hand held by the cameraman. Most units have swivel heads that can be adjusted for bounce illumination; see page 177.

Barlight The multiple movielight with lamps mounted on a rigid bar or set of flexible arms is known as a barlight. It can be attached to the camera or held in the hand. There may be two or four lamps, either photofloods in reflectors or, more usually, the built-in reflector type.

If used on the camera and as purely frontal lighting, the lamps should preferably be positioned above the camera so that all shadows fall down behind the subject, not up above it.

Flexible arms can be angled into practically any position for bounced illumination. With a four-lamp unit, for example, you might arrange three heads for bounced light and the other one as a frontal fill-in. Shadows are like those usually produced by a sealed beam photoflood, but the lamps are mounted in pairs close together and may produce unpleasant double shadows when used in the head-on position. This applies to all double or multiple headed point source lights used from the camera position.

The barlight is economical to buy and run but rather limited in application.

Trough These are available for amateurs and could also be constructed at home. They look just like an animal feeding trough with lamps fitted along the bottom. If the trough has a back reflecting plate over each lamp, thus cutting off direct light the trough produces a powerful and diffuse spread of light that raises the general lighting level in the scene without bright highlights or strong shadows. It is simple in construction, but cumbersome and can only be operated from a stand. Troughs are only needed to light large interiors or where you want exceptional depth of field. They may be used vertically or horizontally.

When using multiple head lighting units be careful not to overload your domestic power socket.

OTHER EQUIPMENT

Various adjuncts to lighting equipment are made for the perfectionist. A filter or diffusing screen may be purchased or made up to fit in front of floodlights or spots. Coloured filters may be obtained, and gadgets for shading the light, such as barn doors or snoots, can be made or, in a few cases, purchased. The same purpose is often served by a simple home constructed "flag" or shading card on a pole which cuts the light off from a particular part of the subject only (see p. 161).

Some lamps are fitted with a clip or wire stand so that they may be attached to, or stood on, furniture. This may entail shifting huge pieces of furniture in order to position the light correctly. It also severely limits the possible height to which a lamp may be raised.

Volunteers may hold lights but it is difficult for them to maintain the same position for any length of time. More reliable is a lighting stand which may be purchased specially made for the job, or constructed by someone clever with his hands. An old music stand can be modified to do the job nearly as well, though again you may not get the height that you need.

Proper lighting stands are not very expensive and you only need two or three. Be sure that the cable runs up from the bottom of the pillar and not directly to the top. This is an unstable arrangement which, with lightweight stands, could trip you up. Cable can be loosely held to the pillar with a couple of rubber bands leaving a loop at the top to allow for extending the upper section.

Make sure you are not limited by the cable extension on your lighting units. Get plenty of cable: manufacturers are too often stingey about this and have been known to supply a 7 ft. high lighting unit with a five foot cable!

Reflectors provide an easy way out of many a lighting problem, even outdoors when you use the sunshine as a main lamp. A reflector may be made up from a large board painted white or covered with reflective material such as cooking foil mounted with the matt side upwards. A roll of unmounted tin foil may prove more portable and compact.

A projection screen can be used in some situations particularly as a neutral coloured object from which to bounce light from a

spotlight. Angled differently it could also be used to shade light off the subject.

An additional luxury which may lengthen the life of your lamps is a surge resistor. This goes between the power supply and your lamp. It effectually softens the blow of the initial surge of current that suddenly strikes the lamp filament every time you switch on. This shock has an ageing effect on lamps, when compared with the more gradual build up through a surge resistor.

Some people find lighting the most exciting part of cine work. Playing with lights and getting widely different effects has a fascination that grips you after a while. So much in a film depends upon lighting and whereas outdoors you very often have to put up with what is there at the time, filming indoors you are in entire control. So much so that you feel you can almost make the film with the lights alone however poor the actors.

AVAILABLE LIGHT

In a few homes and some modern buildings there is just enough light coming through the windows during the daytime to do some indoor filming without lights. Large plate glass windows may give you sufficient daylight to film people on the other side of the room. You will be very glad of this light if you are shooting large interiors in non-domestic surroundings for a documentary type of film. This kind of lighting, however, does not usually look

Indoors, available light from a window falls off very quickly across the room. This uneven lighting is far more noticeable to the film than to the eye. Unless you are aiming for the effect, it is easier to draw the curtains and work with artificial light.

so good in films shot at home. One side of the room is much brighter than the other, you need to constantly change exposure as people walk across the room, all the light comes from one

direction and you cannot, with colour film at any rate, use additional lighting.

It is the possibilities of lighting that make interior scenes specially interesting. You can get unusually lit scenes in your film only if you do without the daylight, so the large plate-glass window instead of being useful is in fact a nuisance. You can only get away with mixed light sources if you totally drown the window light with indoor lighting and exclude the window from the picture.

If you have such a window and it must be a daylight scene then clearly you have to use daylight film, no lights and keep your action within a small area.

FIRST STEPS WITH LIGHTS

The easiest way to obtain extra light for filming indoors is to change the existing domestic lamps for photofloods. A photoflood is a lamp which takes rather more current than an ordinary room light, but gives many times greater light output. To do this the lamp is overrun and does not last nearly as long as a domestic lamp. Two hours is the normal life for a photoflood, which seems short until you remember that it should be switched on only while you are filming or trying a lighting arrangement.

The standard size (No. 1) photoflood fits into the normal bayonet socket, but as it gives out much more heat, a small shade close to the lamp is in danger of being burned and so should be removed.

A lamp in the ceiling and perhaps one in a standard lamp will

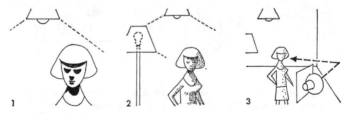

The simplest lighting is a photoflood fitted to the light socket but the shadows are rather harsh and not well placed (1). Shadows may be filled by a second flood in a standard lamp giving lower contrast and more detail (2). A lamp may be covered with a card so that diffuse light comes off the wall, enough to fill the shadows from the overhead lamp (3).

166

throw strong shadows on the subject. You can easily film by such light although the shadows may be unflattering to some people. If you have light-coloured walls, some light may be reflected off them, greatly reducing the effect of the strong shadows. If you place something such as a piece of card in front of the lamp, the subject is lit only by light from the walls and ceiling, a very soft light almost without shadows, though not as bright as the direct lamps.

Take care when filming not to let the lights get into the view of the camera lens. If you do, the colour will look washed out of the subject or you will spoil the sequence altogether. If you are using a movable lamp, place it next to you, but not behind or you may throw your own shadow across the subject. Do your lamp positioning with the lamps switched off: the hot filament does not take too kindly to shock or vibration.

The positions of both lights and subject are important. Lowly sited lights may throw large shadows on to the wall behind the subject. If they are placed higher, shadows fall down behind the subject and are not so noticeable. Similarly, the shadow is heavier when the subject is closer to the wall. Watch out, too, for reflections from mirrors, glass bookcases, glazed pictures, TV screen, polished furniture and glossy paintwork.

You may use a movielight in preference to photofloods. This can be a single lamp on top of the camera, or a fitment with a lamp at either side. The same difficulties of reflections arise, although shadows are hardly visible from the camera viewpoint. The idea is that the lamps only light that part of the subject seen by the camera, so when the camera is moved the lights, being attached to it, move with it.

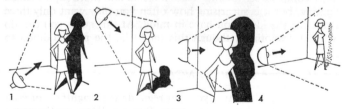

Light angle and distance affects shadow. A low-placed flood gives a tall shadow (1). With a high-placed one the shadow falls down behind the subject (2). A lamp nearby gives a huge shadow (3). From a distance the shadow is not so deep but well defined and about the size of the subject (4).

167

These movielights are quite suitable for ordinary home movies, although they do have the disadvantage of a trailing lead to the mains, which can get in the way, especially with young children running about the room.

To improve the light on a subject you could use a large white card, placed on the opposite side of the subject to the lamp (and out of view of the camera) at such an angle as to throw light into the darker areas.

A STEP OR TWO FURTHER

Photoflood lamps inserted into your existing domestic light fittings can give results good enough for the simplest requirements where you just want an image on the film, and that's all. The lighting in terms of shadows and bright areas is, in fact, rather poor as everything near the lights is exceptionally brightly lit and some parts of the room are relatively dark. Bright reflecting objects in the room that appear overlit in the picture have to stay like that and deep shadows may prevent you from showing what you really want. If the lights are too bright generally there is still little you can do about it, and you cannot, of course, light people in any way that will flatter them. Dramatic effects are out of the question.

The camera-mounted light is likewise restricted in its use, and if you want to make really well-lit films you have to find more efficient equipment.

Separate mobile lights are the perfect answer, and we discussed earlier all the types available and those you can make up yourself. You do not need to start with dozens of lights. Two No. 1 floods and a No. 2 will do for a start. With more lights you can tackle more complete scenes and create unusual and more sophisticated lighting, but it is surprising how often you may want only three lights for the ideas you have in mind. At this stage you can do without a spotlight, though this might be the next addition to your lighting.

LIGHTING AND DISTANCE

With artificial lighting you can regulate the brightness of your subject to get the correct exposure. Your regulators are the power of the lamp itself and its distance from the subject. The subject has some effect, too, because a light-toned subject reflects more light than a dark-toned one. But that is not generally under your control.

The usual working procedure is to set up the lights as you want them and then use an exposure meter to determine the aperture required. Sometimes, however, you may want a particularly wide aperture for differential focus (see p. 90), or a small aperture for depth of field. Then you might work the other way about: set up your lighting, taking frequent exposure readings and make sure that the general level of illumination is suitable for the aperture you intend to use.

Light falling on the subject may come direct from the lamp or it may be reflected off some surface such as the wall. Allowance must be made for the fact that reflected light travels farther from lamp to subject and so loses some of its strength and that some light is absorbed by the reflector itself.

A spotlight sends out a parallel beam of concentrated light that loses little intensity over a distance (1). Light from a flood covers a much wider angle and loses intensity quite rapidly as the subject moves away (2).

Reflectors must be aimed at the subject or the light must be bounced off the reflector at the correct angle. This is not difficult to judge because, at whatever angle you direct light on to a surface, it always bounces off at the same angle to the surface. If you direct it from 45° it will come off at 45°; if you bounce it very obliquely it will come off obliquely. You may direct the lights straight on to the wall: it will come straight back at you.

Surfaces for reflecting lights should always be light in tone. If you use colour film, they should be white or grey or, at least, have no strong dominant colours that could cast a coloured light on your subject.

Bounced or reflected light avoids the trouble you get with bright reflections from the shiny surfaces of objects in the picture. It casts a very soft, glowing and almost shadowless illumination over the subject. It is frequently used in conjunction with direct lights.

Spotlights, as we have seen, give a narrow beam of concen-

trated light which can be thrown over a great distance and yet still maintain its brightness. This beam can be regulated in spread, and therefore intensity, by focusing and without moving the lamp.

Floodlights behave quite differently. The illumination from a floodlight or any unfocused lamp bulb falls off very rapidly over a distance of only a few feet. If you set up a lamp at two feet from the subject and then move it back to four feet, the loss of light does not look very great but in fact it actually amounts to 75 per cent. As you double the distance, the subject receives only a quarter of the light. You would need four such lamps at a distance of four feet to get the same amount of light as you had with one lamp at two feet. Alternatively, you would have to give two whole stops extra exposure on the camera.

The light actually decreases in inverse proportion to the square of the distance between light and subject, but it is easier to use an exposure meter than to work by calculation, which with a multi light set-up, could soon tie you up in knots! This fact just serves as a reminder of what happens when you move a floodlight. If you find yourself in a situation where there is not quite enough light, moving the lamps forward slightly may make all the difference.

MODELLING

Now we meet one of the most attractive aspects of light. Put an orange on the table and shine a single light on it. You will notice that the light illuminates only half the orange and, moreover, that the illuminated half is not the same brightness all over. That part of the orange directly facing the lamp is the brightest and there is a bright patch or highlight in the centre.

The farther you look round the side of the orange the less brightly lit it is. The more oblique the side of the orange is to the light, the more the light misses it and goes elsewhere leaving a smaller amount lighting the surface. We would say that the light is *modelling* the orange or drawing its shape as a solid object.

Notice also how, where the light falls on it obliquely, it brings out the surface texture of the orange better than the light which falls directly on it. The tiny ridges are catching the light and the hollows are in shadow. Now walk round the table and inspect the orange from all directions. See how different it looks from behind, the light just reaching round the edge and a large black shadow behind. Lower the light and see how you can lengthen or shorten the shadow.

This is the basis of lighting. When you light people and objects in your film you want them to appear three dimensional even though the picture is on a flat screen. You have seen how the effect of light varies according to the direction it comes from. In filming you usually set up the camera to suit the scene, and then move the lights around to get the effect you want. The lights

Modelling the subject. Light from one side shows the roundness of the subject and where it strikes obliquely enhances texture (1). With the light behind it is rim lit but otherwise in shadow (2). A high light gives a short shadow (3) and a low light gives a long one (4).

can be easily shifted about until you settle on a lighting set up. In some situations, however, the lighting is more difficult than finding a camera position. Here the procedure may be reversed. This applies particularly to filming groups (see p. 176). If you intend to take many shots of the same scene you may either light each individual shot you take in the room, or set up the lights so that they will be correct for the various camera positions you will use when you shoot the scene. But you usually need plenty of lighting equipment to make this method practical.

BUILDING UP THE LIGHTING

There is an established pattern for general lighting which, to start with, you should follow. Later you can be adventurous with your lights when you have seen on film what they can do.

All lighting experts, even the masters among professionals, light their scenes in stages. Don't start by switching on all the lights. If you do you cannot see what you are doing! Begin with one light. This is your modelling light or *key* light as it is called. Use a flood.

Before switching on your lights consider what it is you are aiming to do. Any lighting you use for a cine film should be

171

an *imitation of the natural lighting in the scene*. So, if you are trying to film a normally lit room, the light must look as if it comes from the usual places, e.g. from the ceiling, or walls, or from a table lamp or standard lamp that usually provide the light in any room. It would come from the window if it were an indoor "daylit" scene, in which case you would draw the curtains to exclude the real daylight.

You must arrange the lights to give this effect even if it does not necessarily mean putting the photofloods in the exact positions of the normal lights. The room and the people in it must look naturally lit wherever they move about. Some cheating is needed to get this effect all the time, as we shall see.

At the same time you have to consider the appearance of your actors or actresses. They must be favourably lit and by angling the lights you have to give them some modelling, like the orange, to make them appear real and separate from the background.

If your main light source in a room is meant to be from the centre of the ceiling, as is most likely, then your main photoflood must appear to come from this direction. If you actually put it in the light socket you would probably not get this effect at all. Set the flood on a high stand, say seven or eight feet up, and far enough away from the subject to give a pleasantly modelled shape to the face. The light should be to one side of the camera so as to light the actor's face more strongly on one side. This helps the modelling.

Do not move the lamp too far round for your general shots— you can experiment with that effect later. A 45° angle to the camera/subject direction will do, or possibly a little less.

It is preferable to use a more powerful flood for this key light because a weaker lamp would have to be closer to the subject for it to dominate the lighting set-up. The closer your lights, the less space you have to move your actors in, owing to the greater variations in brightness as they move about. Use as powerful a light as you can for the key. A No. 2 photoflood will be adequate if you use a good reflector.

Having positioned your key light you must next use a fill-in. This is from a frontal position and throws light into the deep shadows caused by the key light. Put your fill-in directly over the camera. You can even use an on-camera light for this purpose.

The fill-in is secondary, it must not kill the effect of the key light, but it must raise the tone of the shadows until they are slightly less bright than those areas lit by the key.

The balance between key light and fill-in is a matter of lighting

skill. It also depends on the film you are using. Most colour material has a relatively high contrast, so for a normal effect you want low contrast lighting to allow for this. Faster black and white films on the other hand have lower contrast and so for average-looking results you need greater lighting contrast. For intentional contrast effects in dramatic lighting you would give far less fill-in, or leave it out altogether.

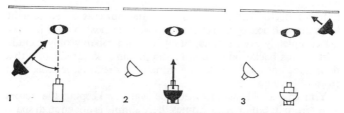

Start lighting with a simple set-up. The key light is the strongest light and is placed at 45° to the camera (1). The fill-in is placed frontally over the camera and at a greater distance (2). A light on the background kills shadows (3).

The subtle difference in brightness between key light and fill-in falling on the subject is sometimes difficult for a beginner to see. If you look at the subject through half closed eyes the highlights and shadow areas appear more widely defined. It also brings to notice any large, heavy areas elsewhere in the picture that do not suit the mood of the situation.

SHADOWS

When lights are placed above the level of the camera lens, all shadows from the subjects fall down behind them and may not be visible from the camera position. In many cases the lamps placed to one side create shadows that are visible and these may fall on the wall behind the subject. Worse still, a second shadow resulting from the use of another light may appear superimposed on the first. This gives you an unpleasant double or multiple shadow, which at all costs must be avoided. One main shadow in the scene, however, looks quite natural. Diffusing the lights may soften shadows but they will still be there.

Remember that even a weak light can produce a second shadow where a strong light dominates the set. Double shadows from crosslighting produce unfortunate effects on people's faces such as rings under their eyes and two nose shadows running in

opposite directions. This is why you can keep out of trouble with a simple set-up. One strong light produces one strong shadow. Your fill-in produces none, and you get a clearly modelled result.

Shadows on the background at some point are inevitable. You can kill the secondary ones with a third light placed behind some feature in the scene and shining directly on the wall. Unfortunately, this does not light the wall evenly unless you are clever with the angling. Use a fairly directional type of flood—one with a deep reflector and angle it so that the rim cuts off some light from the wall nearby and evens it up with the next. You will never get completely even results, but you will probably only include part of this background area in the picture. Be careful that this light does not itself create any unnatural shadows or reflections from objects on the wall.

You can avoid shadows on the wall by keeping the actors away from it, but in many homes there simply is not enough space to do this and also have the camera and lights at an adequate distance. Though you can get more camera distance by shooting through open doors or windows you can rarely use this expedient for the lights, except occasionally with spotlights.

In full-length shots the floor sometimes appears too dark on the film. It is easy to overlook this while setting up lights. Try to cover it with your existing lighting, otherwise exclude it from the picture. Light only that part of the scene covered by the camera, so that you get the maximum from the equipment you have.

Finally, before shooting the scene look through the viewfinder to check that there are no highlights on the edge of the frame, as these tend to draw the eye away from the actors. If the characters are to move about, have a run through first, following them with the camera, and look only for anything in the lights that may need correction such as shadows, reflections, lamps in the picture or some bad lighting. Incidentally, be sure that you don't see your own reflection in a mirror on the wall!

You may, instead of moving the lights, limit the movement of the actor so that he does not get into a bad lighting position. Put a marker on the floor and rehearse again, telling him not to move beyond that point.

EXPOSURE PROBLEMS

For indoor lighting set-ups you are safest to take a reflected light reading (p. 104) off the subject. Be very careful not to let any of your lights shine on the meter cell and make sure that

your own shadow is not thrown over the subject while you take a reading. This applies equally to those who use cameras with built-in meter. Read the exposure through the *whole* shot.

The exposure should be even on the actor as he walks about, but with simple set-ups this is difficult. The important thing is to have the correct exposure when he stays in one place for any length of time. He should start and end his movement in good lighting, even if he passes through a dark patch on the way.

Automatic cameras make corrections for any shift in light intensity. Strictly speaking, they "iron out" any dark patches in the movement, although with indoor lighting you may be working near the maximum aperture anyway, where the camera cannot make further corrections. If you *want* the actor to pass through a shaded part you must use the automatic camera on a manual setting; alternatively, light the scene so that you are using maximum aperture all the time. On some cameras this can be found by looking at the needle in the viewfinder. Auto cameras that do not indicate the exposure sometimes have a warning signal for underexposure. It may be possible to shift the lights so that this does not happen.

ADAPTING TO THE LIMITATIONS

You cannot expect to achieve perfect lighting for movement over a large area with just two lamps. It is better to confine the movement within a given shot and use other methods, such as cutaways or close-ups to get action into the sequence. On a big film-set an actor's movements are covered by a great many lights arranged to blend imperceptibly with one another. You cannot do that but you can tackle the problem in another way.

Stage the scene as if it is supposed to be lit by very few lights. For instance, a dramatic effect could be obtained in a lounge by using only one dim light placed next to a character sitting in a chair. This could be a lamp in the table fitment. You see only his outline, perhaps backlit, with the light hidden by his own body. In the next shot you see the side of his face and the dim shape of a door across the room. Slowly the door opens and another figure appears in silhouette. A scuffle could take place in the semi-dark, and a gun fall on the floor in the path of light from the open door.

This treatment gives a more dramatic result than the same action happening in a fully lit room. It needs a minimum amount of equipment—one photoflood lamp and one floodlight. The

floodlight can be strategically placed just out of sight in the hall where it casts the strong light across the room when the door opens. The photoflood would be exchanged for the household one in the table lamp, though this might give too much light. You could use a domestic light although it would appear rather yellow in tone if you were shooting in colour.

LIGHTING TO SUIT THE SUBJECT

Lighting for atmosphere can be great fun, but your lighting should also be sympathetic to the characters you portray. Young women need soft flattering lighting, whereas hard directional lighting, with strong shadows, can be used for men.

You can adjust lighting marginally even in the same scene without letting go of the realism. Obviously you should not suddenly change the whole nature of the lighting for two people in the same room, but even so, if you move people around a room lit by an overhead and a side light it is amazing how many different kinds of light you can get. You can choose them to match the characters and situation. For example, the dominant character may be backlit so that you cannot see his face, the victim could be in such a position that a rather flat frontal light reveals all his terrified responses. In the interests of glamour, a spotlight from behind could highlight the hair of a female character provided that there was a logical explanation for the source of this light, such as a nearby standard lamp. In any filmed scene, the brightest lit person is the one you notice most. In a scene where one character is more brightly lit than another, attention is drawn to him even if the other character completely dominates the picture.

This more refined treatment requires extra lighting equipment, especially spotlights, which allow you exact control over whatever areas you like. But any light can be shaded and you get interesting effects in this way. Shading lights in certain areas often improves an indoor scene.

When filming groups of people you will have greater difficulty in maintaining correct lighting for them all. Here the normal procedure, camera first then the lights, does not apply. Where you have only simple equipment arrange people in relation to the lighting rather than the camera position. If you want a large figure in the foreground, move the camera around the existing set-up until you get the result you want rather than position the figures and then try to light them.

An extra hazard with groups is that shadows become more complex. See that the shadow from one person does not fall across another, unless you intend it, when the people move about. Also be sure that no one comes too near a light, overlighting themselves and darkening the set.

Fairly static groups can be lit in much the same way as before. For preference, keep the stands carrying lights as close as possible to the wall to prevent people kicking them over.

With a large number of lights at your disposal and the fear of bad shadows as people move over a large area, you may find mainly bounced illumination best. You can direct spotlights on to the ceiling to raise the general light level and use a fill-in from the camera position, attached to the camera. Alternatively you could fit photofloods into the existing overhead fixtures provided this does not overload the lighting circuit.

The result will not be first-class lighting, but with gatherings of people at parties where you don't have much time to play with lighting you can wander around with your camera and pick people out at will. Shoot at a uniform distance so that the on-camera light always gives roughly the right amount of frontal light leaving the bounced light to illuminate the surroundings.

If you have a powerful modelling light and time to adjust it results would be better, but with people constantly milling around it is rarely practical.

MOVING SUBJECTS

With only limited lighting at your disposal you will have great difficulty giving full light to a moving subject all the time. In confined spaces subject movement is a greater problem. Movement towards or away from the lights can produce wide variations in brightness.

Unless you tolerate poor lighting while the person is actually on the move, or unless you avoid the situation by using cutaway shots, it may only be possible to show movement by indirect methods.

You can show movement of a subject by a shadow on the wall. This is fairly easy and for more dramatic results the shadow should be strong. It is better if it passes over various objects as a plain wall will not show movement. By placing the lights close to the subject you can make the shadow enormous, and a low angle throws it well up the wall. Many scenes have greater effect when action is shown, only the scene should make the shadow

believable—you would not get a strong shadow in a well-lit room. Use a single light and have a single shadow thrown by each character.

A wall mirror is sometimes helpful in a scene where a character crosses the room. It gives you a greater shooting distance and as you see only a part of the room, only that part need be adequately lit. This can be a relatively small area because you can make the character walk straight up to the mirror. Avoid shooting too close to the mirror or this will open up too wide a view of the room. Shoot at an angle to the mirror and follow the action through the viewfinder.

A moving subject can in some situations be followed by a light. Ask someone to hold the fill-in and walk back as the actor moves forward, always keeping the light at more or less the same distance and angle. The angle must not change unless the actor is supposed to actually pass a light, but even then it is tricky to get it to look natural. A light moving quite independently shows up badly in the scene. Always rehearse these more difficult actions, checking them first directly then through the viewfinder. It will probably require exact timing for best results.

In all lighting it is easier to work if you think of the light emitted from a lamp as a solid block or triangle. You can then determine exactly where the light will fall off and how far it will reach. This is easier with the more directional type of light.

You can place objects in the path of the light to obtain a special effect. For example, in a fireside scene, the fire itself would not give nearly enough light for photography. Put a spotlight on the face of the actor and imitate the flicker of the fire by waving the fingers or some loose objects on strings in the beam immediately in front of the lamp. The flicker looks amazingly realistic and adds greatly to the scene. Such lighting devices help to sustain interest through the film.

Most films need more than straightforward filming of the scene in front of the camera. The transition from one scene to another can often benefit from a fade or dissolve or similar treatment. Some scenes need added atmosphere or even distortion of reality. Others can only be filmed in an unorthodox manner.

FADES

Fades arc when the scene gradually disappears into (fade out), or reappears from (fade in) total blackness. They are often used at the beginning and end of sequences and perform the same function as a full stop at the end of a written sentence or a capital letter at the beginning of the next.

Cameras which allow manual control of the aperture diaphragm can be used to produce fades. As you gradually stop down the lens, so less and less light reaches the film until it is quite dark. If you attempt a fade you should try to make it smooth and not too fast.

Special fader attachments are available to fit in front of the lens on some cameras. These may sometimes be more effective than using the diaphragm for fades, because if you are shooting in very bright conditions you may not be able to stop down the lens far enough to blot out the scene completely.

DISSOLVES

A common method of changing the scene in a film is to merge the last shots of one scene into the first shots of the next. This is the dissolve, which consists of a fade-out and a fade-in over-lapping.

You need a camera equipped with backwind or reverse running, and a frame counter. The dissolve must be precisely timed to maintain a reasonably even level of exposure. This involves an

overlap at each end to avoid the excessive lack of density that would otherwise occur at the mid-point of the dissolve.

Film the scene and run on the camera for an extra three seconds (48 frames) gradually and evenly turning the aperture control so that at the end of the three second run you have reached minimum aperture.

Now rewind the camera four and a half seconds (72 frames). Set up the camera for the new scene. Start the camera and begin the fade-in simultaneously. Reach your full aperture after three seconds (48 frames) and then complete the scene.

This effect must be done over a range of at least 6 stops (say, from f 4 to f 22) to get sufficient blackout, unless you use a fader attachment.

A simple dissolve can be produced by two fades. You fade out on one scene with a fader or by gradually stopping down the lens starting at (A) and ending at (F). The film is wound back to the beginning of the fade. You then fade in the new scene starting at (A) and finishing at (F).

When the scene is too bright, you may already be too far stopped down to permit the use of such a range of apertures. You can then place a neutral density filter over the lens and reset the aperture control, e.g., two stops up for a 4x filter. This will give you a greater range of stops to fade through. A normal outdoor scene may require f 8 for correct exposure. The filter will make it f 4.

The same thing happens with a cross polarising filter which fits over the lens. At the wide open setting this too has a factor

of 4x which makes it suitable mainly for bright outdoor scenes.

This complex effect requires practice and experiment to get the best results. It is inadvisable to tackle important scenes with it until you are quite confident.

WIPES

A wipe effect is a further way of removing one picture from the screen and replacing it by another. A black mask moving from one side of the screen to the other passes over it until the screen is totally black. The mask can then "unwipe" in the other direction to reveal the next scene.

You can obtain this effect by passing a piece of black card across in front of the camera as the scene ends. Start the next shot while the black card is fully over the lens and move it away again as the scene begins. In editing you can cut the scenes together removing all the intermediate totally black frames. The wipe should be straight and steady, and if the card is held some way in front of the camera you can get a sharp edge to the wipe.

You can use the subject itself for a wipe effect, passing the camera so close to it that the view is blacked out. The next scene can start from a similar position in the new subject and by moving the camera you uncover the new view. The camera may pass in front of a foreground object to obscure the view, or the subject approaches the camera until he covers the lens.

NIGHT SCENES

Night scenes are nearly always faked by a trick with exposure. By under-exposing the film you get a darkened image and the sun conveniently looks like the moon. Highlight reflections in the subject resemble moonlight, and for many scenes the effect is very convincing.

The scene should, if possible, be backlit so that figures or shapes show in outline, and shadows run forward. Do not stop down the lens too far. You need some light in the scene for anything to be visible on the screen. On colour film three stops is quite enough. Black and white may require a little more. On automatic cameras you can get the right effect by readjusting the film speed control by the equivalent amount.

The sky may appear very dark grey. Do not use filters with black and white film or you will disturb the normal balance of tones in the night scene. It is easier to film these scenes in the

morning or evening when the sun is quite low, and you may include it in the picture, perhaps with some cloud passing across it for the effect.

DIFFUSION AND DISTORTION

Occasionally you may want to produce a scene where the subject appears bathed in a misty and romantic atmosphere. Special optical attachments are available which fit over the lens and give this effect. A less expensive way is to make your own diffuser by stretching a piece of white muslin, gauze or similar material over a small frame or cardboard mount. Hold the gauze about half an inch from the lens, and give a little extra exposure to compensate for the loss of brightness due to diffusion.

A properly diffused image is always sharp, but each image point is surrounded by a wispy halo. It is not the same as an image thrown out of focus.

You can get a similar effect over part of your subject by cutting out the centre of the gauze or by cutting out a particular shape. In this case, however, the gauze must be a little in front of the lens. If it is directly on the lens, the effect is to reduce the amount of diffusion over the whole picture area.

Two diffusers placed one behind the other give a stronger effect. Or you could vary the amount of diffusion in local areas by using one cut-out gauze in front of the lens and one full one attached to the lens.

A scene in which one of the characters is supposed to be suffering from some mental aberration, drunkenness or other condition where his vision is not clear, may be filmed as if from his viewpoint. Here distortion is useful.

Any form of uneven transparent material will do. Glass and plastic with even slight ripples or defects will give a surprising degree of distortion to the image when moved about in front of the lens. Mirrors may be used, preferably metal ones which can be bent about. The surface of water also provides fine distorted reflections when set in motion. In both cases the camera must be positioned at an angle to the subject which is lined up in the viewfinder.

GHOSTS

A popular method of manufacturing ghosts is by double exposure. For this you have to be able to run the same film

through the camera twice, so the effect cannot be done on Super-8 mm. cameras.

The first exposure can be made and the film back-wound for the second run. Alternatively, if you do not have back wind, note the reading of the footage counter at the end of the first exposure and run the whole film through (both sides of a Double-8 film) with the lens capped, until the footage counter again reaches the mark you previously noted. Leave plenty of leeway as a precaution if there are other valuable scenes on this same roll of film.

For the actual filming, set up the camera on a very firm support; it must on no account move between the two exposures. Note the footage. Film the room with the figure walking about in the normal way, but giving only half the indicated exposure (one stop under). Note the second footage. Then rewind the film to the first footage number. Now film the room again, this time without the figure, but again giving only half the normal exposure. The effect is now complete and the figure will appear transparent although his surroundings are quite normal.

A ghost can be put on the film by placing a sheet of glass (A) at 45° to the camera reflecting an image of the subject (C). The scene (B) is also visible through the glass. The art is in balancing the lighting for (C) and (B) to get the right amount of each in the picture.

Another method of producing ghost images is with a sheet of thin plate glass. This is placed at 45° to the camera lens and completely covering the field of view. Two sets are prepared, one directly in front of the camera seen straight through the glass, and the other to one side of the camera and reflected in the glass. The whole of each set-up appears in the picture. In the case of a ghostly figure, the second set consists simply of the figure against a black background.

Lighting on each set may be balanced so that each image is equal in strength, or otherwise, as you wish. You can do this by

watching the result through the viewfinder. The glass sheet must be clean and rigidly fixed, as must the camera. The normal full exposure is given. This effect can be done with any camera and does not need a second run or backwind.

SPLIT SCREEN EFFECT

With the split screen technique you can make two images of one person appear in the same scene. You must have backwind, and the camera must be mounted rigidly as before. You need to construct a mask frame and sliding black masks to go in front of the lens. These can be made from wood and cardboard.

The idea is to expose the halves of the picture separately. Half the field of view is masked with the sliding black card, and you first film your actor in that part of the room which is still visible. He must not cross the dividing line between the halves. Cap the lens and rewind.

Move the actor to the other side of the room and adjust the masks so that now only the other half of the room can be seen, the first half being masked off. Now film the actor in this other scene giving just the same, full exposure as you did for the first run.

The split-screen effect is done by first covering half of the scene with a matte black mask and shooting (1). Then cap the lens and rewind the film. Shoot again this time with the mask on the other side (2). The result is (3), where the man disappears into the tree.

In the result the dividing line should not appear on the film if the masks are properly positioned. The position of the masks affects the nature of the join. If the masks are fairly close to the lens, say within two or three inches, the join will be soft. If the masks are much farther away from the lens a sharp dividing line

can be produced. The technique calls for considerable experiment to attain perfection.

Sequences of this sort can be very funny if the action for each sequence is timed to coincide with what will happen in the other. The picture may be divided horizontally or vertically, in the first case the top half of someone's body could detach itself from the lower part.

REVERSE ACTION WITH NON-REVERSE CAMERAS

Many cameras, in common with all Super-8 models, have no reverse filming facility. You can still do reverse action by filming your subject in the normal way but with the camera turned upside down.

When the processed film is returned, this scene will, of course, be upside down in relation to the others. Cut the scene out and turn it the other way up and back to front, so that all the perforations still run down the same side. This means splicing the shiny side and matt (emulsion) surfaces of the film together, so extra care must be taken to get a good firm splice.

The image will actually appear reversed left to right, so the subject should be chosen not to give that away.

The serious disadvantage with this method is the loss of focus on projection due to the image being on the wrong side of the film. The only way to overcome this is to refocus the projector as the scene comes up on the screen, and reset it afterwards.

In a trial run before the film is shown to an audience two marks could be made beforehand on the projector lens mount to show how much correction you will need. Extended reverse sequences are a more practical proposition than short ones occurring frequently throughout the film.

FILTERS

You can use various filters over your camera lens either for "correction" purposes or to obtain certain effects.

With black-and-white film, clouds in a blue sky can be made to stand out more clearly with yellow, orange or red filters. The yellow gives the weakest effect and the red the strongest. The stronger filters can also to some extent penetrate haze in the scene.

A filter lets through light of its own colour and holds back light of colours complementary to it. Thus, in black and white, you

can use an orange or red filter to make red flowers appear lighter than the green foliage around and behind them.

Colour material needs less filtering because you do not have to worry so much about tonal differences. In fact, you cannot use strongly coloured filters on colour film without imposing a strong cast of the colour of the filter all over the image.

Filters for colour are usually confined to those required to correct the colour temperature of the light to suit the film (see p. 74), and the UV-absorbing filter to prevent excess ultra-violet radiation from making the image look too blue. This is usually only necessary for shots taken near the sea or on mountains.

A "morning and evening" filter reduces the reddishness of early and late daylight to make the film appear as if exposed to normal daylight. Most people, however, prefer to retain the natural effect.

Filters should never be used unless absolutely necessary—and they rarely are. Even the best of filters has some effect on definition and the not-so-good product may give a quite disastrous result.

The UV-absorbing filter generally does not affect exposure. Other filters, however, cut out some of the light reaching the film and cause under-exposure unless you open up the lens aperture to compensate.

The amount of compensation required is indicated by a filter factor engraved on the mount. A filter factor of 2 means you must give twice the normal exposure, or one stop, i.e. open up your lens diaphragm by one stop. An indicated normal aperture of $f\,8$ must be changed to $f\,5\cdot6$. A factor of 4 indicates 4 times extra exposure needed or two stops, i.e. $f\,8$ would be reset to $f\,4$. Exposure adjustments are necessary for colour conversion filters, effect filters, polarising filters, faders using cross polarisers and coloured filters used with black-and-white films. They are not required when using ultra-violet or haze filters or neutral density filters.

On non-automatic cameras the adjustment can be made with the aperture ring.

Some automatic cameras have a special setting mark on the exposure meter setting control to take account of filter factors. On optionally automatic models the setting may be made manually.

Auto cameras with neither optional manual control nor filter factor settings can sometimes be reset by adjusting the film-speed setting ring. Here you need not concern yourself with apertures, and indeed the meter may not indicate readings. For a filter

factor of 2 you adjust the film speed to half its previous value, e.g. reduce a 200 ASA setting to 100 ASA; for a 4x filter factor reduce to 50 ASA and so on. Before making adjustments check that your basic setting is in fact the speed of the film loaded in the camera. Remember to reset the meter when you remove the filter.

A number of automatic cameras use the through-the-lens metering system. Here the exposure meter takes a light reading through the actual lens which takes the picture. If you fit a filter on the lens, it automatically affects the reading you will get with the meter. You do not need to make any further adjustments.

If you want to reduce the depth of field in the picture and you have an automatic through-the-lens-meter camera with no manual control, you can place a special neutral density (ND) filter over the lens. This fools the meter into thinking the scene is darker than it is, thus opening the diaphragm. With black and white film, an ordinary coloured filter will do this, although it will of course also affect the rendering of the scene (p. 185).

If you do not know the factor of a filter, on some cameras you can hold it in front of the meter cell and see to what extent it influences the meter reading. The difference can then be set manually, or on an auto camera an appropriate alteration made to the film speed.

WHEN TO USE TRICKS AND EFFECTS

The various tricks and effects discussed here and on pages 179–85 are normally added to a film like adding spice to cooking. They can be used to enliven a rather flat or uneventful scene and should not be constantly appearing in a film where they are purely incidental. One or two may add punch. An overdose would mar the film.

Fades are used at the beginning or end of a scene or title. They overcome the rather abrupt joining of one scene to another and can be used to denote the passing of time. They will certainly disconnect one scene from another wherever they are used.

You cannot say that a fade is intended to mean such and such a thing. People today use them a good deal less often but for an increasingly wide number of purposes. You will probably find them most handy when you want to show that the next scene is in a different place.

A fade is always useful where you are changing to another phase of the film—where, if the film can be divided into parts, you are making another point.

Comedy scenes often end in a fade so that they are not confused with the scene that is to follow. When switching from comedy to seriousness the fade has obvious uses.

Fades at the beginning and end of a film give it a polished appearance and they are particularly effective in titles. You do not *have* to use them; you could make a good film without a single fade from beginning to end, but they do help as a sort of punctuation.

Fades, like many other effects, have to be done with the camera while the scene is being shot. They must be planned beforehand if they are to be fitted into some special place in the film. They could be taken as alternatives, one shot with a fade and one without. On a lengthy shot the fade could be cut off if not wanted.

Fades can be used more often than other effects. We are accustomed to seeing them. But they should always be used with the same kind of intention through the film, to isolate certain scenes from others.

Tricks like reverse filming and slow and fast motion can be used, but rarely in a normal film. They are jokes that soon become rather tiresome.

Speeding up the subject is an effect generally confined to comic scenes.

Slowing down the subject or slow motion on the other hand has a number of serious applications. It can be used for analysing movement in sport, for instance. In any situation where a rapidly moving subject is to be studied in detail, slow motion, using say 45 or 64 fps filming speed, could be helpful. Some cameras allow the motor to be adjusted to the slow motion speeds while filming. With this facility the normal action can turn into slow motion without a break, and back again if required.

The disappearing trick could be used humorously or perhaps in titles.

Reverse action is a comedy effect.

Time lapse (the use of single-frame shooting to show a prolonged event in a much shorter space of time) can be used for the study of plant growth or in business for time and motion study!

Tricks need not be confined to discreet use in normal films. You can make films consisting entirely of trick photography, based on human or non-human subjects, recognisable or unrecognisable. The familiar object, however, is likely to make a more interesting subject.

Imagine, for example, using the single-frame device to film a

reading lamp with a flexible stem. The lamp, a familiarly dead thing, could spring to life! It might seem to converse with other objects on the desk. This would be much more effective than the antics of two unrecognisable shapes cut out of paper.

Remarkable effects can be produced in an action film. You may pay attention to the action itself rather than the subject so that subjects can be combined for beautiful effect. Scenes of parachutists could be linked with those of a dandelion clock shedding its seeds. A recent notable film showed how much the motion of cantering horses resembles the tumbling waves on the seashore and linked them visually by changing from one to the other and matching up the shots. There are all kinds of things you can do with tricks and effects, too many to enumerate here. You can experiment and do things quite new. It is one of the most exciting and entertaining branches of cine-film making.

PUTTING IT TOGETHER

Having gone to much trouble to shoot a film, it is only good sense to make an effort with editing too. Human nature being what it is, the matter is constantly put aside because it does not seem so "interesting" as doing the shooting.

Editing is not only interesting, it is just as absorbing and creative as using a camera. It all depends how far you take it.

At the very least, a film always needs tidying up. Unfortunately, the nearest many people get to editing is joining together the separate rolls of film so that they do not constantly have to rethread the projector when showing them. This is not editing; it is not even tidying the film up. It is just overcoming a laziness problem, and adds nothing to the film at all. Without editing of some sort there is no such thing as a *film*.

We will see in this chapter how you can, with the minimum of trouble, make something out of the most loosely shot holiday film, and with extra care turn reasonable material into an excellent film. But first to the essentials.

The basis of film editing is cutting the film and joining it together. You therefore need equipment to make the cuts and joins, to see where to cut, to handle the film and view your results. The appropriate items of equipment can be purchased separately, or bought already assembled and mounted as one "editor". Actually it is very easy to make up this editor yourself. All the component parts are just fixed on to a board.

THE SPLICER

The joins between pieces of film are called splices. The splicer for making these joins is a small metal gadget equipped to hold the film in place, trim it, and prepare it for the join. They vary in price, and the more expensive types have a built-in scraper to remove the emulsion from the film so that it will take the cement used for the join. Tape joins can also be used and, in that case, the splicer does not need a scraper. Such splicers are

less expensive, but you have to buy joining tape, which is much more expensive than cement.

THE VIEWER

You have to be able to see the film before and after splicing, and for that you need a viewer. It is the most expensive item needed for editing, but some models are available at a very reasonable price. It uses a rotating prism system, so that when the film is wound through a lamp throws the moving picture on to a small built-in screen. You can run the film backwards and forwards at will to find the exact frame to be cut. On some models, by pushing a small lever a mark is made on the edge of the film. This is where you cut the film and is exactly on the frame you saw in the viewer.

It is possible to use a projector as a viewer for editing purposes, but it is not so handy for doing splices and the continual switching on and off of the projector lamp shortens its life considerably. A projector must have reverse run to be used for editing.

It is quite normal to do one or two runs through on the projector to check how the editing is going, especially for timing. But this would always be a straight run through and the lamp remains on all the time, as it is designed to be.

REWIND ARMS

These are geared winders to wind the spliced film on to a take-up spool. You have one on either side of the bench in line with the viewer so that by turning the handles you can run the film

The essentials for editing are: (1) a splicer to cut and rejoin the film, and (2) a viewer with rewind arms. The film is spooled from one reel to the other via a rotating device in the viewer from which an image is thrown on to the small screen.

191

Film hangars (1) are a means of holding the separate shots aside in a particular order. A tub (2) does the same job but also keeps the film ends out of the way. Shots may be kept coiled in numbered storage slots.

through and see it much as it will appear when finally projected. Rewind arms can be bought separately and are not expensive.

These items are all you need to do editing, but for sorting out scenes which have been cut out of the film and will later be reinserted it is handy to be able to store them in order. They can be hung vertically from clips or pins or kept coiled up in pigeon holes.

You can make your own film bag or bin. Take a piece of wood and insert pins in two rows one at either side along the top spaced an inch apart. Number the pins and lie the wood across a tub. Hang each piece of film from a pin by the end perforation. You can now find any scene you want in a moment.

There are many variations of this same design and you may need only a single row of pins.

Pigeon holes can be made by glueing small square cardboard boxes and their lids to a board. The lengths of film can be coiled inside.

A pair of cotton gloves is useful to avoid fingermarks when handling the film.

CEMENT SPLICES

When using a splicer to make cement splices, put both pieces of film, emulsion side upwards, into the clamping plates, taking care to fit the perforations over the register pins, so that the film ends overlap slightly. Close the clamps and by doing so trim off the ends of film squarely. Now scrape the emulsion off one tongue of film with a razor blade or the built-in scraper. Apply the cement—a special cellulose solvent—with a brush or glass rod and bring down the other clamp so that the two ends are in

contact under pressure. The cement sets in about 20 seconds. Remove the film from the splicer and check the splice by pulling the two ends of film sharply and twisting it about. Don't be timid about it! The splice must be a good one, it has to last a long while and probably go through the projector many times.

How to make a cement splice. Slot the trimmed film end in the right clamp (1). Insert the other end in the left clamp, trim and scrape the area to be joined (2). Apply cement to the scraped area (3). Lower the right clamp to bring the film ends into contact (4). The cement hardens in a few seconds.

TAPE SPLICES

Here, instead of cement you use a strong translucent polyester tape with similar perforations to the film. The film does not need to be scraped. It is cut squarely at either end along the frame line, that is, the line between each picture. The two ends

A tape splice is done by first trimming the ends of film square. Bring them together end to end. Lay the splicing tape across the join on both sides and the splice is made. It can be pulled apart again if desired.

are butt-joined without any overlapping film, i.e. the pieces of film are in end-to-end contact. The ends of film are laid on a splicer or block with register pins and a short length of tape stuck over the join, its perforations coinciding exactly with those on the film. The film is then turned over and the same is done on

the other side. This is a very tough splice and a good deal more convenient than the cement method, although some people feel that the cement method makes a better join.

SORTING OUT MATERIAL

Having learned how to do a splice, and practised on a few odd ends of film you can now set about the real job of editing. Cut your film up into all its separate scenes. In the case of more ambitious films each scene may have been identified by its number chalked on a board or *slate* and held in front of the camera for the first few frames of every shot. These frames help in sorting out the material for editing, but must be cut off when spliced into the finished film. If the scenes have no filmed numbers you can number them at the editing stage by writing at the beginning of each in wax pencil a number indicating the correct order for editing. Hang the scenes along your pin rack in the approximate order in which they will appear in the film. Finally, re-sort them into their correct order. Now you are ready to make the rough assembly.

THE ROUGH CUT

It is always a good idea to put the film together in a rough cut version first. Join all the scenes together in their correct order leaving in the reference (camera slate) frames. Do not cut any scenes at this point.

Now run through this large reel of film on the projector or viewer (preferably the former) and examine each shot in turn. Start by noting down any shots which are quite useless throughout because of poor exposure, unsharpness, or the subject being very badly framed.

Having eliminated the duds you can either cut them out at this stage or leave them in for a second run through. This depends on how many there are or if they are confusing.

On the second run you can select the best shots from alternatives you may have taken. You will often have to strike a compromise between technical quality and appearance or performance of the subject. You must be prepared to throw out material which is not up to standard, but remember that it may be useful for brief cutaways later on, so do not discard it altogether.

Return to the editor and take out all the material you have

noted. Hang those shots together in an isolated group for future reference. Now run through the film again and make notes of: which shots should be rearranged, which need to be shortened and where to shorten them, and which shots do not follow logically.

You can now work on the editor, using the viewer to watch your progress. Do not try to tackle the whole film at once. Start at the beginning and work steadily through to the end. This will be your first cut version. You may do your timing of shots fairly accurately at this stage, but if in doubt about the length of a particular scene leave more than you need—it is difficult to put back material you have cut out when working with only one copy.

The scenes in the film should now be in their correct order. Before fine cutting, return to the projector and run the film through again. This will give you the correct sense of timing through the film and help you to decide where any scenes should be "tightened" to give the film a brisker and more engaging pace. You may often end with several shots which are but a shadow of their former selves and yet are quite long enough. Proceed very carefully at this stage and be sure before you cut.

ERRORS AND CORRECTIONS

Make cuts with scissors or a splicer. If you cut a scene too short with a butt-end splicer you can sometimes joint it up again. If the cut is made with scissors, it may be repaired with splicing tape. Although the join may be across one frame, in some cases this is not too noticeable. With an overlapping splice you always lose a frame or two, which you cannot put back. When you simply rejoin them you will get a bad jump in the middle.

If the two halves of an accidentally cut scene are both needed in the film and they are long enough, you can sometimes make a repair by inserting a cutaway shot. The original shot then has to be shortened by the time of the cutaway.

Take an example: a man walks through the garden gateway, up the path and through the front door. If you cut the part where he is walking up the path and instead of joining it again insert a shot of a dog, which you took as a cutaway, you must also shorten the man's journey up the path. Actually you can shorten it far more than the length of the dog shot.

You can use the illusion of film to solve your problem and make the actions more brisk. The man closes the gate and turns

towards the path, the dog looks at him, then you see him take the last few steps to the door and pass through. Time is only relative in films. This shot, although faked, will look quite natural on the screen.

This process of cutting-in and condensing the action goes on all through a well-edited film. Now we will see how you use it not with cutaways that you shot for emergency use, but with the actual material intended for the film.

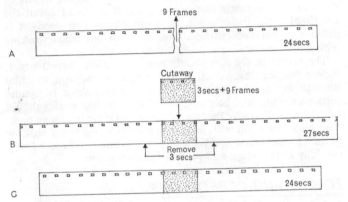

If a number of frames are accidentally lost through damage, bad film or a cut in the wrong place, use a cutaway shot to cover up the error. If the damaged film is a continuous piece of action cut from it the equivalent of the inserted piece, less the length damaged or accidentally cut. If you are editing, this is a preliminary—you may now be able to shorten the shot further.

One final point. Your cutaways must, of course, be related to the story or at least the surroundings. If the dog does not play a vital role in the film, the shot of him must not make it appear that he does. This depends on the scene, and you must judge the effect for yourself.

RULES IN EDITING

The more variety there is in your shots, the more scope you will have in editing any sequence. A choice of long, medium and close-up shots may mean more film in the first place and more film eventually thrown out, but it also means a more arresting end product. A sparsely shot film is more difficult to edit, and

196

sometimes means breaking the rules and making the broken rules obvious.

Rules in editing are made to follow and only an experienced editor can break them and get away with it. You probably have only one copy of your film, whereas a professional who tries something that doesn't work can just order up another print, leaving the original negative untouched.

We saw in the chapter on filming (p. 47) how a variety of shots from different angles of different parts of the scene in long, medium and close-up resemble the jumble of impressions we get in real life. Our eyes, flashing from one object to another, pausing at the next and then moving on again, are giving us brief "shots" of our surroundings like those in a cine film.

Actually the situation is not an exact parallel. Our brain "edits" the visual impressions so that we usually get a coherent and understandable chain of thought following these impressions.

The camera shots, too, have to be edited; we have to set out the filmed impressions so that they, too, can be understood. The visual impressions are on the piece of film you have taken. Whichever way you arrange these is the way the audience will think when they see the film. The object of editing is to make the events on the film seem as if they are actually happening. Anything in the film that does not look real very soon breaks the spell so that the audience no longer believes in what it can see.

PRELIMINARY EDITING

To take a closer look at the effect of editing, let us suppose we have filmed a sequence and are now going to edit it (see p. 198).

The times shown are those actually filmed, allowing for overlap at either end. In the script the times marked would, of course, have been shorter. So we have too much film. We must tighten the sequence, and at the same time consider whether moving any of the shots will improve it.

At present, the shots are in correct order—the order in which things happened—so we cannot move them indiscriminately. If shot 21 was placed in front of 20 it would change the meaning of the whole sequence. Instead of a plucky, if frightened, girl, you might think she was just slow witted and wise after the event. And, still being in the road, lucky not to be run over. By interchanging these shots you also change the situation and the character of the person appearing in it. Sometimes it is tempting to change the meaning by rearranging shots, but you can get in

197

an awful muddle doing it, and perhaps end up with an open-ended story.

SEQUENCE AS FILMED

Shot No.	Type of shot	Action	Time (seconds)
11	LS	Girl cycling along the road.	10
12	LS	Comes round corner.	8
13	MS	Comes from out of picture and slows up at a point in the road looking down. Gets off bicycle.	7
14	CU	Hedgehog in the road (from her angle).	10
15	MS	She bends over to look.	10
16	CU	Hedgehog. Hesitant hands move into the picture.	8
17	CU	Her face looking down. Then she turns her head; she can hear something coming.	15
18	LS	Car speeding along road.	10
19	CU	Hands grab the hedgehog (pass out of frame).	3
20	MS	She quickly picks up the hedgehog and dashes to side of road.	7
21	MS	Car approaches, flashes past very close, pan to it, disappearing in distance.	15
22	MS	She stares after it, then looks down, she is holding the hedgehog.	8
23	MS	Quickly drops the hedgehog in the grass.	8
24	CU	Cutaway shot of girl's face staring ahead.	

Now let us tackle the sequence methodically. Leave shot 11 as it is for the time being; it sets the scene. Shot 12 can be shortened: 8 seconds is too long to take on a corner. Half the length will do, so cut either end. Cut the first part of 13, which only repeats what we have already seen in 12. Cut 14 to 4 seconds; we can cut further later if we need. The next one, 15, is not so easy. Cut just before she bends down and just after (fully bent). No. 16 is far too long for such a simple action; cut the first part before the hands appear, but keep the hesitant hands for the time being. Cut 17 drastically; this is much too long. Cut the part with her face looking down to one second and give her three seconds listening time. Leave 18 as it is for the moment. Leave 19 also, as it is quite short. Cut 20 *after* she has picked up the hedgehog but *before* she starts to move off; keep the dash to the roadside but cut off the end where she waits when she gets there. Leave 21 for the moment. Cut 22 immediately after she looks down,

leaving the earlier part where she stares after the car. Cut 23 after hedgehog is in grass.

This is a preliminary edit. Now we run through and see what it looks like.

A SECOND BITE

In some places the sequence is still too long. Before we tighten it further we can increase the tension in the scene by removing no. 18 and putting it back earlier, interchanging quickly with 16, so that you move back and forth between the hands and the speeding car. Some of the car shots could go back even further (between 14 and 15) so that for a short while we see the approaching danger but the girl does not. For a moment the audience will wonder if she will hear it in time.

There is another problem. At the end we have two shots of the girl following one another. Due to an oversight in shooting, the girl is not in the same position at the end of 22 as she is in the beginning of 23—she has "jumped" between shots. One of our shots has been broken. We may be able to make amends by cutting. We need a cutaway shot to separate the unequal shots. No. 21 provides the answer. If we cut on the pan just as the car passes we can put in 22, cut again just before she looks down, insert the remainder of 21, then add 23. Actually we should cut some out of the beginning of 21 to allow the car enough time to move away as she is staring at it. We would have just the tail end of this shot—the car disappearing. The sequence is not as good as it might have been because the end of 22 may have had a good facial expression in it. Repairs are not always made without loss. But in editing later we may overcome this by virtue of some changes.

THE FINAL VERSION

Running through the film again with the newly placed shots we can see that many scenes are too long by comparison. For instance, we can cut 15 while she is still bending; that is, cutting on the action. There are numerous places where cutting will condense the action and we can check these by running through on the projector each time.

By keeping the off-cuts, we have managed to re-use some of them. Shot 18 has been removed from its original position and distributed elsewhere and 22 was dropped altogether.

Shot No.	Type of shot	Action	Time (seconds)
11	LS	Girl cycling along the road.	6
12	LS	Comes round corner.	3
13	MS	Comes from out of picture and slows up at a point in the road looking down. Gets off bicycle.	5
14	CU	Hedgehog in the road (from her angle).	4
(18)	LS	Car speeding along road.	4
15	MS	She bends over to look.	3
(18)	LS	Car speeding along road.	2
16	CU	Hedgehog. Hesitant hands move into the picture.	3
(18)	LS	Car speeding along road.	2
16	CU	Hedgehog. Hesitant hands move into the picture.	2
(18)	LS	Car speeding along road.	1
17	CU	Her face looking down. Then she turns her head; she can hear something coming (now, in effect, she *sees* something coming).	1
19	CU	Hands grab the hedgehog (pass out of frame).	2
20	MS	She quickly picks up the hedgehog and dashes to side of road (we don't see her near side of road).	2
21	MS	Car approaches, flashes past very close, pan to it, disappearing in distance (cut where car is large in frame to where it is just passing away—one carefully selected second from a very lengthy shot).	1
		Cutaway shot: CU of girl's face staring ahead.	3
(21)	MS	(End of shot 21) Car disappearing in distance.	4
23	MS	Quickly drops the hedgehog in the grass.	2

THE EFFECT OF CUTTING

Cutting scenes enables you to change your viewpoint, to add variety. In the early days of films whole scenes were shot from one camera position, and the films suffered as a consequence.

Moving the camera while filming was an improvement but, while it gave a smooth change from one shot to another it slowed up the action far too much for modern audiences. The changes of viewpoint and camera distance that cuts allow you show facial expressions and close-up details in the action far more easily than by moving the camera during the take.

When shooting the film you should take a second or two extra time at the beginning and end of each shot. Then, while editing, you find it makes it easier to cut in just the right place or make a scene slightly longer than originally planned. Again, this extra film may be handy for cutaways or for cutting back and forth.

The rules you follow when shooting the film must not be contradicted by the editing. By all means cut for variety, but do not lose the sense of the original sequence.

Do not splice together sudden changes of subject size which are either too great (e.g. long shot to close-up in the same scene) or too small to serve any useful purpose.

Do not splice any changes of viewpoint that are only slight and *never join together shots from the same viewpoint*. Remember the camera error of changes to the opposite viewpoint (see p. 30). This applies just as strongly to cutting together such shots in editing; the sense of direction would be lost.

When splicing together shots of any action, be sure that in each the subject is moving in the same direction. The subject must also be in the same place. There must be no obvious continuity breaks such as a shopping basket held differently or legs crossed in one shot but not in the next. If the continuity error already exists in the material you can sometimes, by careful cutting, make the differences unnoticeable.

It is a pity to undo the careful continuity you observed when shooting by forgetting about it in editing.

Even professionals occasionally make mistakes. But by careful cutting these may not be noticed by the audience.

In a scene where an actor moves about, cuts are less noticeable if you *cut on the action*. The best place to cut is where the actor is just passing out of the picture. The action then flows more easily across scenes joined together. You should, if possible, make provision for this at the time of shooting, so that you have plenty to play about with on the editing bench.

Any shots which do not contribute to the story must be ruthlessly hacked out. The finished film must be pruned of all superfluous scenes however pretty the photography; they will only weaken the effect of the main material.

PACE AND RHYTHM

The pace of the film depends on matching the length of each shot with the events it depicts. You must complement the subject matter and *mood* of the sequence with an appropriate length of showing.

While editing you should recall that you shot some scenes longer to take in detail. Take care not to cut them short. Shots containing simple or large subjects can be cut right down to their minimum, especially in the action-packed parts of the story. There is no rule as to how short this can be. In most films the average shot can last between 4 and 10 seconds. In certain cases the shot may be cut down to one or two seconds. Only rarely is it less than this, usually when the shot is repeated by cutting back and forth from one to the other.

Occasionally a shot may have great inherent interest so that it is worth holding for longer than normal, say, 15 seconds. But you will soon discover that 15 seconds is a long time on the screen. The only other places where a lengthy shot would be retained are when the action in the shot is continuous and changing or when the camera itself moves while filming. In this case you have virtually changed the shot anyway.

When a number of shots are cut to the same length, or a regular pattern of lengths, you get an effect of rhythm on the screen.

This is permissible with scenes where there is rhythm in the subject, such as children skipping, or a machine at work. The regular timed changes of shot add to the pulsating effect of the whole sequence.

Rapid but timed changes of shot may also be used to build up excitement in a dramatic scene where tension gradually mounts. In this case the shots should get shorter and shorter until the final climax. The last shot should be a long one.

While staccato cutting may emphasise the excitement in one sequence, it must not be used too frequently or the effect will be neutralised.

In other cases where the aim is suspense, lengthy, timed shots can underline the intention.

USING AND MAKING TITLES

A film never really looks complete without titles. They give a polished appearance to the whole thing, making the film an individual entity, crediting you for the work you have done and in a silent film helping to tell the story. Subtitles can set the scene or explain sudden changes of time or place. An end title helps round off the film so that it does not just die out when the audience is expecting to see more. You can buy main titles already prepared on short lengths of film which you simply splice on to the beginning and end of your own. Normally these off-the-peg titles are limited to general themes like "Holiday in France" or "Our Wedding".

MAKE YOUR OWN

It is much more fun—and not at all difficult—to produce your own titles.

Titles in a film should be included only where really necessary. Main titles should contain as few words as possible and be a comment on the film. Try to think up something closely related to the subject yet inviting enquiry. A modest title is better than a pompous one for an amateur film.

Descriptive titles should not contain too many words. Write the idea down first, then work on it by taking words away until you have reached the briefest way of saying it. Quickly-read subtitles have more impact and do not delay the pace of the film.

The only subtitles needed in most films are those provided by the subject itself, such as signposts, names on vehicles or over shop windows. You may even avoid some place-name subtitles altogether by using well-known landmarks like Salisbury Cathedral or the Tower of London at the beginning of a sequence taking place in either of these cities.

You may not need to say "A room over an undertaker's in York". A shot of this building with the Minster in the background and a pan to an upstairs window would do the same job. Keep

subtitles to a bare minimum. Whenever possible, do without.

A subtitle may *very occasionally* be used for a witty remark in a comedy sequence. But the remark must *be* witty, not obvious. Here you might invite suggestions from friends or family before inventing the subtitle if you are not happy with your own jokes!

Before deciding to decorate the film with subtitles ask yourself if they are really necessary. Knowing the story, and having looked at the film several times, it is often difficult to see for yourself. Someone who has not seen the film before could perhaps tell if anything needs explaining, by cutting in an extra shot, shortening, or even cutting one out. Usually a statement in words can be avoided; it looks very old-fashioned to have the screen suddenly emblazoned with some platitude about the sequence. If you *do* use subtitles make them indirect comments. Treat your audience as intelligent beings.

Titles should appear on the screen long enough for the average person to read through them one and a half times. But main titles and simple credits should appear for longer—perhaps three to four seconds.

LETTERING IS EASY

The style of the title lettering must be the same throughout the film. It should suit the subject of the film, i.e. fanciful hand-drawn lettering might suit a phantasy, or an historical subject. But be careful. Hand-drawn lettering must be very good indeed to look right, and a good plain style made up from a lettering outfit would be far more successful than hand lettering that was not precise and legible.

Most films should have conventionally lettered titles and these are available in various forms. Movable letters made from cork, plastic or felt can be purchased. Plastic letters are simple to handle and can be used repeatedly. They may have adhesive backs or small prongs to fix them to the title board. They can be bought in several colours.

Cork letters are cheaper. They can be used many times if handled with care and are available in a wider range of sizes with capitals and lower case. They can be painted, and either lightly stuck to a background with a horizontal title or used loose with a vertical set up. They are usually in low relief.

Felt letters cling to velvet or similar backgrounds and can be easily removed.

By far the widest range of title letters is available in the dry

204

transfer Letraset and similar series. You can get almost any size or style of letter and the results look truly professional. Although they can be used only once, the letters are available with many alphabets and extra letters on each sheet. They are applied by pressure and lined up through the transparent transfer sheet.

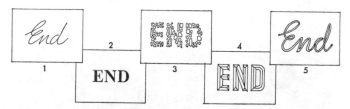

There are several forms of title letter to choose from. But only one style should be used in any one film. (1) Handwriting. (2) Letraset. (3) Small objects arranged to make words. (4) Cork letters. (5) A piece of cord or rope spelling a word.

It is traditional in film titling to use light lettering on a dark background, rather than the other way about. The glare from a white screen is too great for comfort. When shooting with colour avoid very pale toned colouring on the background.

SHOOTING TITLES

This is very similar to close-up work and requires the same approach.

You can copy titles by putting the board on the floor and setting the camera up on a tripod over it or you can buy or make a horizontal titler. This is a sliding camera support with a holder to grip the title card upright at one end.

You do not even need a special titler. You can set up the title card exactly square-on to the camera and strictly vertical. Then support the camera on books so that the lens is opposite the exact centre of the card. With sliding support titles you can find this by moving the camera up to the card.

Lighting should normally be flat, using a lamp on either side of the card and at equal distances from it. Angle the lamps to avoid reflections. Unless you have reflex viewing you will have to place your eye as close as possible to the camera lens and move the lamps around until the reflections are no longer visible. Relief letters can throw an attractive shadow if one lamp is moved forward, but keep the light even. Use a tape to measure the

camera distance, and set this on the camera. The title *must be straight*. Before shooting look through the viewfinder to check.

Titles can be mounted on a photographic print provided that it is a stationary subject. Outdoors, titles can be mounted on a transparent plastic sheet or on glass and fixed in front of the

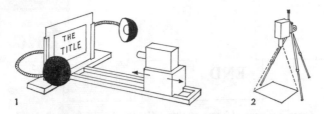

Titles are easiest to shoot in a title designed for the purpose (1) where a steady camera can be lined up exactly square-on with the title and the lighting adjusted as required. Alternatively, a tripod may be set up with the title on the floor (2). This is a useful expedient for loose animated title devices.

camera lens. You need maximum depth of field for this rather tricky procedure. Ideal conditions are a bright, cloudless day. The plastic sheet with its letters or even the letters alone might be placed on some interesting surface and filmed. Watch out for reflections if you use this method.

ANIMATED AND MOVING TITLES

By using the single shot device you can assemble your titles in an animated form, moving the letters around in a jumble until the title of the film gradually sorts itself out. This you can build up by moving several title letters at a time for each shot and then in stages begin to construct the final words. Alternatively a title may be assembled by each letter in turn flying across the screen to join the others.

Roller devices are normally used to get the titles to move past from bottom to top. A roller can be constructed from a large tin, and the titles pasted round the outside. It can be gradually rotated while filming or moved bit by bit taking single shots.

Titles that begin small and come forward until they fill the screen should be done with the zoom lens and not by tracking. The zoom can give you a really smooth action and needs no refocusing. Tracking and the refocusing required with a non-

zoom camera would be very difficult without a specially constructed titler.

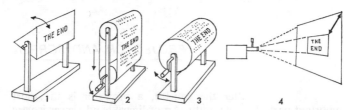

Some simple devices for moving titles in front of the camera may be constructed at home. A rotating block (1) for quick-change titles. A roller titler (2) for extended captions. A roller (3) for main titles. Use a zoom lens (4) for an advancing or receding title.

SUPERIMPOSING TITLER

Another way to obtain titles overlaid on a scene is to use a specially designed superimposing titler which works rather like the ghost set up shown on p. 183. A transparency or film is projected onto a small screen in the side of the box-shaped titler. Inside, a semi-silvered mirror reflects the small screen image through a supplementary lens in the adjacent side. The camera, positioned to look through this lens into the box picks up this image, and also an image of titles on the opposite side of the box seen *through* the mirror. As these titles are illuminated frontally through an aperture in the side of the box, ordinary adhesive white or coloured lettering can be used on a black ground. The titles can be mounted on the same flop-over, roller or other devices used for moving titles, or special mask shapes, e.g.: keyhole, circles, etc.

ADD THE LEADER

Having edited and titled your film add about three feet of "leader" to the beginning and a similar amount to the end. Leader is usually black unexposed reversal film. You can collect your own leader by saving the odd unexposed ends of your previous films. The leader is used for threading up the projector when showing the film and if scratched or damaged while doing so may easily be replaced.

Store the finished film in an airtight tin so that the splices remain strong and the film does not become brittle with age.

PROJECTOR AND SCREEN

After the camera, a projector is the most important part of a cine outfit. An ordinary hand viewer is very much the poor relation. With a projector you can see your films in the way they really should be seen. The effect of a large image in a darkened room is peculiarly captivating; you feel involved with the film, not as if you were just looking at it from the outside as with a viewer. Without a projector you are spoiling the ship, but in this case the ha'p'orth of tar may cost you nearly as much as the ship.

CHOOSING YOUR PROJECTOR

As with cameras, you get in quality what you pay for in money. It would be pointless to buy an expensive camera and use a cheap projector. An expensive camera will give you a good sharp image on the film; a projector with an inferior lens would undo this good quality. The argument works both ways. A high quality projector would not give you first class results if the camera lens was not equally good. In a good camera or projector you are also buying a good mechanism that will give you a steady picture and get the best out of the film.

It follows then that you should buy a projector which is of equal quality to the camera whether expensive or not.

The lower price range is from £20 to £30. In the middle range (£30–£50) you have the widest choice and cameras and projectors are of equal quality. Over £50 you get a very good projector indeed, but cameras can go much higher in price than projectors because they may embody many extra features. Such extra features are not required for a projector and so their prices level out soon after £50. Therefore, if you buy an expensive camera, a projector of equivalent quality will probably cost considerably less. This is in contrast to the bottom end of the price scale where you can get a camera for far less than even the cheapest projector. Before buying a projector consider also the compactness and

portability, particularly the weight. Some machines are rather heavy. Certain models accept both 8mm. film formats (p. 57).

HOW IT WORKS

A projector consists basically of a means of holding and transporting the film, a lamp to illuminate the image, and a lens to throw that image on to a screen. It is designed to take a stated maximum load of film at one time, which may be 200 ft. or 400 ft. The film is carried on reels which are held clear of the projector body on two arms. The film comes off the feed reel and is threaded on to a guide path through the *gate* mechanism and out to the take-up reel.

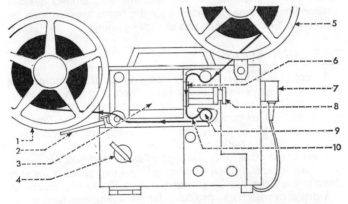

Features of a projector: (1) take up reel; (2) take-up film guide; (3) lamphouse; (4) operating switch; (5) feed reel; (6) film gate; (7) mains input; (8) lens; (9) drive sprocket; (10) loop of film (similar to that above gate). Note: many models omit (9).

The gate is the heart of a projector. It is here that each tiny picture in turn is brought in front of the lamp and the image projected on to the screen. The frame comes into position, stops for a moment, the shutter opens and throws the light through, closes and then the picture moves on.

THE INTERMITTENT

What you see on the screen is, in fact, a series of still pictures rapidly following one another in just the same way as they were

209

made in the camera. This action in cameras and projectors is known as the *intermittent movement*. Each picture must arrive in exactly the same position as the one before it, otherwise the image appears to jump about on the screen. This part of the machine is a high precision mechanism. Generally speaking, the more expensive the machine, the higher the quality of the intermittent movement and the steadier the picture on the screen.

The intermittent movement does not, of course, draw the film through smoothly; it is constantly joggling up and down. To avoid breaking the film and to let it vibrate freely the film is formed into a loop immediately above and below the gate. The film must always be looped when the projector is running otherwise the picture will just fly past on the screen and the film may be damaged. A framing device near the gate adjusts a mask surrounding the image so that only the frame area appears on the screen. You can adjust this at the beginning.

THE LIGHT SOURCE

A projector lamp is specially designed for its purpose. It is compact, but gives a very bright light. There is usually a *reflector* behind the lamp to throw the light forward and a *condenser* (an optical system) to concentrate all the light on to the film. On many modern lamps the reflector (and perhaps the condenser) is actually inside the bulb.

A projector takes only the type of lamp designed for it and you must be careful when reordering to get the reference number correct. Take the old lamp into the shop if you are uncertain.

A problem with some projector lamps is that they tend to get hot after running for any length of time even though the projector has a built-in fan to blow cool air over the bulb.

Many such lamps have a "dichroic" or "diathermic" reflector inside the lamp. This reflects the light forward in the normal way, but lets half the heat pass through it, so that this heat is not reflected forward on to the film.

Most projectors nowadays use low voltage lamps. These are small bulbs with compact filaments. They may run at 8 volts 50 watts or 12 volts 100 watts or similarly low voltages producing a very white light and low heat. They give greater brilliance to the screen image than the other high voltage (300–500 w) lamps.

The so-called tungsten-halogen (or iodine quartz) lamp is a long-lasting type which does not suffer from the yellowing-with-age that you get in many other lamps, so it is in very wide use.

THE LENS

On a few projectors the lens is of fixed focal length. You alter the projector-to-screen distance to change image size.

Most machines have zoom lenses which allow you to adjust the picture to fit the screen without moving either it or the projector. Although zoom lenses on expensive machines may give you a good, sharp image at all focal lengths, with lower priced models you should check this before buying. Low-priced zoom projectors can suffer from poor image definition, particularly around the edges of the picture. A good projector will give a screen image which is sharp all over and evenly illuminated with no dark corners or "hot spot" in the centre.

REWIND AND REVERSE RUNNING

It is quite reasonable to expect a low-priced projector to provide only for forward running and rewind. The rewind runs the spools in the reverse direction like a tape recorder. Taking the film straight across from one spool to the other you can quickly transfer all your film back on to its original spool ready for the next time you show it.

Some machines have reverse running so that you can go back to previous parts of the film without unthreading it.

Other projectors allow *reverse projection*, that is running the film backwards with the lamp working so that you see the action on the screen in reverse.

RUNNING SPEEDS

More elaborate machines have several running speeds, such as 18 and 24 fps for use with films shot at these speeds, or a selector giving any intermediate speed. A slow speed such as 5 fps for pseudo slow-motion is provided on a few machines. This is not necessary or desirable, however, for genuine slow-motion films shot at 64 or 48 fps (see p. 69). A simple, normal speed projector will handle these perfectly.

Another refinement is *still* or *stop frame* projection, where the film can be stopped so that you see just one frame on the screen. It can be used for checking details, although the single image is usually darker than the moving one owing to the heat filter that descends in the light path to protect the film. The stop frame cannot be used to focus the image for continuous running.

A manual winding control is occasionally fitted for inching the film a few frames back or forth.

THREADING THE FILM

There is usually a diagram on a projector to show you where to thread the film. You must remember always to make the loops. A self-threading or automatic projector threads the film itself, often right through on to the take-up spool. It will have a built-in loop former so you do not have to worry about this.

CARTRIDGE LOADING PROJECTORS

With this system, the normal spool of film when returned from processing is placed inside a special cartridge where it need not be touched again. To show the film you simply place the cartridge on a projector which automatically finds the end of the film, threads it through the machine, and afterwards rapidly rewinds it into the cartridge.

Two main types of cartridge loading projector are available, those using a Kodak system and those taking Bell and Howell Auto-8 cassettes. They are similar in many respects. Both are available for 50, 100, 200, and 400 ft film loadings. With the Kodak system however, an adjustment must be made on the projector to take the different sized cartridges. This is not necessary with the Auto-8. There is also a difference in the design of the spool spindle, so that each cartridge may only be used on a projector able to take that type.

With another system, which again uses a cassette of its design, several cassettes (50 ft only) are loaded on a rack in the projector. After projecting, the first film rewinds into its cassette as the next one is showing, and likewise with the remaining films, thus giving virtually no break between films as they are shown.

These cassette projectors should not be confused with special continuous loop machines designed for educational purposes.

SETTING UP A PROJECTOR

It is advisable to establish a routine for setting up your projector such as the following.

1 Set the projector on the table facing the screen.
2 Remove the side cover.

212

3 Unfold the arms, and slip the drive belts over the pulleys. A crossed drive belt will turn the reel in the opposite direction.

4 Open the gate; on some you can remove the gate or swing the lens to one side. Dust out the gate and clean the lens.

5 Put the film reel on the top (or front) spindle. Usually the film spools off anti-clockwise. Pull off two or three feet of leader.

6 Thread the leader through the film path (consult the threading diagram) over any sprockets (many machines do not have them) and form loops above and below the gate. Thread around any posts and on to the take-up reel, which normally takes up the film from underneath, winding clockwise. On automatic machines just tuck the end of the film into the threading slit.

7 Check that the film is properly sealed in the gate; close the gate.

8 Plug in and switch on.

9 Run the film and check the screen distance, moving the screen where required. Or zoom the lens to fit.

10 Focus the lens.

11 Adjust the framing device and tilt to re-align the picture on the screen. The tilt control is usually provided by adjustable feet. It should not be necessary to prop the projector up on books.

12 Rewind and run forward again to the black leader. You are now ready to screen your film.

Note: In the event of a lost loop during a performance, stop the projector immediately or the film might be damaged. Some projectors have automatic loop reformers, but even these sometimes fail. Remove the film from the sprockets and form the loops again.

SCREENS

For a screen you may improvise by using a whitewashed wall or large board covered evenly with emulsion paint, but a white sheet is rarely satisfactory.

You get the best results only by using a proper screen. These are usually made of heavy cloth and fold like a roller blind for convenient storage. Some are attached to tripod stands which fold with the screen into a tube, box or trough. Other models are made to stand on a table, or hang from a wall hook.

For home cine projection you do not need a large screen. The shortcomings of 8 mm. are less obvious if you use a screen no greater than 36 in. in width. Smaller screens cost much less too.

There are several kinds of screen surface and they reflect the light in different ways. Some give a brighter image or are more directional, i.e. they give a bright image when viewed fairly square-on but are dim when viewed from one side.

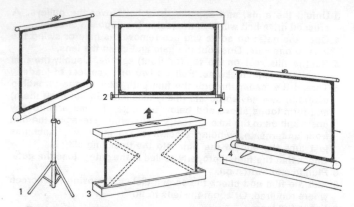

Types of projection screen: (1) stand model with collapsible stand; (2) suspended roller model for hanging on a wall; (3) collapsible screen that forms a carrying box; (4) roller table model with feet, collapsing into a metal tube.

The surfaces and their qualities are as follows:

A matt white screen is not directional but you do not get a bright image. It is only suitable for use with exceptionally powerful projectors used at close range where another screen would be too bright to look at.

Silver screens are directional and they give a brighter image than a matt white surface.

Viewing characteristic of different screen surfaces. Matte white (A) gives a fairly bright image viewed from any angle. A silver screen (B) is brighter viewed frontally. Both screens may be viewed from close range. A glass bead screen (C) is very bright for central viewing but darkens when viewed away from centre. A lenticular surface (D) is very bright from any angle. Both screens should be viewed from farther away because of surface patterns. A daylight screen performs as (C)

214

Glass-beaded screens are probably the most popular, although they cost more than those with metallised surfaces. On some, the glass beads appear more clumped and therefore more coarse than on others. They are very directional and give a brilliant image to those sitting close to the projector beam. They rapidly darken as you move away from this angle and are very dim from an oblique viewpoint. They cannot be viewed very closely because the glass beads become visible—more noticeably on some than others. These glass beads are invisible at about 8 feet.

Lenticular screens offer all-round advantages, but they cost more than other types of screen. They have a surface of metallic appearance with tiny vertical channels which ensure that although the image is bright, it can also be viewed from any angle. From the projector position the image is slightly less bright than a beaded screen. Like beaded screens, they should not be viewed too closely or the surface channels become visible.

Daylight screens are very expensive rigid curved-metal screens which give a bright though directional image even in daylight.

Setting up the projector in the home is a fairly easy matter when there is a small audience. Seats can be arranged informally so that everyone can see, as with the television. Difficulties arise with larger audiences, when the heads of those in front block the view of those behind them and may also obstruct the projector beam. For this reason the seating arrangements and projector position must be worked out beforehand by experiment.

SETTING UP

The screen must be raised high enough over the heads of seated people for them all to see but not so high as to give your audience stiff necks. If possible, arrange the seating to each side of the projector so that the beam can pass unimpeded between them. Raise the projector to the required height on a solid support, which can be one of the commercially available projector stands or a sturdy ironing board, which the projector stand closely resembles. If you have to tilt the projector upwards, remember to tilt the screen downward to compensate. The screen must be absolutely parallel with the film in the projector gate.

A projector can be quite noisy when running and you can lessen this by putting it on a mat of rubber, expanded polystyrene, or felt. If the projector is behind and away from the audience rather than beside them the noise is not quite so bad. Sometimes, you can screen off the noise by setting up the projector in the hall or next room and projecting through a half closed door or serving hatch. The ideal solution is, of course, to project through a small hole in the wall. But that could introduce quite different complications!

Wherever you project from, make sure your mains cable does not trail where you might trip over it. Tuck it under the carpet or run it along the wall.

When all is ready, switch on the projector and sit in each seat

in turn to make sure that your head does not get into the light path. Switch off all the lights on your preliminary run-through and make sure that light spilling from the projector does not reach the screen and weaken the image. You can reduce this with strategically placed pieces of dark cloth or card, but do not obstruct the ventilator grilles on the projector.

PREPARING THE PROGRAMME

Your film show should not, for a general audience, last much longer than one hour. If your own contribution is small, start the programme with one or two short commercially produced films such as cartoons. These will put the audience in a good mood. Everyone likes cartoons, but old-style slapstick comedy suits only certain palates.

Put the major film at the end of the programme. If you have both black and white and colour, show the black and white first unless there is a very good reason not to.

Arrange the reels in the correct order on the projection table, and be sure that they are all wound on correctly and begin at the beginning. It is only too easy, after trying them out, to forget to rewind.

You must not keep the audience waiting in mid-programme while you rewind. Use the empty spool of the first film as the take-up for the next; make sure it can take the length. Better still, have as spares two large empty take-up spools that will take any length of film.

Run through all the films to be sure that there are no breaks and that splices will hold. Check that the cheeks of the spools are not squeezed together so close as to make a scraping noise when the film runs through.

Fit up a small light to use while changing reels. Don't switch on the main lights after the audience have become accustomed to the darkened room. Have a torch handy to use in case of trouble with the projector.

Before the performance, clean the projector gate and the lens. The projector must be positioned so that the film image is centrally placed on the screen, the correct size (i.e. filling the screen exactly) and in focus. The film should be threaded up with the emulsion (dull side) facing the screen, and the picture upside down in the gate. Check that the loops are large enough, by running the film. As a standby you should have spare drive belt, fuses and, most important, *a spare projector lamp*.

Without spares, the chance failure of any of these would bring the show to an untimely end. Lamps in particular have a cheeky habit of lasting right up until the Big Day!

In the event of the film breaking during the performance some sticky tape will allow a temporary repair. The repair must, of course, be past the gate not before it. Much better and quicker than this is to do a "projectionist's splice". This involves no sticking. You simply tuck the broken end of film into the film on the take-up spool and, holding it, give it a couple of turns and carry on.

SOUND ACCOMPANIMENT

Finally, you may care to add music as a background accompaniment to the film. The mood of the music should suit the film, and should not have too great a contrast between loud and soft passages. It can play from a tape recorder or record player—preferably with an extension loudspeaker positioned near the screen, facing the audience. Do not have it too loud. If you are giving a commentary, and the machine is near the projector, you can reduce the volume just before you speak and turn it up again afterwards.

If you wish to talk about the film before showing it, make it brief; don't keep your audience waiting more than a few minutes. Do it directly before the film, not before the whole programme. This talk will be a natural, and not unwelcome, break between films.

Several systems are available for recording while shooting and replaying the sound in step with the picture. They are mostly based on the sync pulse system where electrical contacts in the camera make a once-per-frame pulse, recorded alongside the soundtrack on the opposite edge of the tape. This gives a permanent measurement reference so that when the tape recorder is connected to a projector, the pulse signal is picked up and transmitted to the projector motor controlling its speed to keep the film in step, one frame per pulse, with the recorded soundtrack.

The sync pulse method can also be useful in really advanced film making where the sound is transferred to a track on the film itself.

MAX. RUNNING TIMES FOR FILM LENGTHS

Feet	Standard 8						Super 8/Single 8			
	16 fps		18 fps		24 fps		18 fps		24 fps	
	min	sec	min	sec	min	sec	min	sec	min	sec
50	4	10	3	40	2	50	3	20	2	30
100	8	20	7	20	5	30	6	40	5	—
150	12	30	11	—	8	20	10	—	7	30
200	16	40	14	50	11	—	13	20	10	—
250	20	50	18	30	14	—	16	40	12	30
300	25	—	22	—	16	40	20	—	15	—
350	29	10	25	40	19	30	23	20	17	30
400	33	20	29	40	22	—	26	40	20	—

221

222